S0-AFS-377

THE HEART OF A PEACOCK

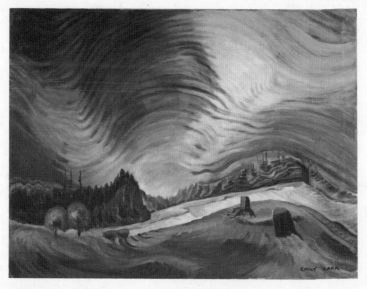

Emily Carr, *Above the Gravel Pit*, 1936–1937, oil on canvas, 77.2 × 102.3 cm, Vancouver Art Gallery Collection, Emily Carr Trust, VAG 42.3.30. Photo by Trevor Mills

EMILY CARR

THE HEART OF
A PEACOCK

LINE DRAWINGS BY THE AUTHOR

EDITED AND WITH A PREFACE BY IRA DILWORTH

INTRODUCTION BY ROSEMARY NEERING

Douglas & McIntyre

Copyright © 2005 by Douglas & McIntyre
Text of *The Heart of a Peacock* copyright © 2005 by John Inglis,
Estate of Emily Carr
Introduction copyright © 2005 by Rosemary Neering

18 19 6 5 4 3

All rights reserved. No part of this book may be reproduced, stored in a
retrieval system or transmitted, in any form or by any means, without the
prior written consent of the publisher or a licence from The Canadian
Copyright Licensing Agency (Access Copyright). For a copyright licence,
visit www.accesscopyright.ca or call toll free to 1-800-893-5777.

First published in 1953 by Oxford University Press

Douglas and McIntyre (2013) Ltd.
PO Box 219, Madeira Park
British Columbia, Canada VON 2H0
www.douglas-mcintyre.com

LIBRARY AND ARCHIVES CANADA CATALOGUING IN PUBLICATION
Carr, Emily, 1871–1945.
The heart of a peacock / Emily Carr; line drawings by the author;
edited with a preface by Ira Dilworth; introduction by Rosemary Neering.
ISBN 978-1-55365-084-3
1. Carr, Emily, 1871–1945. 2. Painters—Canada—Biography.
3. Birds—Anecdotes.
4. Monkeys as pets—Anecdotes. I. Dilworth, Ira, 1894–1962. II. Title.
ND249.C3A2 2005A 759.11 C2004-906463-0

Library of Congress information is available upon request

Editing by Saeko Usukawa
Jacket and text design by Ingrid Paulson
Cover painting: detail from Emily Carr, *Above the Gravel Pit*,
1936–1937, oil on canvas, 77.2 × 102.3 cm,
Vancouver Art Gallery Collection, Emily Carr Trust,
VAG 42.3.30, photo by Trevor Mills
Printed and bound in Canada by Friesens
Printed on acid-free, forest-friendly (100 per cent
post-consumer recycled) paper, processed chlorine-free
Distributed in the U.S. by Publishers Group West

We gratefully acknowledge the financial support of the
Canada Council for the Arts, the British Columbia Arts Council,
and the Government of Canada through the Book Publishing
Industry Development Program (BPIDP) for our publishing activities.

To
Victoria Anderson
and
Viola Morris

❦ CONTENTS ❦

Woo's Life

❧ EMILY CARR AND ❧ THE HEART OF A PEACOCK

by Rosemary Neering

I HAVE ALWAYS had a complex relationship with Emily Carr.

Part of me is pure admiration. That this woman, born in the nineteenth century into a town that drew a clear line between what was respectable and what was not, could accomplish what she did, fills me with awe. That she could defy the expectations of her time and class to paint with such power and skill, that she could ignore convention to behave as she wished, amazes me and arouses not a little envy of her strength, talent and single-mindedness.

And yet, and yet... "Monkey tempers are inflammable," she wrote in *The Heart of a Peacock*, "so is mine." Strangers who were cruel, bullying, hypocritical or simply irritating deservedly felt the sharp edge of her tongue, but she could be equally hard on those closest to her. In Victoria, British Columbia, the city where she lived for most of her life, stories of her temper are still legion sixty years after her death: the time she ended an argument by smacking her opponent with a garbage can lid, the nurse she sent fleeing from her hospital room in tears, the times she vented

her spleen on friends for slights real or imagined. Quick to feel wounded yet almost oblivious to the wounds she herself inflicted, she was a rebel who was easy to admire from afar but probably hell to live with.

We can appreciate Emily Carr's paintings without delving into her tempers and tizzies. But much of her writing is intensely personal; her sketches and stories embody the emotions and contradictions that characterized her life. To know something of that life gives her writing an added depth—especially in *The Heart of a Peacock*, which is almost a sampler of Carr's writings. Her childhood, her relationship with Native peoples, her deep attraction for the West Coast forest, her struggles as an artist, her experiences as an apartment house owner and dog-raiser and her love for all sorts of creatures are woven into the tapestry of the book.

The second-youngest of six living children born into an English expatriate family in colonial Victoria in 1871, Emily was the "puzzle child" of the family, rebellious under the domination of her father and eldest sister, contemptuous of the hypocrisy she observed in the narrow Victorian world of this frontier town on the edge of the Pacific. Alternately indulged as the youngest daughter and punished for her transgressions, she railed against the family expectations yet all her life remained close to several of her sisters. She never married: though she craved love and approval, her desire for complete independence and her aversion to sex closed this door to her. From childhood on, she allied herself to the wild, yet she sought to tame its creatures while she herself fought valiantly against being tamed.

Carr was determined from a young age to become a painter and studied in San Francisco, England and France. Back in

British Columbia, she visited and painted the coast and its Native villages, but made her home in the town that thought her painting strange and her conduct even stranger. She stayed her own course, and the bold, sure strokes of her painting brought increasing recognition outside Victoria if not within.

Late in her life, after she suffered a heart attack that curtailed her sketching and painting trips, Carr devoted much of her small stores of energy to writing, creating word pictures of her childhood and her adult life. Three books—*Klee Wyck*, about her experiences in Indian villages along the coast; *The Book of Small*, her reconstruction of her childhood; and *The House of All Sorts*, on her time as a landlady—were published before she died in 1945. Her writing ability was recognized much more quickly than her skill as a painter: *Klee Wyck* won her the Governor General's Award for literary excellence in 1941.

At her death, much remained unpublished. In her will, Carr named long-time friend Ira Dilworth, who had acted as her editor and who had helped find a publisher for her books, as her literary executor. Dilworth, an executive with the Canadian Broadcasting Corporation, investigated the manuscripts, letters, oil and watercolour sketches, sketch books, account books and other personal items Carr had packed away in a trunk. "In a letter," Dilworth writes in his preface to *The Heart of a Peacock*, "Emily directed me to dispose of the contents of the trunk in any way that seemed right to me, saying that little in it had any value, and reminding me that fire takes care of accumulated possessions 'cleanly and decently.'"

He had no intention of burning the papers, but the question of what to do with the them had no simple answer. *Growing Pains*, Carr's adult autobiography, posed no problem, for the

publisher of her other books knew of the manuscript and was eager to see it in print. It was published in 1946.

Yet Carr's will posed a difficulty for Dilworth. It bequeathed to him "all my manuscripts and all books written by me belonging to me at my death...in respect of such of my manuscripts or books written by me and published in my lifetime." The ambiguous phrasing could be interpreted to give all rights to Dilworth, or it could suggest that unpublished works were the property of Alice, Carr's last surviving sister and the residual legatee.

Dilworth wanted to be sure of his legal position. In 1952, he asked Alice, now in her eighties, to sign a codicil to her will, ensuring that the rights remained with Dilworth and his heirs. Upset because she thought Dilworth was delaying publication unnecessarily and irritated that she would have to deal with lawyers, Alice at length acquiesced. "Perhaps," she wrote waspishly to a friend, "as Ira is to get *all* the proceeds, he *may* hasten the publication of the books." He did. A collection of stories on a variety of themes was published in 1953, eight years after Carr's death, as *The Heart of a Peacock.* This was followed by an account of her time in England, *Pause: A Sketch Book,* also in 1953. Carr's journals, *Hundreds and Thousands,* appeared in 1966, after Dilworth's death.

The Heart of a Peacock is a lovely untidy collection of a few short fictional pieces, some remembrances of the various wild creatures that Carr tamed and loved, a few stories about the coast and a series of pieces on the life of Woo, a Javanese monkey that kept Carr company for thirteen years.

Though the memories in *The Heart of a Peacock* are drawn from many periods in Carr's life, most of the stories were written after 1937. Yet writing was not a new activity for Emily Carr. As Dilworth notes, she took a correspondence course through

an American journalism school in 1927, writing for her instructor a precursor of "In the Shadow of an Eagle," and in 1934 she took a Victoria course in fiction writing, winning the class prize for "The Hully-up Paper." Both stories appear in this book. She worked very hard, on her own and with Dilworth, to make her writing simple and direct, pared down to its essentials.

In "Indian Bird Carving," Carr talks about how the Northwest Coast Native artists create their carvings. "For the purpose of decoration, space filling, and symmetry, he might distort, separate, re-colour, but he *must* show the creature as complete in being, though he might conventionalize it." Not so distant from Carr's approach to writing, for she wrote what we today might call creative non-fiction. Like the Native carver, she bases her stories soundly in truth. But she understands the need for the dramatic moment that should have occurred, the words that are more apt than the words that were actually spoken, the sequence that represents a basic truth—or even just a colourful conclusion.

In a sketch written as Small, Carr's child self, Carr writes about the revenge of her treasured pet crow Crocker, punished for bad behaviour. Though Small and Crocker are real, the reader is drawn to believe that Small relates some of the bird's rampage as it should have happened, not as it did happen. The knick-knacks belonging to the disciplining sister are swept from the shelf and broken. And then, "'Oh, girls!'" cries Small. "'Look at Auntie! I'm evened on her at last!' The sunlight blazed through two pecked holes in Auntie's photoed eyes. She was torn from her frame." Carr wants vengeance on a relative she dislikes; she chooses the crow to enact a probably fictional vengeance, and the act is to her completely satisfying.

Though most of the book is in Carr's own voice, stories of her childhood and adult life, *The Heart of a Peacock* contains four

conventional short stories. They demonstrate that she was not at her best writing in a voice other than her own, for they have not aged well: predictable plots and clichéd characters are combined with what, in our era, are embarrassing attempts to replicate Native speech patterns. Carr must have been frustrated by the medium: her impatience sometimes gets the better of her, and she occasionally interjects an opinion that doesn't really fit into the story's structure.

Yet even these weaker pieces are well worth reading for the window they open on life along the Northwest Coast. "There was velvety blackness under the wharf," she shows us, "when they reached the perpendicular fish-ladder at Hardy Bay. Jenny shook the drops from her paddle, grasped the slimy green rungs, and climbed doggedly towards the dim lantern dangling over the edge."

She re-creates a nearly forgotten craft as she describes a Native basket weaver: "Her small brown hands moved swiftly. She ran moistened fingers down the long strands to keep them pliable. A quick, expert twist, followed by a firm, rhythmic movement, and strand after strand was finished, pared off with a knife, another started."

Sometimes a perfect sentence emerges from a story: "There was more waiting than going but Jenny took the waiting as part of the going."

These short stories share with the other, more personal sketches in the book Carr's marvellous ability to write with a painter's sensibility. Though she wrote most of these personal pieces long after the events occurred and apparently took no notes that survived, she held them in her mind for years, bringing them to life on the page complete in sound, sight, smell, touch and taste. "Blue heaven, green earth," she begins the title story, "betwixt the

two the big old cherry tree in full blossom, with the sunshine drawing in the sweet, heavy scent of honey from the blossoms until the air was almost sickly and even the bees were glutted. Suddenly into the honeyed sweetness burst the passionate cry of a peacock with its long-drawn tang of bitterness."

Much of *The Heart of a Peacock* is taken up with Carr's relationships with the wild birds and animals she adopted or encountered, relationships as contradictory as much else in her life. To touch them makes her happy, but to touch them, she must tame them, knowing full well that they thus lose their independence. Her pleasure derives not only from their wildness, but also from their acceptance of her, their surrendering of their wild selves.

However difficult the creatures she loves may be, they are often better than people. The peacock of the title sketch is proud and lovely, almost too vain for Carr to contemplate. She is content, though, when he comes to her window to preen, admiring himself in a reflecting window and resting his glorious head on her shoulder. "Subtly the bird was drawing from me, as he had drawn from everything else. I knew it, but I knew also that he was returning what he drew, tenfold."

Carr then goes abroad for five years. When she returns, the bird comes when she screeches for him and is again her companion. Soon enough, though, Carr finds confirmation of her high opinion of creatures, her low opinion of people. "The park belonged to the people, and the people missed the peacock." The bird is imprisoned in a pen. "He belonged to the taxpayers: the City demanded its taxes; the taxpayers demanded their pound of flesh. It gave them satisfaction to see their property securely penned before their eyes."

Carr delights in the tricks and depredations carried out by her birds and animals, a counterpart to the sheer joy and rapscallion nature that she herself could let loose. Nowhere is this more evident than in her stories about Woo, she of the temper that matched Carr's. Though the griffon dogs she raised provided both companionship and a small income, though the tamed birds and other animals entertained and amused her, the Javanese monkey was perhaps Carr's closest creature companion. Woo's tempers, her habits, her adventures, her affection, endeared her to Carr as no other creature.

"Woo's rages spluttered up and went out like struck matches. Open angry jaws, spread nostrils, clutching fingers, jerking head, grunts! Next moment all forgotten...Woo was intensely loyal to the few she loved," Carr noted. It's hard not to see something of Carr in Woo's mischief, a sort of alter ego who gets away with temper and tricks, and who is never punished. Woo also represents a victory over those who said it couldn't be done, the same sort of people who shunned Carr for her style of painting or her eccentric behaviour.

"'Your house will smell!'" cried sister Lizzie. "'Everything in it will be smashed! Your friends will drop away—who wants to 'hobnob' with a monkey!' This awful fate trailed back at me as sister Lizzie rushed down my stair returning to her own chaste house and leaving me to contemplate the wreck I had made of my life." How often had Carr received this same message from family and acquaintances? But each sister was eventually charmed by the small beast's antics: Lizzie took note of Woo's capers and used them to amuse her patients, while Alice found Woo entertained her schoolchildren and filled a stocking at Christmas for the

monkey. "Nobody *could* really hate that merry creature Woo; her pranks warmed our spinster middle-aged hearts."

After thirteen years together, Carr's heart attack forced her to convalesce in hospital; no one wanted to take on the burden of looking after Woo. Carr sent her to the monkey house at Stanley Park, where she lived as the "belle of the monkey house" for a year and died in her sleep.

Carr herself lived another seven years, suffering recurrent heart problems and restricted in her travel and painting. She died in Victoria in 1945, leaving a rich legacy of art and literature. Behind her, too, she left a legacy of a woman who lived as she pleased, laying bare through her writing the contradictions, tempers, frustrations, sympathies and victories of her unusual life.

❧ PREFACE ❧
by Ira Dilworth

THE SKETCHES IN THIS volume are now published for the first time. They were left to me by Emily Carr as part of the contents of a large box or trunk. The trunk contained a great many letters, a number of sketch books, several single sketches in oil and water colour, account books, Emily's journals, a number of manuscripts, and a great many miscellaneous personal items. In a letter, Emily directed me to dispose of the contents of the trunk in any way that seemed right to me, saying that little in it had any value, and reminding me that fire takes care of accumulated possessions "cleanly and decently." Her estimate of the contents was, of course, too modest—there was much in the box which has great interest and value. Everything has been carefully preserved.

These sketches deal with a great variety of subjects reflecting Emily Carr's various interests in life. There are two stories of West Coast Indian life; there are sketches, amusing and sometimes pathetic, of birds and animals that Emily had known, and that had taken an intimate part in her existence. There is an unusual story (unusual for Emily) dealing with a simple human

situation. There are a number of sketches dealing with Emily's childhood as seen through the eyes of "Small."

I knew of the existence of most of these sketches before Emily's death—indeed we had worked over most of them during the years after the publication of *Klee Wyck.* The two Indian stories I had never seen before, but "The Life of Woo," the sketches of birds and animals, I was very familiar with.

Some of these sketches, notably "In the Shadow of the Eagle," "The Hully-up Paper," and "Woo's Life," exist in more than one version. In preparing them for publication I have selected what seemed to me the superior version. In a very few cases I have grafted a passage from one version into the other where I felt the passage added something really striking. Otherwise I have done only ordinary editorial work (punctuation, paragraphing, etc.). For instance, in the "Shadow of the Eagle" there is an apparent discrepancy which makes Martha stumble over the base of the eagle which had already fallen. I have not tampered with this. Emily herself told me that Wragge had intended, as part of his honouring of old Susan, to put the eagle back in its place in the cemetery. This, I believe, was in Emily's mind as she wrote—she thought of the eagle as back in its place.

That Emily Carr should in her later life have become known as a writer of distinction has seemed strange to many people. The story of the development of this talent has never been completely or accurately told. Indeed some of the facts concerning it may never be known. Undoubtedly she had a great initial gift in the use of words. Some critics have gone so far as to say that her talent in writing even outran her talent in painting.

It was not until late in 1938 that I came to know that Emily Carr had for a long time been preoccupied with writing. The

information came to me from her friend, Miss Ruth Humphrey. In conversation with me at that time, Emily gave me the impression that she had taken up writing quite recently, indeed after her serious illness only a few years before. This is partially true, but it is not the whole truth. Her interest in writing most certainly increased, and her work on her writing was intensified after her illness, which made it impossible for her to go on long trips sketching in the woods. But there is now ample evidence that her preoccupation with the use of words went back almost as far as her preoccupation with drawing and painting.

As a young girl she had great facility in rhyming, as is illustrated by a number of amusing jingles and limericks which survive. In an article in *The Week* (Victoria, 18 February 1905) Arnold Watson described Emily Carr's studio where she was teaching painting. He says there were many sketches on the walls: "...some of these are serial and nicely bound together. Supplemented by verses (which she calls jingles) they illustrate amusingly some of her experiences in English student life."

In 1927, an important year for Emily Carr the painter, she was encouraged by Lawren Harris and the late Eric Brown, Curator of the National Art Gallery, to write about her life and the interesting experiences that had befallen her as an artist, and she began the first of her journals, which have survived. In this year, too, she was taking a correspondence course with an American school of journalism. This fact, which Emily never mentioned to me, is proved by the existence of a letter from one of the readers of the school's staff. He was returning a manuscript which Emily had submitted, with comments and criticisms. The manuscript was "The Nineteenth Tombstone." This must have been an earlier version of

the sketch published now in this volume as "In the Shadow of the Eagle." The manuscript of "The Nineteenth Tombstone" I have not been able to find.

In the years between 1927 and 1938 Emily's journals make many references to her writing, although she has nothing to say about formal training until we come to the year 1934. In that year she took a course in short story writing at the Victoria Summer School. There is an interesting item in one of the Victoria papers of that year describing the closing exercises of the summer session: "Real literary style was shown in Miss Emily Carr's 'Hully-up Letter,' the prize-winning story produced by N. De Bertrand Lugrin Shaw's short story writing class. Read by the author, this human interest story recounted an incident in B.C. Indian life, and held the rapt attention of the audience." Emily described this ordeal herself in her journal, as she described most amusingly some of her other experiences in the short story class.

During these years, when Emily was working hard at both her painting and writing, she had the habit of reading her stories to her family and friends, asking for criticism, hoping for encouragement. She worked very hard at her writing. Her sister Alice once said to me, "Emily always worked hard at anything she undertook." During this period she received considerable encouragement and help from her friends, notably from Lawren Harris, Flora Burns, Ruth Humphrey, then on the staff of Victoria College in Victoria, B.C., and from the late Fred Housser.

Following the year 1938 we did a great deal of work together on manuscripts which already existed. Some of them were prepared for broadcast, and were read on the air by the late Dr. Garnett Sedgewick. The first collection of sketches, *Klee Wyck*, was

published by the Oxford University Press in the late autumn of 1941. It was immediately acclaimed by critics and book reviewers, and Emily Carr emerged as a writer of importance in Canada.

A great part of Emily Carr's writing has been autobiographical. It recalls all sorts of people and incidents from her own life, particularly from her childhood. These memories of her early years are brought back through the eyes of Small. Who was Small? She was the embodiment of Emily's childhood—but I had better let Emily describe her herself, as she did in a letter to me dated 9 August 1943, and left in the trunk where I found it after her death. She said in part: "Do not be too sad when you and Small unpack the box, let her giggle a bit...she has been a joy to us, hasn't she?...and if there should be an et cetera [Emily's designation of my hypothetical wife] who questions 'Who.is Small?' say 'Oh, she's just a phantom child, made up of memories and love.' Small's adult outgrew her (as every adult *must* or remain an imbecile) but the child Small learnt the trick of coming back to cheer what used to be her...." Small was full of gaiety and laughter, reacting to joy and sorrow, quick-tempered, tender, devoted, and loyal. Emily often called her a scallywag. Her memory was, perhaps, not always absolutely accurate, particularly in situations where emotion was a prominent factor. For instance, it is quite unlikely that Emily's eldest sister ever punished her with a riding whip, as Small tells us again and again. There was punishment certainly, and deep hurt and sorrow on the part of the child, as is evident in the vivid memory which comes out in such sketches as "One Crow."

I have kept you too long from what I think will be a pleasure—the reading of the sketches that follow. My excuse can only be my hope that the facts given above may help to increase your pleasure as you read.

FIVE BIRDS

❧ THE HEART OF A PEACOCK ❧

BLUE HEAVEN, GREEN EARTH; betwixt the two the big old cherry tree in full blossom, with the sunshine drawing the sweet, heavy scent of honey from the blooms till the air was almost sickly and even the bees were glutted. Suddenly into the honeyed sweetness burst the passionate cry of a peacock with its long-drawn tang of bitterness.

He belonged to the public park but, wearying of its confines, he had flown the fence, wandering through the little pine grove and thence into our old garden.

From head to tail he was magnificent and knew it, arrogantly flaunting his beauty as he came. Beneath the cherry tree he paused and cried again.

I, looking from the window of the old studio in the barn, close above the tree, wondered how the cherry tree felt about this rival loveliness, but the peacock seemed to draw yet more glory out of the tree, using it as a setting for himself, as he spread his tail and strutted back and forth. Presently he flew to the low roof of the barn. The grey shingles still further enhanced the beauty of his colouring as he mounted the slope with mincing steps. Then he spied the mirror formed by the folding back of the dormer

window. He ran to it with evident delight and began to peer and prance and preen before it, bending his small, lovely head this way and that, dancing and spreading his tail in a shower of glory. Then he saw me. The indifferent way in which he looked me over made me feel like the poor shabby little girl at the party. Just a careless glance, then he returned to his mirror where he remained all day as though he could not bear to part with himself.

Towards evening his appetite overcame his pride and he returned to the park.

Next day, before the dew was gone, he was back at his mirror. I heard him call in the pines and then he was up on the roof. I offered some wheat but he had breakfasted and only desired to feed his vanity.

From the sunshine he absorbed the glint and glisten, from the quiet grey roof the contrast which multiplied and offset his brilliance; from me he tried to draw admiration and flattery. His beauty pleased me but I resented his arrogance.

"Vain creature!" I said. "Pretty you'd look if they turned you inside out and showed your selfish, shabby heart." I turned to my work, disgusted at his conceit.

He continued to come every day and I grew to like him there behind me as I worked. Sometimes I pandered to his conceit and applauded his showing off. Then he was pleased and would come and sit on the window-shelf in the far corner, gradually moving closer and closer until his head, surmounted by that glorious coronet of sparkling feathers, rested on my shoulder, and my hand *had* to steal out and caress it. Subtly the bird was drawing from me, as he had drawn from everything else. I knew it, but I knew also that now he was returning what he drew, tenfold. Suddenly I sensed the loneliness of this creature, hatched from

an egg, brooded over by a common domestic hen. No kith, no kin: his looking-glass self the only mate he had ever known.

I learned his call. He answered from the pine wood and came hurrying. Often his call woke me in the morning.

Spring passed: the blossoms were cherries now, the bees had moved to the clover patch. The long summer days passed and the crisp autumn ones, and every day the peacock and I screeched our greeting and spent long companionable hours. Then one day I kissed his crest, put him out, and closed the window. That night I went abroad.

In my absence a parson occupied the studio and wrote sermons there. He closed the wall-cracks with newspaper to keep out the singing wind, and caught the mice in traps.

"What of my peacock?" I wrote home.

"He came once, the morning after you left. Since then he has not come at all," was the reply. "We see him strutting in the park, delighted with admiration. He has doubtless forgotten you," they added.

I was absent for over five years. When a young thing stays out of her own world as long as that, and comes back grown, it is hard to fit in. Some things have grown ahead of you, and you have grown ahead of others.

I ran up the rickety barn stairs to the studio. Phew! How musty and "sermony" it smelt! Even as I crossed to the window I was peeling off strips of the parson's newspaper. I threw the dormer wide. The garden was full of November fog. "Come in, old fog, and souse out the sermons," I cried. Everything was drab: the cherry tree, old, past bearing, had been cut down. I thought of the peacock. "Gone where good peacocks go," I sighed, and wondered where that was.

Next morning I was busy on the floor with a pail of suds.

Hark! In my rush the suds were knocked over and trickled through the floor onto the back of the patient cow below. I leaned from the window and screeched that unwritable screech. It was answered instantly. The peacock was hurrying through the garden, unmindful of his tail, which swept the leaves and dirt. Hurrying, hurrying, not to the mirror—he could have had that all these years—but to me.

"Oh, peacock! Now I know that if they did turn you inside out your loyal heart would be lovelier than your feathers!"

How was he aware, that morning, that I had come? I do not know. That is one of the mysteries, and his secret. The park was out of earshot, and I had not been there.

What a pity this happiness could not have continued for years and years, for I hear that peacocks live to a great age. But the park belonged to the people, and the people missed the peacock.

A rumble of little grumbles arose.

What right had an individual to monopolize public property?

They complained to the keepers, who complained to the City fathers, whose fatherly instructions were "Pen the peacock."

Locked up among the sentimental doves and the stupid owls, the peacock beat his breast against the wires in vain. His feathers and his pride were broken.

The glow and sparkle of his plumage dulled, went out. His head sagged forward, wings drooped. He remembered no more the way of brag and display, nor how to spread his tail; it dragged heavily in the dirt.

I tried to cheer him in the padlocked pen. I begged in vain for his release. He belonged to the taxpayers: the City demanded its taxes; the taxpayers demanded their pound of flesh. It gave them

satisfaction to see their property securely penned before their eyes. They tried to "shoo" the peacock into strutting for them, and when they did not succeed they said, "Stupid brute! He sulks," and turned away.

When next they came the pen was empty.

"Where is the peacock?" they asked the keeper.

"Dead."

"So? I suppose you saved his feathers? Will you give us some?"

"They wasn't worth the saving," the man replied. "All the glint went off 'em when his heart broke."

❧ ONE CROW ❧

THE TOPS OF THE pine trees shut out the sky. Down through their branches tumbled screeches and the flapping noise of many wings. Above the tumult rose an agitated treble screech. "Small! Small! Where are you?"

Small's reply was almost drowned by the screaming of crows, the crackle of dead branches and the swish of green ones. The young girl jumped to the ground so close to the querulous elderly voice that its owner "ouched"!

"Mercy, child! What ever were you doing up there?"

"Getting *him*."

At sight of the naked, scrawny-necked bird the girl held out, the woman screeched again; disgust swept over her face. "What are you going to do with the revolting creature?"

"Tame him, teach him, love him."

"You have a yard cram full of domestic fur and feathers at home. Why must you desire to add a carrion crow to your collection?"

Small's gasps were quick and exultant, the sobbing breath of a competitor who has won his trophy hard. The hardest part had been the persuading of this relative to drive her out to the wood where she knew crows nested. The excuse she gave was flower

gathering. The crow's naked flesh throbbing against her hand thrilled her and was more than compensation for her ripped flesh and clothing. "I do call it luck," she gasped, wrenching apart two portions of garment stuck to each other with pine tree pitch, "great luck to find anything so easy; crows usually build in out-of-the-way places."

"I should call that out of reach," said the woman with an upward glance at the trees and a downward glance at the tattered, gummy girl. "Tidy up, Small, while I untie the horse." One foot on the step of the buggy, she called, "One crow is bad luck!"

"Had I best climb for another?"

"Mercy, no! Come home and get your deserts. One-crow luck will fall on you when the Elder sees your bird, see if it doesn't."

Small placed the crow tenderly in the front of her jacket. At the last turn, with the crow's fate and the Elder just around the corner, she said, "Thank you for taking me. I did so want a crow. Just to touch wild things sends me crazy happy."

"I am glad my children are not like you, Small," said the woman. "Out quick! I'd rather be gone before the Elder sees that bird. Don't let her know I had a hand in his getting. I trust one-crow luck won't spill over me too."

Sniff, cluck, slap—the old horse started. Small went in to face the Elder.

There was one thing you could be absolutely sure of—that the Elder would do what you did not expect. There was a twinkle in her usually stern eyes as she regarded her little sister and the crow. A use for the bird came immediately to her mind.

"Small," she said, "Mr. and Mrs. Smith have come to pay us a long visit." Small grimaced. She detested the Smiths, a pretentious couple who preferred visiting to housekeeping. Small took no

pains to hide her dislikes. The Elder figured on using the crow to curb Small's tongue. Each wag of her long forefinger a warning, she said, "Courtesy to my guests, Small, or out goes your crow."

Putting the crow into a small basket, Small was on her way upstairs. "No, Small! The beast lives on the verandah."

THE EVENING MEAL seemed endless. Mr. Smith told bragging stories which Mrs. Smith laughed at. Neither the Elder nor Small's two other sisters *could* laugh at the type of story told by Mr. Smith. Small chafed, longing to go to her crow.

"Why so sober, kid?" A great tweed elbow dug into her ribs.

Small felt the resentment a girl in her teens knows when called "kid" by an enemy. She starched herself, caught the Elder's eye, sagged. A general move from the supper-table saved her. She rushed out to the verandah and the crow.

At her touch, up was thrust a red hole of a mouth feebly supported on a wobbling neck. A yet unconscious eye was on either side of his head. Above and below the mouth the crow had an ineffectual scrap of soft beak. Out of the mouth poured urgent pleading squawks (not made in the throat but coming direct from the stomach), life's roaring for fuel.

With a little pair of wooden pincers Small stooped to fill the gaping mouth. Smith, who had followed her onto the verandah, leaned across and blew a great puff of tobacco smoke into the crow's mouth. The bird cowered and gagged.

"Despicable bully!" blazed Small, and raised her eyes to see that the Elder had followed them onto the verandah and was watching. There was interest in the crow in her eyes, warning for Small, and contempt for the Bully.

THE CROW GREW with amazing rapidity. Soon his neck stopped wobbling and his legs could support his body. He stood upright in the nest and squawked when Small came to feed him. She stuffed the food down his throat and he gobbled greedily.

Soon the little grey casing in which each feather was sheathed burst and the released feather fluffed to cover his nakedness. They tickled and this induced him to peck and preen. Development rushed upon him, he discovered something new about himself each day. The last and most wonderful thing he learned was the use of his wings. At first they only flapped but had no power to rise. The heavy stomach in which his strength was generating required still the warmth and support of the earth. As yet the air had not called him, so he was content to hop or sit until his wings equalled in strength the rest of his body.

When the desire to rise came he hopped up and up from object to object until he reached great heights—then, afraid to trust his wings to float him down, sat screaming for Small to fetch him.

Small said, "Your bird-mother could help you now so much more than I." But she got a ladder and scrambled up to the roof and fetched him off the chimney, or the ridge pole, while the Bully sat below jeering and calling the bird a fool.

It was at this stage in the bird's life that the Bully found unlimited opportunity of tormenting Small, through her crow. Long ago he had sensed that the Elder used the crow to keep Small's tongue in check. He saw Small bite back the angry retort by burying her face down on the back of the crow, holding him tight. The man said to his wife, "Ha! It is fun kicking up pepper in that kid, to watch her hang on to that bally old crow and nearly bust with fury."

"Look out," warned the wife. "For the present this is a conven-ient habitation. Would you drive me back to drudgery? Are you so anxious yourself to seek a job?"

The man scowled. He compelled Small to fetch and carry for them. If the Elder were present she sullenly complied. If the Elder were not present she refused, and then the couple told on her.

Silently Small noted that the Elder said no more about getting rid of the crow, but punished her instead by whipping, scolding or shutting her in her room. The man's pleasure in tormenting the girl lost value when he could not use the crow as a medium.

Before the bird had use of his wings, Smith took him one day and set him on the clothes-line. Then he whipped the line up and down furiously. The fledgling clung to the line as long as the strength in his feet hung out, then he flopped heavily to the stones and squalled for Small. Out of the door she flew. Behind her came the Elder who, looking straight at the man, said, "Mr. Smith, I dislike cruelty."

"Only a carrion crow," replied the man with an insolent shrug.

When Crocker, as Small called her crow, had mastered the air, his movements and entire nature quickened. He seemed pos-sessed with the desire to tease and trick humans.

"Crow, you are getting to be a nuisance," said Bigger, flapping her duster at Crocker who, a small china dog held in his beak, impudently contemplated her from the window sill with guttural croaks and a cocked head.

Bigger hurled a pail of suds—soap, scrub-brush and all—over him. He shook the drops from his glossy back, drank from the puddle with relish, speared the soap with his powerful beak, and flew across the garden to the wail "My soap!" from Bigger.

"Mustn't it be grand to make folks scalding mad, to fly off higher than their threats and farther from their hurls," sighed Small. "But it would be best of all to be a waterfowl and able to use the water as well as earth and air."

Bigger stamped an impatient foot. "Look here, Small! Don't you go bringing any waterfowl home!"

Small never caught up with Crocker's damages: first the family came with complaints and then the crow for comfort. One either side of her, up and down, up and down, she was like the pivot across which their troubles seesawed.

The Bully built a boat in the Elder's back yard. The crow watched from the maple tree. When the Bully was not about, the crow stole his small tools and the galvanized nails. Though the Bully never actually saw, he guessed and he complained to the Elder.

"It would be better to put your tools away when you leave work," said the Elder.

CROCKER RELISHED A BIT of fresh meat. The Elder, frying chops, saw two piercing grey eyes set in shiny blackness peering over the door sill. "No you don't, crow," she said, and shut the door upon him.

To a bird a window is as good as a door. He watched the Elder safely into the pantry and flew into the kitchen. He hovered over the sizzling fry-pan, making careful selection. The Elder's wooden mixing spoon came down on his back. The chop of his selection fell upon the hot stove. But the crow had tasted. With dogged determination he defied the Elder's whacks and hopped across the hot surface, burning his feet but retrieving the chop. Making a

good getaway he retired to the coal bin where he morosely nursed first one foot and then the other. Small came to him with butter for his burns and comfort to his heart. With a twinkle in her eye the Elder related the episode at lunch. Everyone laughed and followed up with some mischief story about the crow.

The Bully alone did not laugh; he looked grim. His wife said, "I can't think why anyone could be bothered with a nuisance like that crow." The Bully looked approval at his wife. He said, "His mischief is not going to last so much longer nor will the kid grin so hard when I wring that vermin's neck. I intend doing so when I catch him stealing my tools."

"You daren't! You bully! You sponger! The crow belongs here, you don't," cried Small, beside herself.

"Small, leave the room." The Elder's voice was cold and hard. The Elder's face was granite.

On her way upstairs Small met the woman who had driven her out to get the crow.

"Crow troubles, Small?"

Small nodded. "It's that beastly bully."

"One black crow, child!" The relative wagged a finger, her head, and her reticule at Small.

Small crossed to the bedroom window. She saw the crow on the edge of the barn water-barrel. As she looked, some bright object dropped from his beak into the barrel.

"Crock!" she called. "Caw" came the instant response. The bird flew to her.

When according to their lights the whip and the Elder had thrashed manners into Small, she went, sore and angry, to the water-barrel. In the clear shadowed water at the bottom she saw a number of small tools glistening and a pile of galvanized nails.

BIGGER WHISPERED TO the Elder, "The 'call of the wild' may be the solution of our crow problems!" The Elder frowned and turned her back. Middle was staring. The Bully and his wife stood grinning. Small, watching intently, was twisting the corner of her apron into a rope. The group stood on the lawn of the cottage they had rented for the holidays. It was near the sea and close to the little wood where Crocker was hatched. To the crow was to be left the choice of returning to the tribe of his blood-brothers, or continuing in captivity with his humans. The crow mob were assembled in a nearby willow tree, clamorously inviting. The wicker cage stood on the lawn with the door open. Six cats crawled out, shortening their legs and elongating their bodies, slinking across the lawn to the nearest shelter available. Administering a smart pinch to the tail of the last cat so that she yowled and hurried, the crow strutted out. He paused to preen the taint of cat from his ruffled feathers. He was keenly aware of the other crows, but gave no answering caw. He shook himself, crouched, spread his wings and took his place among the flock, a perfect crow, black as they; but inside he was different, knowing as he did the feel of human protection, of human love, sensing, by the tone of the human voice, anger and coaxing. Dumbly he understood the difference between human laughter and human crying; here in the willow, among his feathered brothers, he felt the tense watching in the eyes of the humans he loved.

He swooped to Small's shoulder.

The wild flock flew away. The knot of humans dispersed. Small and her crow were alone.

He tried the patience of his humans to the limit that summer— ripping the pillows open for the pleasure of scattering the feathers, hurling every match out the window, picking the eyes

out of a visiting child's doll, and the flowers and feathers from the ladies' hats, raiding the larder, pinching the cats' tails, agonizing the canary, ripping, stealing. Everything was at his mercy, as there was little cupboard room and doors and windows always stood open.

The Bully's razor and his wife's curling tongs disappeared.

"That confounded crow!" muttered the Bully. Everyone said, "Nonsense, they are too heavy for a crow's beak." For a week everyone hunted.

His seven-days' beard turned the Bully into a pirate. His wife's hair streamed from her head straight as bulrushes. Their tempers were seven times worse than usual.

After a week: the crow chortling in a tree top—Small climbing to investigate, handing the rusty implements to the Bully with a mock bow as she descended.

The Bully's revenge on the crow was to molest a hornet's nest close to where the bird was roosting. Hornets swarmed around the bird's eyes, imbedding their venomous stings. The bird, mad with torment, flew to Small. As she beat off the hornets she heard a snigger in the bushes. The Bully was there, his hand filled with stones, one of which was poised to hurl.

"Coward! Mean-natured little nobody! Prating of your ancestors! Why, you are not even a common gentleman!" screamed Small.

The Bully rushed to tell his wife that the kid had insulted him. His wife rushed to the Elder. The Elder rushed for the whip.

Bully Smith sat beneath the open window. Each sing of the whip was salve to his gentlemanly wounds.

When it was over, Small, tearing from the house, tripped over his sprawled legs.

"'Scuse me, kid!" His leer of delight was unendurable.

Small flew to the woods across the field. Fluttering close behind her came the crow. In the deep moss under the trees, her face down among ants and beetles, Small cried into the earth. Crocker strode up and down her spine, chortling, tweaking the loose hair around Small's ears, fluttering his wings, twisting his head this way and that. He hopped down from her prostrate person and tried to poke his beak down through the moss that he might peer into her face. Soft and throaty were the noises he made as he pecked at her fingers. Tender croonings, as of a mother crow urging her little ones to face the world and fly. For the moment the adult crow had changed places with the child who had mothered him.

Rolling over, Small laughed up at the crow "Aren't we eye-swollen frights! If I was you, Crock, I'd go back to the crows."

The crow pushed his head under her hand, a baby crow again, begging to be caressed, begging mothering from a human child.

The Bully resumed his boat-building and the crow his stealing. The man caught him in the very act of teasing the caulking out of the seams of his boat. In a fury he went to the Elder and demanded that the bird be destroyed. Again the Elder said, "I recommend, Mr. Smith, that you keep your tools in their box when not in use." The Elder resented the overbearing attitude of the man. Coolness sprang up between hostess and guests.

Crocker's opportunity was the hour of family worship, when the Elder, sober-faced, read each morning from a little black book. Small knelt in the window seat and encouraged the bird to come to her there that she might divide her attention between the Elder's prayer and the bird's mischief. Hopping through the open window he would creep under Small's hands, his shiny feathers still hot with sunshine.

Bigger saw. "It is profane to share your prayers with a crow!"

Small retorted. "If you had been praying instead of peeping you would not have seen."

"Hush!" The Elder strode across the room, smacked the crow with the prayerbook, drove him away, and slammed the window. Watching the indignant hop of the bird down the path, Small mumbled, "He'll pay back."

He did. The agitated tap, tap of Bigger's heels down the hall said he had before she burst open the breakfast room door and screamed, "It can't be borne! Come and see!"

All left the breakfast table, all followed to the drawing-room and stood aghast.

Bigger's knick-knacks had been swept from the mantelpiece. Everything was in a smashed heap upon the stone hearth.

"Oh, girls! Look at Auntie! I'm evened on her at last!" giggled Small. The sunlight blazed through two pecked holes in Auntie's photoed eyes. She was torn from her frame. The twisted cardboard forced a crooked smile from Auntie. Another peck had provided her with a dimple foreign to Auntie's flesh and blood.

Middle gently turned Auntie face down.

"Don't do it!" cried Small. "She'd far sooner spit fire at us through holes than snub her nose in a pile of rubbish!"

"Small! For shame!"

But even the Elder's thunder was out-thundered by a bolt from the hall.

"Lady, if that black devil ain't shet up I quits me 'angin'! 'Im tweakin' out pegs! Wash floppin'!"

The distracted Elder went to appease the washerwoman. As she passed Small she said, "He's got to go, Small! Manage it how you wish but go he must!"

"Delighted to officiate," said a voice at Small's elbow. With a disgusting throaty gurgle the Bully drew a coarse finger across his own neck. The Elder gave the Bully a look of utter disgust. Small ducked her head into the crook of her elbow and rushed from the room.

"I've done it," she said to the Elder that night in a squeaky, pitiful voice.

"How?"

"Sent word to that boy on board the ship that he may have Crocker."

"The boy who asked you to get him a crow? He will be good to him."

"They," she pointed towards the guest-room, "are going." She wanted to cheer Small.

Small stood before the Elder one week later. "The boat had sailed. My message was too late!"

The Elder pretended her thoughts were elsewhere. "I am having screens put to all the windows and, Small, it would be better to cage Crocker at night. Crows wake so early."

THE ELDER CROSSED the yard. In her apron she carried something tenderly folded.

"What?" asked Bigger.

"The crow."

"How?"

"Shot. This shooting by boys must stop! Their shots always find the wrong mark. The entire band flew away—just one, Crocker, silhouetted against the sky. Of course, he got it."

"Oh, bad luck it should be he," said Bigger.

Middle came and looked into the apron, broke her usual indifferent silence by saying, "I'm sorry."

Small, kneeling by the yard chopping-block, had her head buried among the chips. Her tears were pouring into the sawdust.

Bigger blurted very loud so that Small might hear, "I didn't really mind his mischief."

"My watch didn't break when he threw it out the window," added Middle.

The Elder untied the apron strings from about her waist. She folded the apron round him, making a neat little parcel of the crow, took the spade, and started for the garden. The spade dragging along the gravel roused Small, who lifted a chip-tangled head with red swollen eyes.

"Never mind, Small! I'll do it," said the Elder. Small saw a bright red spot ooze through the white apron. She buried her face again.

"Crow luck again, Small?"

Small jumped and faced the elderly relative.

"You were wrong," she cried. "My one crow was never bad luck. He brought laughs to everybody. He rid us of the Bully."

❧ UNCLE TOM ❧

TOM AND I MET in no-man's-land. What of each other we did not understand we were content to leave unexplained.

Uncle Tom was a vulture, a common turkey-buzzard. I acquired him in the Indian village of Sechelt. Indians had stolen him from the nest of his vulture mother on the Island of Texada, tired of him after a few days, and abandoned him to starve. I was walking through the village of Sechelt and the bird came entreating at my heels, mouth open, starving. I dug clams and fed him; then I paid the Indians fifty cents and put Tom into a sack and took him with me.

I was on my way to visit at the summer camp of a friend, a friend who had invited me to bring my old English sheep-dog and my Australian cockatoo. She was surprised when she saw that I brought too a vulture in a sack. But her heart was big; it opened to the helpless baby vulture. She gave us a tent to ourselves and we were very happy.

I called my vulture Uncle Tom because of his resemblance to the picture in *Uncle Tom's Cabin*. His face was bare and black and was sunk into a body of white baby fluff. When I got him he would be only a week or ten days old. He grew rapidly and soon

shed the white down, replacing it with feathers of rusty black. His face always remained bare. When grown, Tom had tremendous wing spread, keen sight, and an extremely keen sense of smell.

No meat was procurable in camp other than an occasional fowl. Tom gorged on its entrails. I raised him on clams and mussels which I pushed down his gaping throat. He followed my every footstep. I was the only mother he had ever known—he loved me.

Tom grew into a great bird, hunch-shouldered because his wings were so huge there was no room for them to lie against the sides of his body. When furled they rose high on his shoulders.

The cockatoo on my shoulder, the dog and vulture at my heels, I went into the woods and we were very happy. At night we were cosy, folded in our tent. Summer went and playtime was gone. Before returning to my studio in Vancouver I took my creatures and went to visit my people in Victoria. A vulture they could not accept into the family circle. They lent me a calf-pen for his accommodation.

It was when I returned to Vancouver that I discovered how keen was Tom's sense of smell. Leaving him in the travelling-box at the far end of my big studio, I went out and bought him some fresh liver. As I came up the stair, while yet the liver was in its wrappings and there was still a long hall and the length of the studio to go, Tom smelled the meat and began to shout and go crazy. His habit was to gorge, then go to sleep for hours to digest his food.

Now came the problem: What should I do with Tom? I could not keep him in a city studio. I loved the bird. I offered him liberty: Tom refused. He must have known the power in his great wings, yet he never rose on them; he had become thoroughly domesticated, clinging to earth and to me. He knew nothing of

carrion nor of high-sky hoverings, "vulture-waiting" for cow or sheep to die, that he may swoop and gorge. Tom accepted humans, but humans would not accept Tom. He had a queer, wild beast smell.

In perplexity I approached Stanley Park. I said, "I have a tame, hand-reared vulture. He will not accept freedom."

"A curiosity!" they replied. "Bring him to us."

So I gave Uncle Tom to the Vancouver Park. They housed him in a large cage and treated him well. I called often to visit with him.

"Hello, Uncle Tom!"

The bird would press against the bars of his cage and rejoice over me...dear Tom!

✖ SALLY AND JANE ✖

SALLY WAS AN AUSTRALIAN lemon-crested cockatoo; Jane was a green double-yellow-faced Panama parrot. They hated each other. Parrots, all parrots, are bitterly jealous. Sally was a sweet-tempered, meek bird; Jane was vicious—her orange eyes would dilate and contract their pupils in spasms of rage. Sally's eye, round and black as a shoe button, had amazing expression but lent itself more to sentimentality than to anger. In the studio was an old wooden-backed chair, which was the parrots' own. I perched them on its back when they were out of their cages. First they gave each other a glare of malevolent hate, then drew close; each put out a foot, the foot nearest to her enemy; claw locked claw with a ferocious grip. There they sat, hour after hour, holding hands, each balanced on one leg. It seemed that to hold each other's hand was to safeguard against attack. The slightest move on the part of the attacker gave the attacked warning. The birds never talked when they were foot-locked but gave each other vicious, snarling, beaky growls from time to time.

Living in a flat, as I did at that time, I dared not allow my parrots to screech, or we would have been evicted. Jane was an

excellent talker; Sally spoke little but clearly; both could screech magnificently. They knew screeching was punishable either by a crack over the foot with a paintbrush, or, what they hated worse, being extinguished under a black cover and shoved into the dark closet. When I left them alone in the studio, going down the hall to my kitchen to prepare meals, both birds would set up a chorus of screams. The moment they heard my hurried returning footsteps Jane would say, "Sally! Oh, you bad Sally, stop it!" Sally glowered silently and I administered whacks impartially, knowing both equally to blame. Jane's rebuke to Sally was in exact imitation of my own voice.

Sally was not much of a talker; all she could say was "Hello!" and "Sally is a Sally!" This brilliant statement she taught herself. I tried to make her say "Sally is a fool," but with distinctness she corrected the statement, saying "Sally is a Sally," then made the sound of kissing. Jane sang three songs, words and music complete. Her favourite was "We won't go home till morning." She finished the hurrahs off with a magnificent roll; she loved the letter "r." She was really a clever talker, but if anyone approached the cage to look at her she stopped short, cocked her head, and, looking her admirer full in the eye, said "Oh, you old fool!" and burst into mocking laughter.

Sally adored men, from the sprucest gentleman caller to the very soiled old Chinese janitor. Sally was all for men. Let a man come into the studio and she would turn her back on me, scramble from her perch, climb up his chair and, mounting to the man's shoulder, would lay her crested head sideways against his cheek, roll her beady black eye into his and say, in a most cuddling voice, "Sally is a Sally." Every man fell for Sally; she pleased

their vanity. They all wanted to buy her. People laughed at Jane's chatter but they kept out of her reach. Nobody asked for Jane's kisses; Sally kissed everyone.

Jane could assume a sweet, wheedling voice. Once a plumber annoyed me to ferocity with some bad work. He rushed pell-mell down the long stairs, my tirade of righteous indignation following. Jane's cage was round the bend where he could not see the bird. When he got to the bottom of the stair Jane called, mocking the sugariest tones my voice possessed: "Goodbye, dear." I could have wrung her neck! I ran to a curtained window to see how the plumber was taking it. He stood at the stair foot, mouth open, amazed.

They seemed to delight in humbling me, those birds. A new tenant came into the flat below ours. She went to a neighbour and asked, "Who is that extraordinary old woman in the flat above?"

"She is not old," said my neighbour.

"Seventy-five if she's a day," replied the newcomer. "Loyal old soul, always singing 'God Save the King' at the top of her cracked old voice!"

"Oh, that is the parrot," said my neighbour.

The way that Jane learned "God Save the King" was funny. I tried patiently to teach her the National Anthem, working for weeks. Apparently Jane paid no heed; not a syllable of it would she say.

I fell sick. The doctor, suspecting diphtheria, isolated me in my flat, forbidding anyone to leave or to enter. I was in bed. The birds screamed and shrieked at being alone, so I shut them into the dark closet to quiet them. A nurse was sent in. She was told to enter without knocking, that I was all alone in the flat and in

bed. The woman opened the door. A dog barked; two voices said, "Hello! Hello!"

"How are you?" replied the nurse politely, and was greeted by rude laughter.

"You old fool! Ha, ha, ha!"

No one was in sight; the nurse was incensed. She came on down the hall.

Up sprang a great sheep-dog and refused her admittance to my bedroom. I quieted the dog. The nurse came in a little stiffly and began to treat my throat. Presently from the cupboard came a soft voice: "God save! God save!" I was too sick to bother. Nurse said, "I understood that you were alone in your flat?"

"I am."

"I heard a voice very close," said the nurse, gingerly stepping over the sheep-dog who resented her tending me.

"Parrots."

"Oh!"

"God save! God save!" came from the dark cupboard. Jane worked back into her memory all day. By night she had reconstructed the whole first verse of the National Anthem. The nurse was highly amused.

"Too late, too late, Jane," she said, for just the day before King Edward had died.

I tried to teach Jane to end the verse "God save King George," but the wayward bird would make her own version: "God save George!" she sang. To the end of my owning her, that was Jane's ending to the National Anthem: "God save George!"

She heard my pupils call me "Miss Carr." She knew it meant me. Well, if George was not "King," could I expect to be Miss? "Carr!" she would yell when she missed me. "Carr, where are you?"

I do not for one moment think a parrot knows the meaning of the words she says. It is just connections of persons and happenings that she puts together. If anyone rose to go out of the room, Jane invariably shouted "Well, goodbye!" For those sticky visitors who stand on one foot lingering, without the courage to make a start, this was sometimes very good. Jane would get more and more insistent, shouting "Goodbye, goodbye" till they really *had* to go.

Jane always got my toast crusts at breakfast. "More toast?" I would ask. Therefore all food to Jane was "toast." When she saw anyone eat she always begged, "More toast!"

One day I locked myself into my flat, got into my bathing suit, and scrubbed my studio floor. In shoving round the furniture I shut my hand into the hinge of a folding bed. The cot-bed was piled with furniture; there was nothing to do but remove it with my left hand, drag the bed to the telephone and call to someone in the building for help.

"Line busy!" Then I remembered the locked door. No one *could* come to me. I would likely lose my hand. I dragged the bed down the hall. The last thing I had to haul it over was Jane's cage, put out there to clear the room while I was scrubbing. I must have been groaning heavily as I turned the key and shouted "Help!" For a while then I remember nothing. Then I heard groans. "Oh dear, oh dear, oh dear!" Jane's mocking voice! For years I was to be tormented by my own groans. As long as I owned Jane, "Oh, dear!" she would moan, "Oh dear, oh dear!" till I could have wrung her neck. It is obvious that intensity and earnestness of tone make an impression on a bird's ear. I might have tried for months to teach her that groan. Were it only a mock groan it would not have registered.

While living in Vancouver I used often to spend a weekend in Victoria with my people. I took my creatures along, the big sheepdog, the two parrots.

The gentle Sally was loved. Jane? Well, her singing and chatter *were* amusing; no one came too near her, though. Each bird had her own travelling basket. I tried to look fat and greedy as I sailed past the stewards, who shouted, "Check all hand baggage!" I wanted them to think I was carrying along snacks of lunch to consume on the trip. I could not trust the birds checked. I went to the observation room and selected as remote a chair as was available, snuggling a parrot basket on the floor close on each side of my chair. For the first hour the birds were silent. They were peeping curiously through the basket-work. By and by they got bored; then I would hear chewing and tearing of wicker; a sly kick and the chew would stop for a minute only to begin again. The ladies near me would fidget. Men, half asleep under newspapers, stirred, recrossed their dangled leg so that it hung far from my basket. Suddenly a voice. "Hello! Sally is a Sally!" or "You old fool!" and ribald laughter. Out would pop either a green head or a yellow-crested white one from my baskets. Ladies screamed, gentlemen shoved their chairs a little further away. I took my "lunch baskets" and retired to the outer deck. The stewards thought I had gone there to eat. They were pleased that I was not going to muss crumbs in the observation room.

The birds were only half welcomed at home. They scattered seeds and screeched.

TRAVELLING WITH A parrot is not always easy. Once I was travelling across Brittany and carried an African grey parrot in a box. I put the box with my other light luggage up on the rack over my

head. No one was in my compartment except two merry old priests who were saying their prayers hard, clattering rosaries and looking out of the window.

Presently Rebecca, my parrot, began to meow like a cat. The priests looked about and into every corner of the carriage. I could not talk French but I laughed and pointed to my box. "Peroquet," I said, and the priests, bowing, resumed their devotions. We stopped at a station. An old woman got into our compartment with a huge basket of vegetables and a plucked fowl lying over the top, its head dangling. The ticket man came. Rebecca started meowing furiously. There followed an excited argument between the ticket collector and the old woman with the basket. He seized the fowl and made her empty every carrot, onion, and potato onto the floor of the compartment. He shook the basket and then his head. The indignant old woman repacked. Next he attacked a woman with a young baby who had also got into the train at the same stop. He lifted the child and looked behind it and behind the woman. He gesticulated and raved. He now attacked me. I pointed to my tongue and shook my head. The man said "Bah!" and began to meow.

Then the old priests laid down their rosaries and roared till tears ran down their cheeks. They pointed first at me and then to Rebecca's box up on the rack. The ticket collector peeped into the box and laughed too. He went away. It seems you may travel with a bird but you may not travel with a cat or dog in France.

ONE NIGHT I was making the trip from Victoria back to Vancouver. I had been late in securing my berth; all that was available was a top in a three-berth room. Sally was with me but not Jane. It was a very rough night. The boat pitched and tossed. It took several

tries before I landed safely in my berth. I took Sally's basket up with me: I could not leave her rolling around on the floor. I strapped her basket to the wooden open-work of the ventilator. On one side of our room a man coughed all night, on the other a woman, a violent case, was being taken up to the Insane Asylum by two keepers. She swore, cursed, and screamed. Wind shrieked; our empty shoes clattered around the floor, hats too, and tooth brushes. In the middle of the hubbub came a small, sweet voice: "Sally is a Sally!" I gave the basket a sly kick. "Sally is a Sally! Sally is a Sally!" The voice got louder and more insistent. The woman in the bottom berth scragged her neck up to the woman in the middle. "As if," she whispered loud above the turmoil, "that top-berth woman must add to the row by talking in her sleep!"

"Hush, Sally!" Suddenly it occurred to me that the bird was cold. I took her basket under the covers and she stilled.

Sally, after a number of years, got a chill and died. The robust Jane lived on and on; every year of the fifteen she was in my possession her temper got worse. One day, in a fit of violent jealousy because I was tending a sick puppy, she flashed across the room and nearly tore my eye out. Another time she ripped the tip off my finger. Her rages came in a flash. The orange eyes would dilate and contract in fury and then she would strike.

"Enough, Jane!" I put her up for sale.

A woman came in answer to my advertisement. Jane looked her up and down. "Oh, you old fool!" Jane exclaimed, and began to laugh in cackling peals.

"I'll buy that bird," said the woman, much impressed. "Clever!"

"She is wicked," I said. "That is why I am selling her. A wicked bird!"

"All parrots is wicked," replied the woman fingering an ear. "See that?" she pointed to a hole in one ear. "A parrot bit that out!" Jane changed hands.

A few years later I happened to see the woman on a street-car.

"Have you still got Jane?"

"Nope! Sold her to a poultryman. Jane adored my son. After he went to sea she was morose and evil. I was obliged to get rid of her."

I went to the poultryman, anxious to know the end of Jane.

"Have you a green parrot called Jane?"

"That malignant varmint? No. Sold her to a party out of town." His one hand crept to the other smoothing an ugly scar. "'Ot one that. Ef that bird got 'otter with years, she's burnt herself long back. They do say as parrots lives long," he shrugged.

"I owned Jane for fifteen years," I said.

"Did, eh? No lady's bird! God save George!" He slapped his knee and chuckled. "Some bird that!"

"Looks pretty old and scraggy to me," said a sharp voice.

The poulterer and I turned. A customer was fingering a fowl upon the counter. It was the woman to whom I had sold Jane.

"I wa'n't mentioning that particular fowl, mum." He recognized the woman.

"God save George!" he chuckled.

"You old fool!" the woman giggled back.

The three of us doubled over laughing!

I never heard of Jane again.

SOME ANIMALS

⚡ BALANCE ⚡

THE RACOON'S CAGE was set in a narrow draughty passageway between two Indian houses of Alert Bay village. The imprisoned baby racoon was very young and desperately unhappy. A white girl sketching about the village wanted tremendously to own the baby racoon. The desperation of his animal eyes hurt her. She asked Coon's Indian owner, "Will you sell the baby coon?"

"No, me catch for my child's play, no sell."

Every day the white girl said to the Indian, "Today will you sell the coon?"

Every day the Indian replied, "No sell."

The white girl took another path when going through the village. If she could not help the coon's misery she did not want to see the tortured baby. No dark hiding corner such as coons love, no shelter from the piercing wind or the poking fingers and kicking toes of children.

IN SPITE OF HIS wretchedness, Coon grew. So did his temper, so did his teeth. He bit the Indian children in self-defence. The Indian owner sought the white girl. "Sell now—coon come wicked, bite my child."

"How much for Coon?"

"White man pay thlee dollar for coonskin. S'pose lady buy inside and skin too, thlee dollar just same."

The girl bought the whole thing, skin, insides, and heart of Coon. The village wheelbarrow squeaked up the hill carrying Coon and his coop to the white girl's cabin. She placed the coop in a dark corner. Coon spat and hissed when she came near. She did not worry him with attention; she gave him a deep sack of hay into which Coon burrowed violently, hid himself, cuddled in deep, deep sleep. He slept so long she thought him dead. At last hunger roused him. Vaulting from the sack, he lapped bread and milk greedily and grabbed for an unlucky little crab, spitting at the white girl's hand when she offered it.

The girl looked at her three dollars' worth of spiteful suspicion. He was all contradictions—low-set, heavy body on trim, slender legs, petulant sharp nose wrinkling with hate, and a blunt, merry tail circled with black rings like laughing O's. From nose-tip to high up on Coon's forehead ran a rich brown streak. This marking was paralleled by two similar streaks of brown; one crossed the brow over each eye. These three vertical lines across his forehead gave Coon a great frown, but bristles of stiff white whisker, slanting upward across each cheek, gave him an acute, cunning smile. Between frown and smile lay Coon's tormented eyes.

Owning such a morose, resentful beast gave the white girl no pleasure. "Go free!" she cried, and flung the door of his cage wide; but, before he darted, she had changed her mind.

"No, you shall not go to the wild, carrying with you such anger and bitterness against humans." She snapped the door shut. "Woods-creatures think badly enough of us as it is! When

fear and anger have gone from you, when your eyes side with the smile, not the frown, then you may go if you want to." She left Coon in his quiet corner—ignored him.

Coon ate, slept, watched the girl and her sheep-dog play. Coons are as playful as kittens; he longed to join in the fun—he was lonely. Holding the bars of his cage with small, handlike black paws, he thrust his sharp nose through the bars, begging notice. The girl ignored. Instead of clawing and spitting at her hand when she fed him, he now smelled, then licked it. Still the girl ignored the comradeship Coon offered. There was suspicion still in his eyes and bearing. "Trust me all," she said, and then did a thing to him so monstrous that it drove away what little trust he had. While he fed from her left hand, with her right she fastened a collar about his neck and attached it to a chain. Coon saw the door of his cage open—made a dash—discovered the grip about his neck—went mad—threw himself upon the ground, clawed, spat, and rolled, rasping his teeth against the steel chain. No bars now between him and the woods—yet this other detaining thing sent him worse crazy, this pulling fetter which dragged him back from freedom. The girl fastened the chain to the verandah post of her cabin. She sat down on the step near and read a book.

Coon fought long and bitterly till exhaustion killed his madness—back sprawled on earth, paws upturned, listless, limp as death. The girl read on.

DUSK CAME, THE time that old coons hunt and young coons play. Coon turned right side up and shook himself. Finding that the chain still held, he crept closer to the reading girl. She made no sign, was moveless as a tree. Coon raised his forepaws till they rested on her knee. He stared and stared and stared into her face.

She did not embarrass the wild in him by staring back, she lent him her face to explore.

A spring! Coon had decided! A tumbling of softness into the waiting lap, a curling kittenwise to sleep in the lap's cosy warmth. Coon liked her fingers fondling his little rounded ears, her hands buried in his dense harsh coat. Coon's eyes opened. Torture was gone from them. Instead, with perfect pivoting, frown and smile, frown and smile balanced across the contrary features of little Coon.

❧ EVEN A RAT... ❧

THE RATPILE IN THE pet shop squirmed continually with new life; it never had time really to cool from the hot, naked bodies of one litter of ratlets before some other rat mother had filled it again. One nest was common to all the mothers in the rat-cage; neither mothers nor ratlets knew who belonged to whom. The vital little rats tore on into maturity, exchanging pink nakedness for white fur, cut teeth, chewed food, were kicked from the nest to look out for themselves. The flapper-rats dug themselves into the big ratpile mounded in the centre of the cage. Rats of all sizes squeaked and squirmed, cosying pink noses into the centre of the pile to find warmth. Some rat was always rooting for something some other rat had. The rat-mound was always in a moil. Periodically the cage was cleaned out. Then confusion was terrible, even the ratty smell got mislaid, everything had to be reconstructed.

Humans were a nuisance with their tidying! How could young rats practise thrift and hoarding with surfeit of fresh food provided every day? Even a rat loses dignity and self-respect when glutted.

"MALE OR FEMALE?"

"Female—young—"

A selective hand stirred the ratpile. The smell of that hand was known to the rats. Its pick was half-grown and snow-white. The little rat was put into a paper bag. The cash-register jangled, purchaser and purchased joggled away on the street-car. During the joggling a human eye looked into the bag's mouth.

"Hallo, rat! Your name is Susie." There was glad ownership in the voice as well as sober assuming of the responsibility for a bit of life, life which has been pushed from its natural course and, by domesticity, robbed of its initiative. Giving to the little rat a name of her own hoisted her immediately from rat-hoard to individual. Named, even a rat becomes "special."

Arrived at their destination, Susie was introduced to the family circle of her purchaser—her special human. The family drew back with squeals and shudders. They called Susie "vermin." A door banged, another opened, and Susie came home.

The room that was to home her for life was a big studio in which her particular human lived. The woman had prepared a wired box for Susie. The box stood on a large table. The table was a conglomeration. On it, besides Susie's box, were paint-boxes, nail-boxes, match-boxes, flower-basket, work-baskets, clothes-baskets, carpenter's tools, gardening tools, bundles of rag, balls of string, a great lump of modelling clay, brown shoes and black shoes, a bag of oranges, and a hat. It seemed that every lost thing in the world could be found on that table. Susie was allowed to roam the table and acquaint herself with the smell of all the things. She liked one thing best of all, a big leather-bound Bible that stood on the corner of the table. This was Susie's lookout;

mounted there, large flat feet clamped down on the leather cover and haunches squared, the rat pondered and pondered, smelling the world, eyes blank and blinkless, wiggling nose thrust into the air, whisker twitching, tiny pink forefeet waving, beating the air like the paws of a begging dog. The Bible and the soft warmness under her mistress's chin were the high spots in Susie's world— under her "particular" human's chin the rat experienced a throbbing warmth similar to that of the pet-shop ratpile.

Everything in the studio had absorbed through touch the smell of Susie's own human, even the silence was full of her. Susie homed herself happily, accepting, responding, giving herself wholeheartedly, invisibly chained to this being beyond the smell of whom she never strayed.

SPRING FOUND SUSIE adult and sleek. The mate of the griffon dog had a cosy basket full of puppies. Spring and instinct gave Susie notions: she chewed rag and paper and made nests in quiet, out-of-the-way corners, nests that fitted her body; but she tired of their emptiness and went back to the leather Bible, begged with her paws and wiggled her nose.

Down through the studio ventilator came a faint, faint whiff. Susie's nose became still more active. The attic above the studio was a difficult, perilous journey for Susie—jumps, crawlings, squeezings; but at last it had been accomplished.

"Susie, Susie!" Susie's human heard terrified rat screams and rushed up to the attic. When she opened the door it was not Susie who rushed to her for protection, but an ugly brown rat, scared out of his life by Susie's chasing. The door slammed in the face of the wild rat—he scuttled noisily down between walls, too

scared even to be quiet. Susie did not follow; she came, a dusty, cobwebby rat, glad to be taken back to her studio. She never went to the attic again.

UNDER THE SOFT warmth of a feather pillow in the studio was found a morsel of life badly smashed. The creature looked like a rat but was not ratty quite and he was very nearly dead. Warmed and fed, he revived. Susie was sleeping in a ragbag hanging on the wall. Her box was requisitioned for the stranger, and a naturalist consulted as to the creature's kind.

He asked, "When did you last coal?"

"Yesterday."

"Ah, you got more than coal in your sacks. This is a black wharf rat, the kind that come in ships. Maybe he carries bubonic plague, looks pretty battered. Being shovelled into, and poured out of, a ton of coal is not exactly tender handling: better finish him." It seemed "cattish" to pull from death only to push back to death again.

The ragbag quivered, a pink nose stuck out of the top. Susie came to investigate. "Um, check ratlets!" mused the naturalist.

When the black rat saw the white rat he went frantic, tore up and down his box and squealed with fear. For three days he was in the box and screeched whenever Susie set foot on the table. He was disposed of—Susie's human went to the pet shop and bought a sleek, gentlemanly white rat. Susie turned on him and beat him up so unmercifully, paying back with interest the scorn of the brown and the black rat, that he had to be returned to the pet shop.

Susie lived and died an old maid.

SUSIE TRAVELLED. SHE not only made a number of camping trips with her mistress in a caravan, along with some dogs and a monkey, but she went by boat and train and stayed in hotels too.

Susie's human said, "I go travelling. Who will care for Susie during my absence?" There was dead silence—Susie's mistress would not plead. She popped Susie into her handbag along with a purse, travelling clock, knitting needles, and reading matter. When the steward came into the stateroom Susie hid. On the train an over-stout lady sat on the handbag. Susie's human screamed, "Oh, my glasses!" The fat woman said, "I sat lightly," and got up huffed.

Susie's human slipped her hand into the bag to make sure Susie was entire. And then the train stopped. Susie's agitated mistress left the bag on the train! The porter came running down the platform waving the bag. He swung himself again onto the moving train with a tip gripped tight; its size surprised him, and all he could gasp was, "Such a shabby ole bag too!"

In the hotel, Susie slept in the griffon dog's box all day, while the dog and human were off in the woods painting. At night, the dog, the woman, and the rat had romps. The dog was very gentle with the rat. They had been in the hotel a week when the hostess asked Susie's human into her sitting-room one hot evening to drink a cup of tea. This hotel proprietress was fond of creatures, and Susie's human went upstairs and came back with Susie. "Oh!" screamed the woman, "I hate rats' tails!"

"Rats steer by their tails and whiskers," said Susie's human. "Did you not see Susie when you did up my room?"

The proprietress thought it *very* strange to travel with a rat. "That explains certain crusts and lumps of sugar," she mused.

Susie's human remembered that they had fallen out of her pocket-handkerchief on the stair once or twice.

THE NORMAL LIFE of a white rat is two years. Susie, who was robust, added another six months, then she became lean and bony and her teeth got dark brown. She moved wearily and slept a great deal.

It had for two years been the rat's custom to come up the little stair leading direct from studio to her human's bedroom in early morning. It took weeks of patient practice for the rat to manage the jump from tread to tread. Each bare shiny step was just beyond the reach of Susie's spring; she fell back over and over to the step below.

The night Susie conquered the stair her human was startled from sound sleep by a patter of feet scuttling over her chest. "Wild rat from the attic!" was her horror-thought on waking. She flung out an arm and struck some small soft thing weighted with life, knocked it onto the floor and switched on the light. On the mat beside the bed sat Susie, half stunned, wholly indignant at the frustration of all those patient tryings. From that time Susie came upstairs at two o'clock every morning, scrambled up the counterpane overhang, pushed a pink nose under the fingers of her dear human, lay quite still. Presently the hand she loved put Susie to the floor.

"Go down, Susie."

The rat ran back to the studio satisfied.

OLD SUSIE'S TIME was up. Any day now she might sleep and forget to wake.

"Susie, we must shut you in your box at night now." Lidded in her box, the old rat went frantic, rattling the door, chewing the

wire, squealing for liberation. She got it, and continued to mount the stair nightly. Then one night Susie did not come. In the early dawn her human crept to the stairhead. Susie was on the bottom step, dead.

Loyalty to the very last jump—loyalty even in a rat.

🦋 BRAVO, MARY ANNE! 🦋

FOR PUSH OF NOSE, for perseverance, there is nothing to beat a cat. The kitten, Mary Anne, was born with amazing push and perseverance. It was but natural that she should be born so, for both her parents were "stickers." Mamma was a most persistent ratter. Papa, an itinerant vocalist, held his note on the back fences till every shoe and tin can in the neighbourhood lay at his feet.

Cats sum up life by feels; all the feels of Mary Anne's kittenhood were hard. At a very tender age she fell out of the basement coal-scuttle which had been her bassinet. She did not, like her brothers and sisters, emerge from her cradle creepingly, but, scrambling boldly up the coal-scuttle's spout, launched herself squarely from its mouth, landing on her four paws. Immediately, she began to look for something higher to climb, wiggling her pink nose in the air. In the air she was always smelling for something a little higher than herself.

The kitchen steps lured, liver-and-bacon was frying, whiffs tantalized her inquisitive nose. Up the steps ran the pink nose to poke around the open door. It was met by a cruel leather shoe and a stern "Shoo-cat" uttered in a harsh voice. Mary Anne then learned

the feel of kick and spank, and how hard the pavement could hit back when you struck it. The kitten righted herself and, sitting down, lashed the world with her tail—most expressive organ that a cat has. Next she mounted an apple tree that grew so close to the house-of-frying-liver that she was able to spring from it into one of the upstairs windows, landing on so soft a bed that it woke a queer crackling sensation in her throat, a rumbling creak that returned all through life whenever Mary Anne was happy. This time the happy crackle was cruelly cut short, and Mary Anne was introduced to her own scruff by a hard gripping hand. Again Mary Anne hurtled through space—again earth hit back when her pliant little body struck, again Mary Anne's tail lashed in angry protest, but undaunted she rounded the house and came to its front door.

The house-of-fried-liver was the home of several bachelors. The hard hand and cruel shoe belonged to their housekeeper— she fried the liver.

At the very moment that Mary Anne rounded the corner of the house the youngest bachelor was returning at the unusual hour of mid-morning, stricken with an attack of measles. He felt too awful to heed a kitten leaping over his foot, darting in the door and up the stairs ahead of him. A door opened below and the voice of the dreadful one who kicked and hurled called out, "What's up, Mister—'olidayin'?"

"I got measles."

"Lor' to goodness! I 'in't 'ad 'em." The door shut with violent haste.

Mary Anne hid under the bed until she heard it creak under Mr. Measles' weight. Then she jumped boldly onto the measled stomach.

"Drat you, cat!" A spotty hand lunged. The cat dodged. "Then catch 'em." That was the worst Mr. Measles could wish for anyone for the moment.

"'Ere's grool." The bedroom door opened three inches' worth of squeak. A steaming basin slid over the polished floor. The door shut with a snap. Measles did not stir, but Mary Anne did. Gruel was good eating. Measles was grateful to the cat for disposing of the gruel. Measles was a bad enough disease without being gruelled by housekeepers.

Quarantined convalescence is duller than ordinary recovery. He was glad of the company of the cat. He called her "Mary Anne," tickled her under the chin and rubbed her ears to make her purr—it sounded companionable.

"I tell you, Mary Anne, this measle disease is humiliating for a business man. Why didn't Mother give it to me when I was a baby?"

He returned to the office lank and peevish; the boys chaffed. "Look," they said, "if he hasn't brought his kitty to the office!"

There was Mary Anne, sure enough: extra humiliation for him—rubbing, purring, notifying everyone that she was particularly *his* cat. He gave her hurried exit, but Mary Anne was not disheartened. Every time a customer came in she rushed in too and leaped onto Measles with purring joy. She overturned waste-baskets, chased papers, jumped on ledgers; when finally she upset an ink-well the boss said, "Leave that cat of yours at home, boy."

How could he? His home was a trunk. Every inch of the house-of-liver was ruled over by the housekeeper, and she hated cats. Sticks and stones directed at Mary Anne flew behind him from

house to office; she slunk just out of range, but followed steady as a shadow. He took detours through by-ways, but suddenly out of a doorway ahead she would pounce, delighted at doubling back to meet him. He gave her to a newsboy, saw the bulge of her body under the boy's coat for three blocks, but back she came. He lidded her into boxes and left her meowing in back lanes. She always pushed the lids off and would arrive at the office amid the tittering boys and hail him with delight. There was only one sure way to peace. The thought of it made the boy sick.

THE NIGHT WAS black, rain poured. He dared not hug the sack against himself, feel the warm throbbing love of her body. He dangled the meowing sack from his fingertips and ran. When he came to the bluff above the sea the sack hurtled through space and blackness. He put his fingers in his ears and tore away fearful of hearing the splash. After all, the poor little beast, she had only loved him too hard. All the wet on the "business man's" cheeks was not rain—he despised himself.

SHOCK AND WET but invigorated Mary Anne's persistency. Measles' shaky hand had made a poor tie. Mary Ann's push undid it. She swam out of the sack, spat water, battled among the drift, slithered through slime and kelp, beached, crawled up the bank—*yowled!*

If there is one wet that is wetter than salt water it is rain. Salt bites, rain soaks. The shivering cat shook the brine from her coat. The rain chilled her bones. Her yowl was weak; but galoshes splashing through puddles stopped to listen for the feeble wail of cat-distress.

"Kit, Kit!"

The cat crawled towards the galoshes and the voice—was gathered beneath an old grey cape—hugged against warmth.

"Cat, what *will* the Elder say?" The girl's hand was on the kitchen door-knob. (The "Elder" was Grey Cape's big sister.) The Elder said plenty when the dripping pair stood before her.

"Out with her! There is the Persian and the barn cat—enough to mouse our family. Throw her out!"

"She'll finish drowning in the rain."

"So much the better."

Mary Anne knew again the sensation of flying and of wet, but the small-waisted egg-timer on the kitchen shelf could not have half poured her sand into the other end before Mary Ann was again under the grey cape and being hurried up a rickety stair hanging on the outside of a barn. "Studio" was painted on the door. Grey Cape raked the embers in a stove and was soon drying and comforting the half-drowned cat.

MARY ANNE FOUND LIFE in the old studio completely satisfactory. Love, mice, a skirted lap, instead of Measles' bony knees.

"I must find you a name, Kit." But that very evening Grey Cape heard the kitten already had a name, for Measles came to call. The kitten stole and rolled spools of thread from Grey Cape's work-basket across the floor. Fast as the girl took one away, the cat got another.

"Pesky, persistent beast!" scolded the girl.

"Persistent, I'll say!" Suddenly the boy sat up and looked earnestly at the cat. "It's Mary Anne! By Jove, it *is* Mary Anne, the cat I drowned a week ago—one toe missing on left forepaw!"

"Isn't it rather beastly to do things by halves?"

"Mary Anne doesn't—Mary Anne, that is the name I gave her; see, she remembers. Mary Anne! Mary Anne!"

The cat turnèd at the call of her name but would not come to Measles' proffered hand.

"Perhaps she remembers too much," said Grey Cape. "Why did you want to drown her?"

"A business man can't be tagged by a cat!" The business man blushed. He was very young.

SPRING SPROUTED ALL ways at once. It sprouted mouse-nests in the studio wall and sparrow-nests under the studio eaves. Domestic fowls clucked their broods across the yard. Persistent searching found Mary Anne a mate. Soon she too was hunting cuddly corners. The Elder kept her eyes open and all doors and windows shut. Mary Anne got ahead of her every time. Grey Cape provided a cosy box in the studio; Mary Anne, the coal-scuttle kitten, scorned a barn cradle for her firstborn. She broke the studio window, jumped from the barn roof, climbed the house roof, found Grey Cape's window open—the door of the cupboard in which hung the old grey cape ajar. The cat stole in, sprang onto a flimsy hat-box just to reach her cheek to the cape and rub. The box-top gave, spilling Mary Anne onto a bed of soft felt and velvet violets. Grey Cape found her there in the ecstatic state which newly kittened cats affect. "How could you, Mary Anne? My very best hat!"

"MARY ANNE! MARY ANNE! Where is that cat? Somebody bring me Mary Anne quick. There is a nest of mice in my drawer—that Persian fool is not even interested. Takes these common tabbies—who's seen Mary Anne?"

"Mary Anne is in my cupboard. She has five kittens on top of my best hat."

"Fetch her!" The Elder's tongue did not even click annoyance at the kittens on the hat. "Fetch Mary Anne quick!" she repeated.

No wonder Mary Anne's purr was so proud, no wonder she held her tail up so straight, a tail with tabby rings running round it like the rings of honour on an Indian chief's high hat—a ring for every exploit.

Mary Anne, common tabby, had brought tears to the eyes and blushes to the cheeks of a "business man," she had overthrown the Elder's antipathy to stray cats. Climb by climb, persistence had hoisted this coal-scuttle kitten till she had achieved the producing of a family upon the very headpiece of that particular human divinity on whom she had heaped the affectionate devotion of her whole being. There, pinnacled in ecstasy, we leave her... Bravo, Mary Anne!

MORE BIRDS

❧ HEIGHT ❧

VESTOVIUS IS A HIGH mountain in Alaska; it is not far from Sitka. A man invited my sister and me to climb Vestovius with him. From Sitka we went to the base of the mountain in a launch, then we climbed, at first through dense, snarled woods and tall trees which got scrubbier as the mountain rose. At the top, Mount Vestovius was only bare, bleak rock.

When we got above the heavy timber the sun was scorching hot and we were very tired. At last we came to a wide mossy ledge and threw ourselves down to rest, sprawling luxuriously in soft deep moss.

I was flat on my back, spread like a starfish, aching all over. At that moment I wished the earth was as flat as a table and that there were no such things as prodigious lumps on its surface to be climbed. Views were all very well—myriads of islands floating in blue sea. People who had climbed Vestovius came back and talked all sorts of poetic stuff about "jewels set in a bed of sapphire" and "inverted skies with islands for stars," but they rubbed their knees and shin bones as they talked, and now, being myself half up Vestovius, I knew why they had rubbed. I was staring straight up into the sky. We were quiet, resting even our voices and groans.

High, high, two eagles were soaring in great circles, swooping, diving, floating, exhibiting great power and marvellous control. Maybe they were an old pair, maybe two youngsters glorying in their first high flight, or perhaps they were playmates. I watched them for a long, long time. You could not associate tiredness with those wide-flung wings. They expressed power—power, freedom, endurance!

"I wish I were an eagle."

The man turned.

"Why?" he asked fiercely, as if he too had entertained the same wish. "Why?"

"Power, freedom."

"Girl," he said, "you *are* as free. Aim high. Trust your wings."

We finished climbing. On the way down we lost our way and came again to the shore at a place entirely different from what we had planned and expected. We "cooeyed" and screamed. Finally the launch heard and came round for us.

"You *are* free. Aim high and trust your wings." How many times in moments of depression I have thought of that man's words! How many times too have I lost my way, come down from my mountains on the wrong side, had to "cooey" to be picked up! Often I remember the Vestovius eagles.

❧ EAGLES OF SKEENA RIVER ❧

POISED EACH ON HIS own still pine-tree top, majestically silent in the peaceful overhang of Skeena's turbulent waters, sat Skeena's royal eagles.

Looking up, looking down the river's noble sweep, my eye counted thirty of the kingly birds, each independently throned on his pine tree, each wearing a snowy crown of gleaming white, strong against the green of our sombre northern forest—a square-shouldered, square-tailed bird, except for his white crown, all black, rusty black. I can't think why they call him "Baldhead." He has bountiful head plumage, silvery white, which droops in long points graciously onto his rusty shoulders.

A mighty roaring river is Skeena, treacherous—rapids, shallows, ledges, boulders—a violent river, tearing around curves, echoes shouting back her racket.

Skeena used to be navigated by a fussy little sternwheeler, whose noisy going splashed and churned a moil of whiter whiteness than the river's own, foamier even than Skeena's foaminess of hurried anger.

Twice a week this little steamboat staggered up-river, adding her commotion to all the rest. Twenty Indian lads stood ready

on the sternwheeler's deck, listening for their half-breed Captain's signal to leap overboard, stand in the shallows and lay their forty palms against the boat's side, pushing her away from danger: Captain bellowing orders from his glass wheel-house, splash and shout of leaping boys, churn of foam-tossing wheel, echoes doubling the uproar, Skeena's clatter, turning, twisting with the river, but keeping always down between its banks, densely forested banks, which do not allow sounds to escape. Skeena's commotion does not rise more than a few yards above the river but surges up and down. The arch of silence that over-hangs all our western forests keeps Skeena's turmoil to the river-bed where it belongs: in the tree tops along the Skeena's banks all is still.

When the Indian lads had persuaded the boat back into the channel and she was safe to hug shore in deep water, they again leapt, this time from deck to shore. Here they attacked neat piles of cordwood prepared for the fuelling of the steamboat.

It took no time at all for the twenty Indian lads to fling the pile, stick by stick (thud, clatter! thud, clatter!) onto the deck of the boat. The boys then leapt aboard, and the little sternwheeler resumed her fussing way up-river. When she came to the end of steam navigation at Skeena Crossing she was met by huge Indian dug-out canoes. Indians took the passengers the rest of the way. The finish of navigation was at Hazelton, which sat where the Skeena and Bulkley rivers meet, boiling into each other's faces like warring tom-cats.

Hazelton was a tough little mining town. It had three hotels, rough and turbulent as the rivers.

By and by the Grand Trunk Pacific built a railroad a few miles back from the Skeena River. Meek trains slithered travellers through

the forests to Hazelton. The coming of the rail eased travel and gentled Hazelton's hotels. Tourists came. The G.T.P. ran its line close to several of the Indian villages and the tourists looked curiously to see how our Aborigines lived. They did not see real Indian life, the original villages, or the grand old totem poles because, flattered and boastful, the Indians tore down their crude but grandly simple old community houses, built white man's houses— shoddy, cheap frame buildings. They turned the totem poles that had faced the river, welcoming visitors who had come by canoe up Skeena: they turned them to face the railroad by which visiting tourists now came. They loaded garish commercial paint over the mellow sincerely carved old poles till all their meaning and beauty were lost under gaudy, bragging show-off.

The Indians hurriedly made baskets and carvings too—careless, shoddy things to catch the tourist's eye—which brought in a few dollars but lowered the standard of their handicraft.

Everything was changed, cheapened—everything, that is, except the river, the eagles, and the Peace, high above Skeena's roar— the Peace, where the eagles of Skeena reigned.

The eagles came to Skeena every year when the salmon were madly dashing up-river to their spawning grounds. From near and far, eagles came to feed on the worn-out fish that leaped, struggled, splashed over the shallows among boulders. Pounce! An eagle had a struggling fish gripped in talons and beak.

The railway ousted the sternwheeler and the big passenger canoes, but the fish still came. Eagles followed the fish—Skeena's eagle—watching, mighty king of birds.

❧ TWO WOMEN AND AN INFANT GULL ❧

GREY AND GENTLE, the dusk ran down the Skidegate Inlet, that long narrow waterway between the islands of the Queen Charlotte group. Nobody used this waterway now. The few Indian villages on the Inlet and on the wicked West Coast of the Islands were dead, forsaken. It is a passionate coast—wild, cruel. The chug, chug of our gas engine was the only sound in all the world. Jimmy the Indian snapped the gas off and our boat snuggled her nose between the rocks of a little island.

"Gull Island. Eat now," said the Indian.

Gull Island was small, rocky, and round. It had no trees: was only a rounded heap of loose rocks, sedges, and scrub bushes. Seagulls came there to nest. The sheep-dog and I were the first to jump ashore. The dog ran forward, nosing; a gull rose from the sedges with an angry squawk.

"Keep back, Billie!"

I discovered that my dog had found a gull's nest. The dog froze, covering but not molesting the one hatched bird and the one pipped egg. The gull chick was scarcely dry from the egg. I stole it and left quickly, so that the mother might return to her pipped egg. A wild creature held in my hand always thrilled every nerve of me.

We ate on the far side of the island. The Indian's wife looked enviously across at the gull.

"I want one too. I want a baby gull," she said petulantly. We searched the island but there were no more nests with young in them. The woman's resentful eyes were on my gull. "I want one. I want one," she kept repeating, and sulked. She loved creatures as I did. All her babies had died. She had only her husband and a white kitten left to love.

"The little gull is cold," she said angrily. "Put him in the bosom of your blouse. He misses his mother's warm."

The clammy webbed feet of the gull scrabbling down my front were not comfortable, but the little gull peeped cosily. The Indian woman's eyes were enviously watching his wiggle in my blouse, her ears enviously listening to the contented peep.

"I wish I had a gull. I wish I had a gull." She turned her back on me.

I remembered that all her children were dead. I remembered that I had a long rough way to go before I would be home. A little creature having to be fed raw fish every few hours was not going to make travel easy. It would be tough on the gull too, but I was stubbornly greedy about giving him up. I wanted him. I had a passion for acquiring wild creatures to rear, to tame. My people had given up protesting at the things I brought home. Perhaps I *could* manage . . . but was it quite fair to the gull? I crossed to the woman, took the gull from my blouse and handed him across her shoulder.

"You can have him."

The woman snatched him. She poured the white kitten out of her hat onto the stones, filled the hat with grass to make a nest for the gull. Indians take and give; they don't thank. Proportions

scale differently with them and with us. This woman's only hat—straw with flowers—meant nothing to her. The cannery store had charged her a big price for it too. Money for a hat represented many hours of packing fish into cans. Part of every female cannery worker's wages went into a hat to be admired by her fellow workers. Envy, pride, bitter jealousy—these things were part of the cannery season. When the girls and women went back to their villages, the hats were discarded: either their splendid black hair went uncovered, or, Indian fashion, it was tied under a far more becoming gay handkerchief. Clara, Jimmy's wife, did not wear her hat at home. She had brought it on this trip because I was a white woman and hatted. As a hat it failed to impress me. It had made a good cradle for the kitten; now it was a nice nest for the gull.

Clara was very happy on the return trip. Sitting in the boat, holding her hat full of seagull, she sang to him.

The Indians went to Alliford Bay. I continued on further to visit other villages.

On my return I went to see Clara and the gull. The kitten and the gull were cuddled together under her cook-stove. The bird had thrived.

Clara taught her gull to go back and forth between Alliford Bay, where she worked in the cannery, and Skidegate Village. Her home was in Skidegate; her aged mother lived there. When the old woman saw the bird come it was like a greeting from her daughter.

�ష WILD GEESE ✶

I WAS VISITING IN Cariboo. A flock of wild geese in migration descended to feed in a grain field. Driving with two gun-lovers, I happened to pass that way, and we came upon the flock feeding. The roadway ran right alongside the field in which the wild geese were grounded. Such an immense flock was a rare and unforgettable sight. There were hundreds and hundreds of geese. You could hear the aggregate snap and shovel of their beaks feeding, nipping the grass, shovelling grain.

The gun man said to his wife, who also carried a gun, "Drive on. The birds will not heed the horses. Do not speak as you go. The old ganders will be on the listen and the lookout."

The man slipped out of the rig while it was still going and crept behind a line of bushes that hid him, intending to stalk the flock from behind.

The great field was a spread of throb, movement: necks bobbing like black hooks as the birds' heads worked up and down, up and down, cropping, shovelling, their grey bodies lovely against golden stubble—delicious colour. Look-out ganders were posted, heads in air, ready at slightest alarm to warn the flock.

I had never experienced a more thoroughly tingling joy than watching that sky multitude earthed. I had never been close to a flock of wild geese before. In spring and in autumn they rode high over our West during migration, zig-zags of honkers, black dots, lofty and mysterious. As a child I had wondered and wondered about them. Grown-ups immediately said, "Hark, wild geese!" and then started talking of the changing season. I did not know the meaning of the word "migration," nor did I till years after associate these high black dots with the bodies of geese.

Now I was grown up and here was a whole skyful of wild geese emptied at my feet! I thrilled through and through.

"Why doesn't he shoot? Why doesn't he shoot?" quivered the woman, her fingers stealing towards the trigger of her twenty-two. "That sentinel is getting nervous!"

She raised her gun and shot, just as there was a terrific bang from behind the bushes.

The gander screamed! A single movement and the flock rose, one living cloud! One goose lay still. He would never go with the flock again.

In a twinkling the geese were incredibly high. A clamour of honks fell down to us. Every bird was exactly spaced behind his fellow. Their formation was perfect: a V inverted with wide-spread sides, its point cutting space. The gunners, grumbling, shoved the goose's warm body into the back of our rig, angry that he was not two.

How, I wondered, had the dead bird's place in their sky flight been filled? No gap showed in the long, evenly-spaced lines.

❧ STERN PARENT ❧

IN VICTORIA'S HIGHLAND district, where roads were bad and there was little traffic, stood a tiny log cabin used by hunters in the game season. Birds loved this district, the sunny solitudes of its few scattered farms.

In autumn gunmen shot over the district. I rented the cabin for the month of June, when birds were nesting and gunmen were out of season. A grouse hatched her brood beside the cabin door. She brought them to feed in the wild strawberry-patch in front. Father grouse sat on a nearby stump to warn his family of approaching danger. My party—sheep-dog, Javanese monkey, and me—he accepted as part of the landscape. Danger might come from us, but we sat still for hours while I sketched, admiring, not molesting, his family. He trusted us. To be honoured by the trust of wild things is to have one's self-esteem hoisted. Condescension from great humans does not pride one as confidence from wild creatures does. When cocked heads and round, curious eyes stare at you direct, when winged timidness stays on human level instead of lifting to bird-freedom, it raises one's faith in humanity and in oneself.

QUAIL, PHEASANT, GROUSE abounded in the Highland district. The whirr of humming-birds' wings was heard in the air. Robins sang and swallows darted; there was every variety of sparrow. There were wrens, chickadees, towhees—black-hooded, long-tailed, rusty-breasted, shy birds. I threw abundant crumbs before my cabin door to indicate that I was friendly. They came warily at first, but soon in numbers. A father towhee came and brought his three newfledged birdlings. Mother Towhee was hatching her second brood back in the woods. The three children sat agape and squawking till Father had filled them up. Then Father, with beak full and crop bulging, flew off into the woods. Soon he was back again, lean, empty, and very hungry. He fed himself. The children watched, too full to squawk. Father Towhee thought it was time to teach his family self-reliance. He took a crumb in his beak and softened it by pinching, then dropped it before his young. The children obstinately refused to bend their necks and help themselves. Ever since they hatched they had thrown their beaks wide, braced their necks, while a parent poked food down. Father Towhee was weary. Soon it would be all to do over again for the second brood. He disappeared. The children squawked and squalled dismally. Father did not come. I feared some calamity had befallen Mr. Towhee. I could not imagine a parent's heart untorn by such frantic pleadings.

"SPARROWS, WHAT ARE we to do? I can't show the little towhees! *You* must."

The sparrows pecked on quite indifferent.

A shadow swooped silently through the cabin door, circled me where I stood, circled me again, swept out into the sunshine... Mr. Towhee! Stepping out of the cabin I saw him peeping over

the edge of the gutter, worried as I over his stubborn family. But a firm disciplinarian was Father Towhee! For three days he and I watched the obstinate children, hungry almost to starvation.

I had a hammock out in front slung between a tree and the snake fence. Father Towhee would creep along the lower rail of the fence, my bulk hiding him from the crumb patch. He knew that I knew; we pooled knows—watched. Three days' anxiety, then the birdlings, one after another, found the bend in their necks, took bits of food from the ground, twisted them in their beaks, tongued and spit them out—lazy tongues wanting a parent bird to beak food down their throats till it met their gulp. At long last they did learn. Then Father came back and fed with them.

Before I left the cabin Mother Towhee brought her second brood to the feeding grounds and left them to Father. Patiently he began the process all over again, while Mother and the grown brood looked after themselves.

✖ BIRDS OF ENGLAND ✖

EIGHTEEN MONTHS OF recuperation in a sanatorium is desperate dulness. The sanatorium was in a part of England crammed with wild-bird life. Only that made things bearable: open fields, hedgerows, little woods, rabbit warrens—places that song birds love.

The San sat on a little rise. It was a sanatorium primarily for tuberculosis. I was not T.B.; therefore I enjoyed freedom and privileges which lung patients did not. When I was able to roam at all, it was at my own will; the only restriction was, "Don't tire."

T.B. patients had prescribed walks, so many miles to so much time. Men patients took one road, women patients another. I saw them start in dreary draggles—over-cheery voices contradicted by lagging heels.

At the back of the San lay a little wood; further on was a rabbit warren. I crept into one or the other of these places and lay upon the ground rejoicing in the birds. Theirs was a real joyousness. Those patients' cheeriness was a sham, a brave enduring spread over a pause—life?—death? Meantime suffering, monotony.

Every kind of bird was in my wood—"Cuckoo, Cuckoo!", a robin's trill, a thrush's gush of rapture, liquid running of a black-

bird's notes out over the open, the trembling ascension of a lark spilling delight—higher, higher, lovelier for the highness.

The doctor said, "Why do you not walk sometimes with the other patients? If their walks are too far, rest. Let them pick you up on their return. It is morbid to go into woods alone."

Morbid! Song-wrung woods morbid! London had broken me. I loathed great cities. Morbidness was in *them*.

FATHER HAD ALWAYS told me of English birds. He had loved them in his English boyhood. In London I crept often to a slummy district called "Seven Dials" where the birdshops were—not the sort of place young ladies were supposed to be. I went into the small, stuffy dark shops of "Seven Dials" to see the English birds which Father had told of. I found trapped, frightened creatures, caught with snares or bird-lime. Brutal, coarse men hoped to make a few pennies on each bird. Dispirited little larks crouched in low-roofed cages so that they should not attempt to rise and soar. Thrushes, blackbirds, starlings, some trying to sing even in those miserable quarters! It shamed me. I, who had the whole of London to roam, felt as prisoned and more crushed than they!

Every English boy bragged of his "bird-nesting exploits," exhibiting collections of bird-nest robberies. I heard too of fox-hunting, badger-hunting, of dogs that had lips and cheeks torn off by the badgers who got under rocky ledges and ripped unprotected dog faces. I was told of royal stag hunts: deer hounded up to the royal guns; pheasant shooting, partridge shoots—birds driven by beaters to the guns of men called sportsmen; shoots for the pleasuring of the guests at house parties on great estates of the rich; clean bushes spattered with blood, festooned with scattered

feathers of luckless birds, killed not for food but for fun. I raged with disgust, hating it all.

NINE MONTHS OF LONDON embittered me. Easter came. The Art School was closed for one week. I went to a little village in Kent, Goudhurst, sitting on the top of a low hill. This is where I first properly saw and heard English song birds.

"They don't deserve them! They don't deserve them!" was all I could say as I stood listening, drunk with delight.

Goudhurst had an inn, a chemist, and a butcher. I know, because I stayed at the inn, which, when I arrived, was all bustle, for that very day the butcher's daughter was marrying the chemist's son. The inn folk were nearly distracted with hubbub—rush of visitors from neighbouring villages. The church-bells nearly dislocated themselves from their hangers, tossing out their clamour. I saw them up in the belfry; I saw the tombstones in the churchyard, gay with roosting gawpers awaiting the bride. I passed among them, came to a stile, climbed, was suddenly in a little wood, new-foliaged for spring, ringing with bird-song. The clang of the bridal bells was out-distanced. I heard only England's birds singing.

THANK YOU, MY ENGLISH father, for bequeathing to me this happy heritage—joy in birds. Your English birds *are* exquisite: they suit England. I wish Canada too had song birds. But oh, I would not trade Canada's spacy silence—dim, tremendous—for England's warbling woods! When Canada is peopled end to end, then, per-haps... not now, not yet.

✄ BULLFINCHES ✄

I WAS THE ONLY mother the nine little bullfinches had ever known. I stole my two bullfinch nests, one having four birdlings, the other five. I stole them while yet the birds were deaf, blind, and only half fledged. When first they heard and saw, they were in a sanatorium and I was poking food down their throats. They found nothing strange about either my voice or looks, apparently; they thought me a comfortable mother.

I wanted to take my bullfinches home to Canada. Then I got ill and was unable to travel. The two nests stood on a tray beside my bed. I fed my nestlings every half-hour from dawn till dusk. The sanatorium nurses and the doctor were most co-operative.

When the little birds discovered that they had wings, their first flight was direct to me: they nestled round my throat as I lay in bed, circling it like a necklace. They never again returned to the nest but were put in a wicker cage in my room. Whenever a sanatorium patient was downhearted or dreary, his nurse came to my door begging, "Lend the little soldiers." Then the nine bullfinches would spend the day in that "down one's" room to cheer him. It was very amusing to lie and watch them sitting in

a long bobbing row trying to sing. All the while they tried, they danced and bobbed. The male bullfinches had rosy breasts, the females brown; all had black bonnets.

ONLY ONE PAIR OF my bullfinches got out to Canada with me. They were so pugnacious, such bullies, that one by one, for the sake of peace, I had to give this one and that one away, or they would have killed the others. By and by I had just one pair left, and then at last I came back to Canada. The "Bullies" thrived very well out there for five years. Then one day the cage fell and Mrs. Bully broke her thigh bone.

I took her to a doctor friend of mine. He and his wife often cared for my birds when I was away for a few days.

"She'll live," he said, "but her leg will always stick out hideously. Broken up in the thigh, it cannot be set. Suffer? Yes, I guess she will for a bit."

"Chloroform her for me, please."

The doctor's wife interposed.

"Oh, no! If she dies, Mr. Bully will die too. Bullfinches mate for life. If one of a pair dies, so does its mate."

I stood holding the little bird. She was easy, lying in my hand.

"Think it over," suggested the doctor. "You can bring her to me later."

I held her all day. I could not go to bed holding her in my hand. When I laid her in her cage she called and fretted.

It took only one drop of chloroform on a pinch of cotton-wool. Her calm, gentle heart-beat stopped against the palm of my hand. This saved her the worry of being transferred into a strange grasp.

Did the faithful husband fret? He did not. For the first time in his life Mr. Bully was "it," took and gave all the petting which his

mate had done him out of, swelling himself in the glory of being "the only."

I kept his cage on a low wide seat so that he could share the doings of the old sheep-dog and me. We were his idols. He adored us both, had no fear whatever of the hot-breathed dog; he would lie in the palm of my hand, not one quiver or mad heart-beat, loving the great dog's moist tongue to lick him. If the dog and I went into the next room, Bully would call and fret till I bade the dog "Go, sit by Bully."

The gentle lumbering beast would go into the studio, sigh himself patiently up onto the bench, and hump a shoulder against the bars of Bully's cage. The lonely little bird would trot up the perch to the wire and snuggle against the dog's warmth. Great dog—tiny bird!

I went into the bitter North one mid-winter. I was to be away for only two weeks. I dared not take Mr. Bully with me: he would freeze on the way. I loosed him in the aviary among the canaries. I had before let him fly among them. They were on good terms, but then Bully knew I was always near. Now he called and called— I did not come. At the end of the first week he was dead, just wanting me.

❧ GARDEN GONE WILD ❧

TWO BOYS MOTORING to a near lake to swim invited, "Come along."

"Not to swim, thank you. Drop me on your way at that old forsaken farm in the woods."

I CLIMBED OUT, their crazy old car wheezed away. I went through a broken gateway and up a grass-infested path. Windows gazed blank, the door creaked on its sagging hinges, its lock gone. Otherwise all was still as death.

This had been a dear little place, somebody's home chipped out of the big forest, a home that had snuggled itself back into the heart of the forest and the forest had hugged it. I wondered why these pioneer farmers had abandoned it. There was the empty chicken house, the dog kennel, the well, the barrel for rain water—empty, all empty. Wind and rain tearing, rotting the little home to bits.

The house was built on a little rounded rise. Just below it in the hollow the settler had made a little garden, unlevel, unfenced. The forest was creeping back, grabbing greedily for its own, binding it with bramble vines, seedling trees springing, choking, choking every planted thing—a few stunted apple trees whose

crop the squirrels had commandeered, starved gawky marigolds and marguerites, poppies and a scragged sweet-william. The forest was coming, coming to reclaim its own, to oust them all.

I sat down upon the broken house step; over me was a writhing sprawl of honeysuckle, clinging, swaying round the porch-post. The tips of its scraggy woodiness were hung with clusters of sweetness.

Whirrr! Whizzz! The noises and whir were in my very face; right under my chin was a humming-bird, sipping from the honeysuckle spray I had thrust into my coat. "Mother Hum" was resting on the bush watching her two top-heavy children. A dozen humming-birds, red, green, and darting, were noising their wings, too quick to see.

As soon as the sound of the boys' motor had died in distance the garden had come to life—swallows swaying, circling, wrens, robins, sparrows, quail back in the woods shouting, grouse drumming.

Swallows darted over the garden hollow teaching their young to fly. Even to my eyes it was plain that the young were unsteady and poor at quick turns—wobbly, jerky! It was amazing to see how they improved even in the few hours of my stay in the old garden.

"SORRY WE'VE BEEN so long; water was fine!"

"Were you long? It seems only a minute, boys."

"You were not bored by this awful stillness?"

"It was not still. When your car snorted away it burst into life! It was noisy!"

Listening, the boys held their united breaths.

"Don't hear a thing!"

"Come on, Goofy! We're famished."

✺ ALICE'S SPARROWS ✺

I LIVE IN PART of Alice's house. My studio window overlooks her garden. Beside my window is Alice's sparrow bush, a great rounded mock-orange shrub, whose myriad stalks and twigs are of just the right gripping size for the feet of sparrows.

Alice is nearly blind. She cannot see the flowers in her garden now; flowers and weeds are all a hazy muddle to her. The apple and the pear tree are dim and shadowy against the sky. Her feet feel their way down the gravel walk. She fingers the smooth skin of an apple, the smoother skin of a pear, and asks, "Are my trees fruiting well this year?" It is just too bad to be blind.

In the mock-orange bush all day the sparrows sit waiting for Alice to come with handfuls of bread. She has made them lazy. They chortle and wait idly, no thought of searching for their own food.

All the cats in the neighbourhood found Alice's garden a conveniently spread dinner table too—sparrow dinners whenever fancied. Green eyes, yellow eyes peered from under shrubs and plants—sudden darts! agony chirrups! Alice erected a miniature Eiffel Tower, impregnable to cats, on her lawn. She now puts the

food on top of the tower. The outwitted cats have slunk back to their rightful homes.

Alice's sparrows comfort her. She hears the flutter of their wings and their chirrups in the air around her head when she carries their food to the tower. She can discern their shadows when they come between the sunlight and herself. She feels less blind because of these shadowy movements.

Suddenly, away fly all the sparrows! They are gone for weeks. Alice is desolate, but she knows it will not be for long. They have gone away to nest and will come back, each pair with a husky brood of dishevelled, half-fledged youngsters, who will sit in squawking rows beneath the Eiffel Tower, mouths open, waiting for parent sparrows to fill them with Alice's bounty.

❧ SITKA'S RAVENS ❧

WHEN IN DELICIOUS remembering my mind runs back to Sitka, what does it see? Not the little old town with a long wharf approach straddling over mud flats, its final planks meeting the dirt roadway of Sitka's main street; not the quaint Russian church which is one of Sitka's tourist attractions; not Totem-Pole Walk winding through trees beside a stream named Indian River, named for the pleasing of tourists but really the farthest possible distance from the village of Indian shanties—a walk ornamented at advantageous spots with out-of-setting totem poles, transplanted from their rightful place in front of an Indian chief's house in his home village, poles now loaded with commercial paint to make curiosity for see-it-all tourists, termed by them "grotesque," "monstrous," "heathenish"! Nor do I remember the army barracks—Sitka is a United States military outpost. But I *do* see the barracks flagpole, tall, with a shiny gold ball on its top, and over that ball always, always three or four of Sitka's great black ravens—circling, hovering, trying again and again, each in turn, to maintain a foothold on the slithery gilt ball. Generation after generation of ravens has tried; it is a tribal game, old as the

flagpole. No resident of Sitka has ever yet seen one raven succeed. All Sitka's ravens try. It may be the glitter of the gilt which attracts them or it may be just raven fun—no one knows. They balk and hinder each other, clumsily jocular about it.

To the left of Sitka's long wharf, a little way from "White Sitka," lies the Indian village: a straggle along sea-beach of low unpainted shanties; a few weather-worn unpainted totem poles left in their true setting because they were not considered worthy of tourist attention; on the Indians' beach a muddle of canoes, fish-nets, and sea-salvage—and stalking among it, flying over it with guttural croaks and hoarse cries, ravens—Sitka's ravens! Black and shiny as well-kept parlour stoves, their curious half-swallowed, guttural croakings mixing with sound of wave-splash.

Sitka would not be Sitka without ravens—noisy, weighty, powerful, swooping, uttering sepulchral wisdoms, winging, wheeling blackly into the deep woods behind the village, male and female calling over and over his or her own cry—the male and female note differing.

"Ping!" says one—the strident ping of a twanged guitar string. "Qua!" replies the mate—a flat throaty call.

"Ping—Qua! Ping—Qua!" call the ravens of Sitka. Indians have fabulous tales of Raven; he figures conspicuously on their totem poles.

I asked an Indian, "Could you get me a baby raven from a nest? I would like to take one home."

Grinning, the man shook his head. "Raven lady heap smart. Nobody can't find her nest. Injun tell, s'pose anybody find raven nest that somebody got good luck always, always!"

So I had to be content to carry home with me only raven memories, dear memories of the tricky, persistent, croaking ravens of Sitka.

Tourists came back from their twenty-minute stopover at Sitka and lectured on Indian totem poles and Indian *un*culture, having seen a few old Indian squaws who spread shawls on the end planks of the wharf and sold curios—baskets, panther-claws, bear-teeth, whalebone in the raw, shells that were used in old times as Indian money. There were quaint little rattles too, made of deer-hooves, and carved grease dishes made to hold oolichan oil. The tourist turned over, bartered, carried off the cheapest and poorest articles, exhibited them as specimens of Indian craftsmanship. He hurried to the Russian Church, to the Totem-Pole Walk. Never did he go near the real Indian village. His steamer tooted. He ran down the wharf, returned home—dared lecture on Indians. He had never seen the muddled inside of an Indian house, the motherly cuddle of an Indian woman with a papoose under her shawl, had never smelt salmon steaks smoking over an Indian fire; nor had his eyes smoke-smarted in an Indian hut. Never had he seen an Indian woman's hands fashioning a basket, nor an Indian's acceptance of weather and discomfort, nor an Indian's cool courage in his dug-out canoe among gigantic waves.

Nine-tenths of the tourists probably thought Sitka's ravens only a band of glorified *crows*. These people went back and lectured glibly.

TO SENSE SITKA is to see her composed of a three-strand weave—Indians, peace, ravens. Perhaps the most insistently vital, the

most unchanging of the three are the ravens. Soldiers and tourists broke Sitka's peace. Civilization cheapened her Indian. But generation after generation, her ravens will mate, create, go on, on into time...

"Ping—Qua! Ping—Qua!"

❧ INDIAN BIRD CARVING ❧

ALL KINDS OF nationalities have carved all kinds of birds in all kinds of ways, and from all kinds of material. I think the Indian has used deeper insight, carved with greater sincerity than most. The totemic carvings of his crest emblem, animals and very frequently birds, lived with all their attributes in his work. An Indian believed himself actually related to his totem. This relationship was considered closer even than a blood tie.

Unlike the designers of our heraldry, an Indian might use the creature that was his crest in any pose that suited his fancy; but it must be endowed with the characteristics of the bird or animal represented—never must he waver from the concrete actuality which represented the living creature. From bones to feathers the Indian *knew* his bird—every characteristic, every minutest detail of its true self. He need not arrange its parts in the way nature had sequenced them. For the purpose of decoration, space filling, and symmetry, he might distort, separate, re-colour, but he *must* show the creature as complete in being, though he might conventionalize it. The carver must make it express weight, power, being. Let wings, tail, talons be unconnected: they must be told. Three or four conventionalized feathers on a bird's

wing or breast suggested through the carver's art a bird fully feathered.

Eagles and ravens played an important part in Indian totemic heraldry—eagle, fierce and strong; raven, wise and cunning. There was, too, a big bird with a long, long straight beak which often was shown on the poles. I thought it might be a representation of the crane or heron. Indians said not. They called him the "How-how" bird. He was probably mythical.

These great wooden birds were carved with dignity and intensity. Crude, regal, they surmounted tall poles, wings spread or wings folded. In primitive simplicity their calm seemed to pervade the village.

As far as I could judge, Indians seemed to entertain no sentimentality towards creatures. They treated animals and birds with an indifferent brotherliness but, when using them for totemic symbols, the Indian's attitude towards his creature seemed to change. For his clan or personal crest the Indian entertained superstition, fear, reverence, a desire to propitiate the supernatural powers of which the totem creature was possessed.

Some of the eagles and ravens which topped the totem poles were really magnificent. Certain carvers projected the upper part of the great black eye-pupil of their birds to give the impression that the creature was looking earthward. Bird eyes were humanly shaped and deep-set. They were frequently overhung by a heavy eyebrow painted black. The eyeball was shown in an oblong of white such as the human eye has. These crest birds, endowed with supernatural powers, were supposed to see more, hear more, know more than ordinary birds. Ravens and eagles were provided with huge square ears, one on either side of the top of the head. Birds that had wings wide spread were crudely braced

from the back to prevent the wind from tearing the wings away. Cumbersome, heavy as was the build of these wooden birds, you felt the lift and sweep of the carved wings amazingly.

How well I remember one old eagle sitting her pole in Skidegate village. She was uncoloured except where wind and rain had stained and mossed her. The rest of the pole was plain but for the figure of a beaver carved at its base. This eagle had folded wings. Her head was slightly raised, slightly twisted. I called her Old Benevolence. Maternal, brooding, serene, she seemed to dominate Skidegate.

INDIAN AND OTHER STORIES

❦ IN THE SHADOW OF THE EAGLE ❦

CHIEF MOON LOOKED down upon the wizened brown face of his heir, neatly and securely laced into a coffin-shaped basket cradle. There was grim determination in the small Indian features shut up tight like an aggravated sea anemone. The brows were well defined, the hair long and very black.

Without pause in her basket-weaving, the mother gently shoved the cradle with her naked foot until the shadow of the great carved eagle rested full upon it. The movement did not escape her brother, Chief Moon.

"It is good, Susan Dan, that you put him in the shadow of the big Eagle. That make him come big and stlong."

"He come better now," the mother answered. "Fat come soon."

Moon nodded and lifted his eyes to the noble emblem of his tribe. "Big Eagle take care of your baby, Susan Dan. He got stlong heart—fierce but wise. He not like clooked talk. You teach your boy be very ploud of Eagle."

The woman's soft, thoughtful gaze rested on the great carved bird, standing proud and magnificent above the squatting bear, on the totem pole before Moon's ancient, square-fronted house in this old-time British Columbia village. She loved it as Chief

Moon loved it, and as the carver who, loving it, had put himself into every stroke of the tool, seeking to express himself in it. The Eagle was the very essence of his being. The sweep of the wide-spread wings, the tilt of the noble head, cruel curve of beak, powerful talons, keen piercing eye—all were himself. He had given of his life to it, created it.

"I make my boy so Eagle never have shame for him, Moon," said Susan.

THE BOARD WALK creaked as a massive form waddled towards them. Swiftly Susan took her cradle to her lap, drew her old plaid shawl across it, like the protecting wing of a hen when a hawk is near. But Martha's heavy hand lifted the corner of the shawl. She bent over the child. "Velly small and weak," she said. "Too bad! All your li'l babies die, Susan. Too bad! Too bad!"

Martha telescoped onto a log, her chin sinking into her chest, her chest sinking into her stomach, her stomach absorbing her legs, a great groan enveloping all. She removed the handkerchief from her head to wipe her sweat-washed cheeks and brow, and called in a voice half strangled in her fat throat, "Jacob!"

Her oldest, heavy and black, produced her youngest from a dustpile where she had been wallowing. The baby roared at the interruption.

"Hush up! Don't make that noise! Ole Eagle up there get mad. Slap you with his big wing. Pick you eye out. Maybe eat you up."

"Martha, it is not good to tell you childlen clooked talk about the Eagle," said Susan. "Eagle good for his people."

"Ha, ha! Susan, you make me laugh. You ole, ole fashion. I see you bling you poor li'l baby, put him down in Eagle shadow, make

him come stlong. White woman put her baby in sun make him come stlong. My Steven, my man, got white blood, he tell me. Look, my Paul, he got white man eye, blue-colour."

"You Paul got clooked eye what white man call squint," retorted Susan. "I think blue eye so surplise he not black Injun eye, he never stop looking. No matter for Chief s'pose he not fat if he got stlong heart and talk stlaight."

"Ya! Nobody want skinny chief. Look...poor!"

Chief Moon listened with troubled eyes. If Susan's baby died, Martha's coarse child would become chief. It was the tradition of his people, against which he was powerless. But any dread of such an event was veiled by his gentle, kindly voice as he said, "Eagles do not quarrel, do not make squawk like spallow. Eagle see what he want, fly stlaight, take it. Spallow fight and flutter, forget what he want and fly away empty."

Susan's head drooped low over her baby, but Martha waddled off in a huff.

AND ALL THAT spring, despite Martha's jeers, Susan continued to place her child in the shadow of the Eagle. He grew, but not fast enough to silence Martha, who persisted in her venomous comparison of Susan's frail babies with her strong ones, and her own larger house with Susan's shanty.

For Susan's home, like most in the village, was furnished with the minimum requirements of life. It bore the full brunt of the prevailing wind, and would have collapsed but for long poles of drift-wood wedged under the eaves, which braced it at a tipsy angle. Crevices and knotholes were stuffed with rags and newspaper. Within, the rusty stovepipe twisted hideously on its journey

from the cook-stove to the roof. There was an iron bedstead, a broken-backed chair, used exclusively for the coal-oil lamp to sit on, a battered sewing machine, a dresser holding a few dishes, a figure of the Virgin, and some paper roses in a jug. Rough, unlovely boxes containing Susan's "things" hobnobbed with beautiful Indian baskets. From a single nail in the wall dangled companionably a cracked mirror, a rosary, and Susan's church dress. These were the worldly goods of Susan Dan.

Dan, Susan's man, occupied a place in the home equivalent to the other things, perhaps not quite as important as the dresser. Sweet-tempered, unambitious, talking little, smoking much, loving Susan and his babies not ardently but comfortably, he was scarcely missed when he went fishing.

This spring, less than ever, Susan dreaded his going. For she had her little Tommy, whose health was too precious to risk life at a cannery. The men would go on the fishing boats, the women pack salmon in tins. But Susan had determined to stay and make baskets for the tourist trade and add to the little store of savings in the box under the loose planks beneath her bed.

So, with little Tommy who had outgrown his cradle and now lay on the plaid shawl beside her, Susan sat before the cabin weaving baskets and watching that activity which approach of the cannery season always brought to the village. Men tinkered with boats, women baked and did up bundles of clothing and bedding which children lugged down to the beach. Dogs watched eager-eyed, anxious.

The breeze played pranks with Susan's cedar roots and dried grasses and fluttered the handkerchief on her neck. Her small brown hands moved swiftly. She ran moistened fingers down the

long strands to keep them pliable. A quick, expert twist, followed by a firm rhythmic movement, and strand after strand was finished, pared off with a knife, another started. Sometimes her bare toes wiggled as she sang to her baby.

Martha stopped beside her. "Too bad you can't go to cannely, Susan. Poor li'l baby, too weak. Too bad! Too bad!"

"Look," replied Susan, "my baby get big now, Martha."

It did not please Martha to see the child had grown. "I buy buggy at cannely store first thing. My Christine too heavy for Jacob to cally. Mosquito could cally your baby, too small for buggy."

A wave of fury swamped Susan. "I glad you go away, Martha, you scare my baby so he can't glow quick. I don't want buggy. I want him close, close on my bleast under my shawl. I solly for you, Martha. You too fat to cally baby."

"You stupid, Susan! Ole, ole fashion," and Martha waddled off to superintend her family's departure.

BEFORE THE BOATS returned at the end of the season, Tommy had a little sister. Both children thrived. While she made baskets Susan sang Eagle songs to her babies. Time passed swiftly. When the village people drifted back, a boat or two each day, they came to see Susan's new baby and to tell her of Martha, who was working to the last that she might make more purchases.

"She going to buy white-woman clothes," one of the women told Susan. "She no want Injun han'kelchief for head, or Injun shawl. And shoes she want for always, not just go-town shoes. She heap mad that store man just got corset for skinny lady."

Martha had indeed arranged a triumphant return. She stood in the cannery store on the last day of the season searching the

shelves with covetous eyes. The storekeeper was weary of her bartering. Her purchases, a silk dress, a purple umbrella, skirts, blouses, sweaters, perfume, powder, a few pots and pans, a stand lamp surmounted by a floral hat, were heaped on the despised shawl. The tip-top moment of her dream was when, dressed in her finery, she would wheel the rest of her new things home in the buggy, tossing Susan a careless nod in passing.

Gathering up the shawl by its corners, she waddled outside to get the buggy and found a little group of people surrounding the howling Jacob. A woman held Christine, quiet and limp. The baby's heavy head hung over the woman's arm. Others were righting two upturned buggies. Christine was dead. Jacob and another urchin had been racing buggies; Christine had pitched over the bank, striking her head on a rusty anchor.

Martha went to her cabin uttering long, blood-curdling, dog-like howls. All the village came, even the manager's wife and her widowed mother. "Poor soul!" said the little white woman. "Is there nothing I can do?"

The widow's veil brushed Martha's cheek. Martha's howls ceased abruptly. "You give me that sollow hat for my funeral?"

"Would it help? Of course you shall have it."

"Mother!" gasped the daughter.

"But think what she's lost, Edith. A baby!"

Martha cried no more. The salt spray took all the crisp daintiness out of the sorrow hat, but not the exultation out of Martha's soul. Susan had had three funerals, but never a sorrow hat.

But Susan's eyes were fixed on Christine's little coffin in the wheel-barrow. Never once did she raise them to the sorrow hat which perched precariously on top of Martha's thick hair and rocked in the breeze. Martha caught the flying streamers, tying

them under her chin with an exaggerated jerk. But even then Susan did not see. She was crying for Martha.

"Oh, Martha, I so solly. I have pain in my heart for you. I lost li'l babies. I know how bad it feel."

Hate burned in Martha's eyes. It was envy she wanted from Susan Dan, not pity.

The little procession straggled its way to the point where lay the cemetery, with its consecrated part for the baptized, presided over by the big white cross, and the heathen portion where Moon had erected a great carved Eagle. In solemn dignity the emblems faced each other. Not even the sorrow hat could sweeten Martha's bitterness when Christine, unbaptized, was placed among the heathen while Susan's three shaggy little graves lay across the line which the tangle of sweet briar and brambles tried to hide.

NO MORE BABIES came to Martha. But they came and went in Susan's home with amazing rapidity, fluttering in and out, short-lived as butterflies. If it had not been for Tommy and Rosie, Susan could not have borne it. And as the number of little graves grew, Susan realized that only through Tommy could she mother a chief who might uphold the honour of the Eagle.

Martha was always among the first to witness these recurring humiliations of births and deaths. One fine spring morning she waddled as fast as her white woman's shoes and tight skirts would permit to Susan's home. Susan, lying in her bed upon the floor behind the stove, where she loved to have it, felt the floor-boards quiver.

Martha's greedy eyes, blinded by the sunlight, searched anxiously until she saw the two tiny papoose cradles tipped up before the stove.

"Girls!" she gasped.

"Yes."

Martha gave a relieved sigh, and pushed among the other women. Susan winced as Martha fingered the black hair of her babies. "Too bad! Too bad! You always get girls now, Susan. S'pose Tommy die. You got no boy left."

Susan closed her tired eyes. What was it that Moon had said about sparrows and eagles?

Susan's strength came back slowly. Even good-natured Dan grumbled. Twins were not lucky. They belonged to the supernatural world. He felt no great sorrow at their passing.

Martha saw them buried. But some of her bitterness at the number of Susan's consecrated graves was assuaged by the news she rushed to tell Susan. "Steven got a job in his father's sawmill. We go today. We got a house with thlee looms, and a sink and kitchen tap. Jacob and Paul go to school with white children. Too bad you not got white man for husband, Susan. Maybe good house with kitchen sink make you babies come stlonger."

"I like this Eagle place," Susan answered. "Sawmill make too much noise. White boy tease your Jacob and Paul because they stupid."

Martha bounced off the box like a kicked football. "Some day I make sollow for you, Susan Dan," she spluttered, as she bustled ponderously down to Steven's boat.

Susan watched her go. She was glad that Martha would not be present at the arrival of her eighteenth baby. That, too, was her first quick thought when only Johnny Paul came home from the fishing boat on which her Dan and five others had gone to the West Coast. The bodies were not recovered. The next day Susan's dead baby was born.

IN THE YEARS THAT followed, while Tommy grew into a keen-eyed lad, and Rosie into a sunbeam, a singing soft-eyed thrush, Susan's savings piled high in the secret box. As well as her cannery earnings and basket-making, there were her cherries. The children gathered them from the gnarled old tree before the cabin. In June her customers expected the gentle knock and smile, the "chelly come lipe now" as she held out the glistening fruit.

On Tommy's seventeenth birthday, after just such a trip, Susan and Rosie turned homeward laden with special parcels. "Tommy's eyes stick out like codfish's when he see the white-topped cake," and Rosie rubbed her pink cotton front in anticipation.

"Tommy plitty soon man now. When he come Chief, I make big feast for him."

"Mask dance, tom-toms, and—potlatch?" asked Rosie eagerly.

"Government say no, I say yes, for my Tommy. Long time now I work and save lots of money for my Tommy's potlatch. I got it safe in box under my bed. Lots, lots money."

They turned the last corner and looked for the smoke of Tommy's fire, which was to be ready to cook the birthday feast. Smoke there was but no house. Tommy rushed out from the little group.

"Mother, fire come from nowhere. I not got stove light. Nobody know where he come from."

Susan stumbled to the corner where her savings had been hoarded. She groped and found only ashes.

Chief Moon's kindly voice broke into the wails of women. "Cly no good, Susan. Eagle no cly. You Bludder Moon got big house. Got money for Tommy's potlatch too."

"You good man, Moon. But I like cly just little. Long time I work for make money for my own chief potlatch."

MOON'S HOUSE WAS large, dim, peopled by the past. The big roof-beams were supported by massive carved house poles representing squatting bears, surmounted by eagles with outspread wings. The floor was of earth, smoothed and hardened by generations of naked dancing feet. Upon it burned the fire of driftwood, its smoke circling lazily to the hole in the roof. Low sleeping-platforms were built around the walls. A huge painted canoe occupied one corner, and Moon's carved cedar seat, without legs, was before the fire.

It was a happy house. In the autumn, when the people returned from the canneries, there was feasting and dancing. Susan, working again upon her baskets, was content. Even Martha's return to the village could not spoil the peace of that household. Feasting continued long that year, for the weather was mild. Indians travelled from other villages and Moon's house was always filled with guests and mirth.

Then, suddenly, a blast of bitter weather struck the village. Stoves were filled till they roared, clothing stuffed into broken windows. People walked blanket-shrouded and shivering. The cruel wind swept under shacks, darting up between floorboards like sharp knives. It shrieked around frail dwellings, tearing at them, wrenching shakes off the roofs, drifting fine snow under windows and doors. The one tap in the village froze so that the women, looking scarcely human in their wrappings, were forced to carry buckets to the creek and break the ice.

And then influenza, that most dreaded enemy of the Indian, seized its opportunity. Old and young were smitten. Haughty death stalked through the village pointing his finger now here, now there. Wind shrieked like hellish laughter. Snow and sleet churned to mud beneath the feet of the coffin-bearers. The people cowered low—broken, terrified.

Chief Moon was tireless in his efforts to help his people. With a blanket about his shoulders and his head swathed in mufflers, he went from house to house and back and forth to the Indian Agent, getting what help he could. Many he sheltered in his home. Tommy accompanied him everywhere.

Moon saw the anxiety in Susan's eyes. "Be blave. Our young chief must know the way of the Eagle."

Not for anything would Susan have restrained Tommy.

Martha, wearing the sorrow hat, saw her husband, Steven, laid among the heathen, and her greedy eyes sought the cross of the white man. Susan, bare-headed, stood by Rosie's grave, her eyes upon the big eagle, pitiful and imploring. To Moon's house came a dreadful silence. The flickering firelight cast fitful shadows across the bears and eagles and lighted up the little group of silent watchers gathered about the fire. By Moon's bed was Martha—by Tommy's, Susan crouched.

It was Martha who came to tell Susan that Moon was dead. She peered closer. Tommy's head was cradled upon Susan's breast. Her arms encircled him. Her shawl was drawn across the face of *her* dead chief.

Martha went out quickly to find Jacob.

SPRING WITH ITS insistent life brought no joy to Susan. Everywhere was warmth and sunshine and pulsing life. The swollen stream, freed from its frozen sleep upon the mountain, roared its way to the sea. Flocks of crows quarrelled on the tide flat. Swallows darted over the water. Buttercups and daisies rushed up to greet the sun. There seemed scarcely room for another blade of grass upon the bank. The village cattle were glutted. Leggy calves followed their mothers. Village dogs produced pups, no two resembling each

other, or their mother. New babies cuddled their way into places that had been empty and aching since the influenza.

Spring and winter were all the same to the benumbed Susan, crouching in the low doorway, huddled inside her shawl. She stared out over the sea, scarcely aware of the village happenings. When Tommy died, she had said to the Eagle, "All my young life I tly to make chief for you. What for you not help me?" Her faith in his power was shaken. Her face turned away from him.

Martha made a grand feast for Jacob when he assumed his chieftainship, but angered the people by ignoring many of the old traditions. She selected a showy half-breed for Jacob's wife. But Jacob, wishing to regain his people's favour, married a full-blood Indian from another village. The bride refused to have Martha live with them. So she lived in her old house above the cemetery, with Paul, whose squint eyes had grown so tired of looking at each other that they had gone blind.

WITH SPRING, MARTHA cast aside her sorrow hat with its dilapi-dated veil. The detour by which she escaped risking her bulk on the two-plank bridge brought her frequently past Susan's door.

"Hallo, Susan. I got big hully-up. I go get a fine tombstone for my Steven and Christine. My white fliend work on government load," Martha simpered coyly. "Tell me lots toulist come now new load finish. He like see ole time village and cemetely. I want my glaves look smart."

In spite of her "hully-up," she lowered herself onto a box, which proved unequal to the strain and collapsed, throwing Martha back into a dish of fish belonging to Susan's cat. "Oh! Oh!" she wailed. "Fish all in my hair! What for you not got chair for sit, Susan? Not ole lotten box. Too bad! Too bad!"

Susan rolled her over to free her from the box and helped her to her feet. Red and panting, Martha flipped herself with her "white-lady han'kelchief," a scrap of muslin, lace, scent, and dirt. With a fancy comb that held her hair, she combed out the fish, searching for a parting dart to hurl at Susan before she left. "Now I go get my stones," she bragged. "Too bad you got so many glaves, Susan. Nobody could buy stones for all you got. Toulist not see just glass glaves. Too bad! Too bad!"

Like the stinging swish of a whip, Martha's words brought life back into Susan. The limp hands clenched themselves into hard little fighting fists which she shook at the shapeless back of Martha.

"I show Martha who can buy tombstones for glaves. I show that jellyfish Martha. Maybe I show the Eagle too."

From the moment of her awakening Susan's life was one steady push towards a definite goal, with a double objective—the honouring of her children, the humiliating of Martha.

"Oo!" she chuckled as she pierced the tough cedar roots with her deer-bone stiletto. "Martha's house just above my glaves. Martha's eye got to see my eighteen tombstone." Without pause, without hurry, Susan worked steadily on.

A winter's basket-making, a summer at the cannery, a second winter, happy because her triumph was so close. Before Susan left for her second cannery season, she bargained for her stones.

AMOS HEARNE HAD moved from the city where rents were high and tombstones a luxury to the vicinity of the Indian reserve, where rents were low and tombstones a necessity. For an Indian will deny himself much in life to make a good showing after death. Since the flu epidemic, business had been excellent. Whistling and chipping, Amos did not hear Susan approach. She touched his arm.

"Hallo, Missus! What can I do for you?"

"How much this kind?" She smoothed the little white cross as if it were flesh and blood.

"Twenty dollars."

"How much for eighteen?"

Amos laid down his chisel and stared. "Say! You ain't a-goin' to start a tombshop, are you?"

"I got lots children in glaveyard: sixteen little one, two big one."

"Whew! Some family! Sixteen at twenty 'ud be three hundred and twenty dollars. I'll make it three hundred. One corpse goes deadhead, see?" Amos roared.

Susan supposed he meant dead-in-the-head, or lunatic. "He dead all over," she replied, so gently that Amos was ashamed, and wholeheartedly threw himself into her service.

"When d'you want 'em, Missus?"

"When cannely stop."

Susan struggled with the knots in her handkerchief, and Amos counted her savings—nearly enough to include the tall beauties she had selected for Tommy and Rosie.

SUSAN WENT TO the cannery with the rest of the people. But she came home a week earlier and went straight to Amos. High above struggle, sorrow, loss, she stood gazing in ecstasy at the little group of dazzling whiteness that was to commemorate her motherhood.

Amos was to put two words in black letters on each stone free. Licking his pencil, he prepared to make the list. "Can you remember all the names?" he queried.

They slipped from her tongue faster than he could write. Last of all, "Tommy Dan—Rosie Dan. I want gold words for these."

"Cost more."

"No matter."

After they were set in the hummocky grass, Susan lingered, straying from grave to grave, smoothing, patting, whispering the names of the children who had drifted away from her one by one. Now she saw them assembled. She leant against Tommy's stone, her finger tracing his gold words. Lovingly her arms stole about Rosie's stone. She kissed it. The cemetery was bathed in moonlight before she left, and as she opened her cabin door moonbeams glided in, flooding the little room. She left the door open, and the soft breezes whispering across from the cemetery point were to her as the voices of her children. With daylight her dreams vanished, replaced by exultation at the chagrin she was about to cause Martha.

The boats came late. Martha squawked and flapped over the ooze like a winged duck, leaving deep footprints in the wet sand.

The people streamed up the bank, all talking at once. Susan could hear Martha's insistent voice, arguing with Jacob. They pointed first to Jacob's pole and then to the cemetery. "Jacob is telling her it is good to have so many fine stones for Eagle. Oh, he-he!" laughed Susan. "Martha heap mad! See her arms go flap-flap like seagull. She so mad an' so fat maybe she bust! Oh, he-he! Maybe I just a little solly for Martha. I wonder who tell it before people come." It was a bigger stir than even she had expected.

As Martha approached, Susan seized an unfinished basket and fell to work to steady herself. But instead of making the detour past Susan's door, Martha strode straight across the flimsy two planks to her own house.

The basket and Susan's jaw dropped. "Oh, what a mad Martha got!" she gasped. Then—"Maybe Martha sick." Snatching her

shawl, Susan followed, and, as she climbed the bank, Martha's voice reached her.

"And, Paul, it is five hundred dollars they are giving Jacob for that ole eagle pole. Five hundred dollars for a ole good-for-nothing thing like that! Ha, ha!"

Susan's world went blank. She forgot her stones and her triumph and Martha. Moon's great Eagle, emblem of all that was finest in herself and her people, was to be sold.

"Martha! Martha! What you say? What you say about Moon's big Eagle?"

"He going for culiosity," Martha replied exultingly. "I make my Jacob sell for big money. Silly ole bird make toulist laugh at Injun."

"Cemetely eagle go too?" faltered Susan.

"Na! He too lotten. Nobody want ole bloke thing like that." She glanced scornfully out of the window in his direction. There was a sizzling noise like hot fat. Her black eyes bulged and grew hard. "Where you get money for all those stone, Susan?"

But Susan was stumbling blindly down the bank to her cabin. She flung herself upon the floor as strangling sobs tore. "When my Tommy die I get big mad for Eagle," she moaned. "Now I shamed, I solly."

After the village lights were out she crept to the pole, laid her forehead on the Eagle's great foot, and, sobbing bitterly, declared anew her faith in his supernatural powers, and her love and allegiance to the noble crest of her forefathers.

MARTHA'S LIFE BECAME unbearable. She heard the village women say, "Susan Dan a good woman and her poles are velly fine." Greed and envy ate into her soul. Every time she threw the water from her dishpan or hung out her washing, she saw

Susan's stones, and saw the fingers of the tourists move as they counted them. She cut a new door in the back of her house among the trees and covered the window with sacking. It was no use. The eighteen tombstones haunted her night and day. Martha took blind Paul and went to live in another village.

As predicted, many tourists came. The Indians, resentful at first, found their basket trade good and ceased complaining to the Indian Agent about the intrusion. The Agent endured rather than gloried in his job; as long as the Indians did not bother him he did not bother them. When Susan Dan came into his office, opened a handkerchief bundle, displayed the broken remnants of a china grave-wreath, and said, "White boys make bloke in cemetely," he replied not unkindly, "That's too bad. What shall we do about it?"

"Get padlock and key for cemetely gate," she replied promptly.

"But tourists like to see the cemetery," he objected.

"Me keep key—me show," said Susan.

"Um..." Susan's aboriginal quaintness might be an attraction. "Where'd you stay so they could find you quick?"

"Shovel house."

"Go ahead. I'll get the lock and see that you are paid ten dollars a month for showing people round."

Next day Susan moved into the gravedigger's hut. A couple of feet of chain attached the iron gate to the cedar post. The padlock was enormous. The key was Susan's glory.

AND SO IT FELL out that Horace Wragge, wealthy and somewhat eccentric tourist, faced Susan Dan, West Coast Indian, and asked permission to view the cemetery.

"Me Susan Dan—me show it."

"I have heard of you from others who have been here," he replied. Susan unlocked ceremoniously, opened and shut quickly, and led the way, clutching the big key.

The old part had its tattered wreckage of valued possessions. Clothing, baby buggies, gramophone, sewing-machines, and a few modern stones to the unbaptized. Horace was much impressed by Moon's big Eagle. "Belong my bludder, Chief Moon." A note of pride rang in Susan's voice and remained there as, indicating the dividing line, she said, "This new fashion. Baptized people."

Horace read the queer mis-spelled wording on the stones and home-painted boards with interest.

Susan saved her corner to the last. With a free, sweeping gesture of the arm and shawl that had circled her babies in life, she indicated their graves. "Mine, all my children."

Horace counted. Eighteen—what a family! "Who put up all the stones?"

"Me."

For some moments Horace remained silent. Susan and this quiet spot and the eagle had cast a spell over him. Then he said, "Susan, I write stories for a big paper. I'd like to tell people about you and your children and the stones and the big eagle. Will you tell me about them? Were any of your sons Chief?"

The old longing to mother a chief swept over Susan Dan, engulfing her as the undergrowth had engulfed the baby graves. Summoning all the dramatic power of the Indian, she made a big, big story for Horace. Tommy as chief was all that she had imagined he would be. She wove every brave deed she had ever heard of or

imagined about the lives of her children. Suddenly her eye fell on Moon's Eagle. Her voice faltered—softly, tenderly, she told of the "li'l weak babies" who did not stop long even though "I cally evely day and put in the shadow of big Eagle to make them come stlong."

"It's a grand power that eagle has over you people," Horace told her. "I want to take another look at him." But Susan waited by the gate.

HORACE WROTE FAR into the night.

And Susan in the shovel house?

When night shut down, Susan's hell closed about her, gripping, tearing, scorching. Her thwarted ambition, repeated losses, even the giving up of Tommy and Rosie, had not equalled this. Those sorrows had numbed and deadened—this quickened, tortured. She had lied, stolen, made crooked talk against the Eagle, which, now that Horace had gone, she was powerless to recall. She had dishonoured her dead, and given Martha cause to laugh. In an agony of remorse she cried out aloud; the wind shrieked back, taunting her, and furiously shaking the ramshackle hut. Then in the cemetery a heavy, dull, horrible thud. Force of habit made Susan rush to the door. Always in trouble or fear she looked to the big Eagle for help. Save for the cross, the skyline was empty.

MORNING BROKE CALM and sunny. Horace wanted a basket for his wife and another gulp of atmosphere for his story. He would not have known this wild-eyed, broken Susan.

Pointing to the fallen Eagle, in a torrent of broken English her confession poured out. Then—beseechingly—"Give me the write? Oh, please!"

Reluctantly he handed her his manuscript, and watched it float in a million scraps from her brown hands, while tears of relief coursed down the deep wrinkles and fell. Running to her hut, she brought her best basket and laid it at his feet. Rather embarrassed, Horace suggested, "Shall we lift up the eagle?" Susan shook her head. "No can. He ole and bloke."

Then an idea was born in the brain of Horace Wragge which completely changed the life of Susan Dan. "Say, Susan Dan, it was sporting of you to own up. You are a peach of an eagle. Tell you what's going to happen. Right there in the middle of your stones, I'm going to erect a fine motherish one for you. You won't need it for a long time, I hope, but it will be there."

Amazement, joy, and pride rippled in quick succession over the tired old face. Then suddenly—"Will there be words?"

"Sure, what shall they be?"

"Write, 'Susan Dan was the mother of sixteen li'l weak babies, one big girl, and one boy nearly come Chief.'... And put, 'Susan Dan tole one big lie.'" Susan had atoned. The tourists—even Martha—might laugh. What matter—she was right with the Eagle.

AMOS HEARNE HAD one bad debt. The Mayor's wife had ordered a tombstone for her dead husband. Before it was finished, she herself died. Standing there, unclaimed and unpaid for, it had been deeply coveted by his Indian patrons. Horace saw it placed among Susan's stones. Not for worlds would he have deprived Susan of the comfort of her atonement. Beneath her own words he wrote:

Beloved and honoured by Indian and white people
Erected by her friend Horace Wragge

In a far-off village, Martha shook blind Paul from a sound sleep. "Paul! Paul! Susan got the Mayor's tombstone! Injun come tell it. I go see for my own eye."

SUSAN WAS NOT aware of Martha's coming, did not see her creep in by her back door and pull aside the dust-rotted sacking. "Ah! Too bad!" she groaned. "All that gold write and the Mayor's tombstone just for ole Susan Dan!" She would not ask Susan to unlock, but cut a hole in the wire fencing among the trees, crawling through after dark. Thorns and brambles tore her, but she reached the stone, and turning her flashlight, fingered and counted the gold words she could not read. Then stole away.

Creeping stealthily in the shadow of the great Eagle, Martha's foot caught under the brace, and she sprawled at the foot of the great symbol she had dishonoured. Her torch rolled away. In a panic of pain and terror she screamed.

"Ow! Ow! Too bad! Too bad!"

Susan's key grated in the lock.

"Oh, Susan! Eagle make black shadow. I fall down. I all bloke. Too bad! Too bad!"

⚜ THE HULLY-UP PAPER ⚜

THERE WAS TROUBLE at Bessy's. Jimmy Jacob brought the yellow "hully-up paper" the last lap of its journey by canoe. His lean, brown hand put it into the hand of Jenny Smith, which was plump and old—also Indian.

It was the first wire Jenny had ever seen.

Having delivered the paper, Jimmy Jacob sprawled upon the wide uneven planks in front of Jenny's door, settled his back against the cedar shake wall, and gave himself up to the sun and to his pipe.

Jenny looked at the wire with slow wonder. "What's it say, Jimmy Jacob?" she asked.

"Some trouble come your Bessy. You got to go quick hully-up," he said.

"Who tole you?"

"Letter-house woman say," replied Jimmy.

Jenny bent. They held the wire between them, upside down, scanning the words they could not read. Jimmy had spoken their meaning in English because they were written so. Jenny, having married white, spoke white from habit.

Jenny put the wire back in its envelope and looked a long moment at the splendid typed address: "Mrs. Jenny Smith, Mussel Creek." She was very proud of her name; it was the only thing she knew in print. Her white husband had taught her that.

A white girl may adore her "Smith" husband, but it is safe to say she is not crazy over the name "Smith." Jenny had both loved her husband and gloried in his name. It was infinitely finer to be "Mrs. Jenny Smith" than to have her name hitched to an Indian man's and be "Jenny Joe" or "Jenny Tom."

HER PRIDE CHANGED swiftly to anxiety. There was trouble at Bessy Joe's.

Bessy Joe was Jenny's only child and a bitter disappointment. She had longed to see the blue eyes of John Smith reproduced in her baby, but Bessy was all Indian, dark and strong like her mother.

Jenny had given the child a white name, had insisted that English be spoken in the home, and hoped Bessy would marry white. Bessy had married "Charlie Joe, the Indian," and gone to his people. Her children would be all Indian too. This, and John Smith's death, had swept Jenny's life clean of joy.

But now trouble had come to Bessy, and the love that had congealed during the three years of Bessy's married life poured molten-hot into her mother's heart.

She buttoned the yellow slip under her dress-front, knotted the few bits of food that were in the cupboard into a handkerchief, turned the cat and fowls out to shift for themselves, and took her shawl from the peg. "Get up," she said, prodding Jimmy Jacob in the ribs. "Paper say 'hully up.'"

No breath was wasted in words as they tramped over the half-mile of brush trail that led to the spot where Jimmy's canoe was beached.

She joined her weight to Jimmy's. The canoe crunched gravel and met the waves. Kicking off her shoes, Jenny tossed them into the canoe and waded into the icy water holding her full skirts high till she was safely settled in the stern; then she tucked the folds of pink calico about her, brought her arms up above her shawl, and, with a dexterous twist, bound it about her body.

Dip—dip—dip! The paddles cut the water, hers keeping Jimmy's up to time. The breeze fluttered the handkerchief that bound Jenny's head, Jimmy's old felt was jammed down hard. Jenny's every thought was dulled—all but one, the one buttoned up on her bosom.

The canoe shot across the leaping waves; Jenny gave herself to them—they were carrying her to Bessy. Her eyes, soft and motherly, gazed straight ahead as though they would bore through the darkening night into the very heart of her child's trouble.

THERE WAS VELVETY blackness under the wharf when they reached the perpendicular fish-ladder at Hardy Bay. Jenny shook the drops from her paddle, grasped the slimy green rungs, and climbed doggedly towards the dim lantern dangling over the edge. She was not young. The ladder wrenched her rheumatic joints, but she said, "I got to, some trouble has come to my Bessy."

The journey from Jenny's home to the village where Bessy Joe lived was tedious rather than long: a canoe trip—a wait—a drive through virgin forest—a wait—the little gas mail-boat up Quatsino Inlet, passing but not pausing at the village of Koskimo where Bessy lived. There was more waiting than going but Jenny

took the waiting as part of the going, and the only way to reach Bessy.

Her broad figure, framed in the doorway of the Hardy Bay store, left little empty space. "That boat for Quatsino—when she come?" she asked. A black silhouette against the coal-oil lamp, with shadow hands weighing things into paper bags, replied, "Tomorrow afternoon."

Jenny skirted the wharf to a straggle of huts squatted above high-water line. She opened a door without ceremony and exchanged a greeting in the Indian tongue. They gave her a corner and a mattress. She ate, drew her shawl about her, and slept—deep, quiet, Indian sleep.

HURRY IN THE MORNING was useless. The bus did not go till the steamer came. It only seated six or seven. Many men went through to Port Alice. There was little chance of a seat for Jenny. She negotiated with the Indians to take her in their springless wagon. Perched heavily on a plank across the back and clinging desperately to the seat in front of her, Jenny rumbled through the forest road, her flesh wobbling with every jolt. Eventually the wagon drew up at the little float where the gas-boat lay moored.

Hour after hour Jenny squatted by the shed, hugging her knees, stolidly waiting. Night had come again before the little mail-boat chugged up the inlet. The water had an oily black smoothness, with treacherous little eddies and whirlpools here and there. Mountain peaks on either side of the inlet stuck up like jagged teeth. When they passed Koskimo, the village was all in darkness.

It was late when they tied up at Quatsino. Jenny took shelter among a pile of oil-barrels, crouching between them and taking what rest she could. She was grateful to the sun when he rose and

warmed her cold, stiff body. As soon as whiffs of smoke trembled from the cabin stovepipes, she got up and made her way to a half-breed who owned a canoe. "No good going to Koskimo, old woman," he told her. "The village is empty, everybody gone to the canneries."

Jenny shook her head. "My Bessy stop," she insisted. "She send me hully-up letter, she got trouble."

The man shrugged.

SWIFTLY, STEADILY, THE canoe doubled back through the inlet to Koskimo. From house to house went Jenny, peeping through blindless windows into disorderly vacancy. "Bessy! My Bessy!" she called, but there was no answer. The staring eyes of the big carved eagle on top of the totem pole told nothing. Jenny wrapped the wooden nose of the great squatting bear outside Chief Tom's house impatiently, as if she thought he could tell if he would. The image of D'Sonoqua, the wild woman of the woods, was there too, staring from vast eyeless sockets. Doors were padlocked. Stinging nettles grew high. Jenny had to beat them down before she could look through the windows. The bruised stems gave forth a rank odour. A few cats, lean and shrinking, and a speckled hen were the only living things in the village.

The last cabin in the straggling row had no padlock. There was a blind which was not drawn. Jenny opened the door and entered. All was orderly, the bed neatly made. On the floor were a woman's basket materials and a basket half-woven, lying there as if the worker had just gone. Yet the little pan in which the weaver moistens her strands was empty and rusted. On the stove stood a frypan containing a dried-up fish, and there was a cup stained with tea.

Jenny sat down on the cedar mat beside the unfinished basket, and closed her fingers tenderly over something. It was the knife John Smith had given the little Bessy when she made her first basket; later Charlie Joe had carved her name on the handle. Perhaps Bessy was hiding like she used to long ago. "Bessy!" she called softly. "Me come to help your trouble." But she knew that no human being was there, nor had been for many a day.

Jenny got up. "Who send me that hully-up paper? I dunno. My Bessy know I can't read and I got no one to say it for me." She came out onto the board walk. Turning, she closed the door and waddled down to her canoe.

Two miles further up the inlet was another village. "I dunno— I dunno," her paddle seemed to say as she made her way there.

The second village was almost as empty as Koskimo. There was an old couple there, but they had few wits and scarcely any hearing between them. One on either side of her, Jenny screamed into each of the four ears in turn to try and get a hearing. At last she found that she could dimly penetrate the woman's left ear.

She learned that Bessy had not gone to the cannery with Charlie Joe and the others, but had remained in the village to care for Charlie's infirm old mother. One night a gas-boat passed, going to Koskimo. Soon it returned. Two men came ashore in a small boat. They lifted Charlie Joe's mother from the boat and carried her to the hut of this old couple. They left some money and bade them care for her; said they would come back soon and see about her; said also that Bessy Joe was out in the gas-boat, and that she was going away with them. That was all the old deaf couple knew. They did what they could for the sick mother, but she died two days later, just before the men returned. They took her body away.

Jenny Smith's heart, new-melted with love towards her daughter in trouble, froze harder than ever before. Under the pretext of caring for her mother-in-law, Bessy had let her man go to the cannery alone, and then she had gone off with white men. Bad girls did that. Bessy had disappointed her mother in that she was too Indian; but Jenny had never suspected that Bessy was bad.

WEARY AND HEART-SICK, she paddled back to Quatsino, returned the canoe, then took the gas-boat back to Hardy Bay. "I got no more child," she moaned. "I tell Jimmy Jacob, 'Take me home—I want forget Bessy Joe.'"

But Jimmy Jacob was drunk and safely hidden away. So Jenny was forced to wait at Hardy Bay till he sobered. She slumped down on the board walk outside the post-office, a faded bundle of dumb misery.

The postmistress came to the door, shaded her eyes with her hand, and looked across the water to see if the southbound steamer was in sight. She saw Jenny. "Did you get your wire?" she asked.

The huddled figure straightened. "Who send me that hully-up paper and fool me?" she asked angrily.

"Don't you know?" replied the woman. "Haven't you been to her?"

"Jimmy Jacob tell the paper say hully-up quick, my Bessy got trouble. I hully, hully. I never stop. That paper fool me. Bessy not there. She quit Charlie Joe. Bessy gone with bad white mans," she added miserably.

"Dear soul!" gasped the woman. "You don't know what happened? I'll tell you. Bessy didn't go to the cannery with Charlie Joe, she stayed behind to care for Charlie Joe's old mother. Then

there was an accident at the cannery. Charlie Joe was caught in the machinery and horribly torn. The cannery manager sent at once for Bessy, but Charlie died before she got there. Bessie loved her man. She insisted on seeing his mutilated body. After that she was hurried unconscious to the Alert Bay hospital. Ten days ago her life was despaired of. The hospital wired her mother to come at once. Jimmy Jacob was despatched with the wire from Hardy Bay, but Jimmy got drunk and was discovered days later on the beach with the wire still in his pocket, was severely reprimanded and sent forward again."

Ten days ago! Jenny sat stupidly staring. From across the water came a gruff "toot." The postmistress stooped and put a gentle hand under the old woman's arm. "Come," she said, "the boat is here. You may be in time yet."

Jenny scrambled up and broke into a loose waddling gait, jostling against the scant population of Hardy Bay, intent on the one thing they all had in common, meeting the boat. The gangplank rattled as she took it on the run, desperately intent on reaching Alert Bay and Bessy.

In a quiet corner between decks the sobbing heave of her haste subsided. She knew now what Bessy's trouble was—knew also that ten days ago Bessy was near death. Perhaps now Bessy's trouble was finished.

CARRYING HER SHOES that she might walk quicker, she covered the mile from wharf to hospital with amazing rapidity. At sight of the building, her haste slackened to a crawl. Sinking on the lowest step, she drew her shawl across her face.

"You wanted something?" asked a nurse coming to the door. The trembling lips could scarcely frame the words, "My Bessy?"

"Bessy Joe? Are you her mother? She's fine now, but how she has cried because you were mad and wouldn't come when we wired!"

Dumb and shamed, Jenny stood beside the little white bed, knowing how she had wronged her child. Bessy's great brown eyes, watching her mother's face, did not read it right.

"Mother, you not be mad any more for me and Charlie Joe. Charlie Joe dead."

The bent head, with its heavy black hair bound by the gay handkerchief, shook vehemently, vibrating the chin and worn flabby cheeks. "My Bessy," whispered the tired old voice. "You got big trouble for Charlie Joe, and I got trouble too for Charlie Joe. Too bad! Too bad!"

Bessy laid a pleading little hand, blanched by weakness, on her mother's brown one. "Mother, you will love Charlie Joe's little Injun baby?" she asked, drawing down the sheet.

The child had Indian hair and was brown and swarthy like his parents. The old thought stabbed at Jenny's heart. If Bessie had married white, her child would have been three parts white.

Keeping her eyes steadfastly on her mother's face, Bessy roused the baby. With a strangling gasp, the new-made grandmother folded her arms tight across her breast, as if something there were too big to hold without support—for Charlie Joe's Injun baby opened eyes blue as those of his grandfather, John Smith.

JIMMY JACOB, SITTING beside his canoe on the beach, sad and sober, received a painful jab on the shoulder-blade. "Get up," said Jenny Smith. "My Bessy and me and Charlie Joe Smith want to go home."

"Huh!" grunted Jimmy Jacob. "You always got hully-up, Jenny Smith."

❋ LILIES ❋

IT WAS NOON. Save for an attendant or two, the flowers had the great building to themselves. Exquisite hothouse "exotics" stared at wholesome "garden blooms" and claimed no kinship, but the perfume mingled without snobbery, and the smell of the flower-show was one smell, immense, magnificent.

Tyler's lily exhibit occupied the centre of the great hall. Tyler specialized in lilies. Tyler's Madonna lilies filled the churches at Easter. Potted Madonnas, carefully swathed in transparent wrappings, were exchanged with Easter greetings, or soothed invalids, or decorated graves.

This show, Tyler had outdone himself. In a glorious mass of shining white, the mount of blossoms towered, up, up, into the dazzling light under the great glass dome. So "unearthly lovely" were they that people caught their breath and held it, as if they could not let the delight of their perfume go; while the white purity of the lilies held their tongues silent.

Mr. Tyler's only son Nat was in charge of the exhibit. The hot heavy air sent him dozing. Were those footsteps dream or reality? His own neatly shod feet dropped from the flowerpot. The legs of his chair settled squarely, but he did not open his eyes. Time

enough to offer the catalogue when the bombardment of superlatives began.

Silence—then a long-drawn quivering "Oh!"

Nat's eyes opened. A substantial motherly woman was gazing up at the blooms with shining, worshipful eyes. Beside her stood an undersized girl, wide-mouthed, red-haired, freckled, looking, not at the flowers, but at the woman.

"You do love lilies, Ma!"

"Yes, Janie, there ain't nothin' hits me so hard as Madonnas."

Nat stepped forward with his catalogue.

"No, thanks," said the girl. "We can't afford to buy, and Ma likes looking better than print. She's dreadful fond of lilies." Her smile was in her mother's pleasure, not for Nat. She turned to the woman. "Lil's gone to see the peonies, she don't care much about her name-flower. Says they make her head ache. Say, Ma, why'd you call her Lily Madonna?"

"She were my first, Janie, and she were so lovely, seemed like it were the best I could do for her."

"Why didn't you call me Tiger after the speckled kind?"

"You was Pa's namin'. He says, 'She's Jane.' 'For who?' says I. 'Aunt o' mine and a good woman,' says Pa. So Jane you be."

Before Nat's eyes swam the corner of his father's nursery garden, where a riot of speckled faces, under upcurling crimson petals, sprang up each year, unsown, uncultivated, growing for the sheer joy of life. He did not give the girl a second glance, because Lily Madonna was crossing the hall to join her people. When anyone's eyes fell on Lily Madonna they stayed there. Tall, slim, gold and white, no wonder Ma had named her so. All the superlatives folk showered on "Tyler's Madonnas" shrivelled to commonplace before Ma's Lily Madonna.

"Well, Ma, so you found all the other 'Me's'? Whew! how they smell!" Her quick glance took in Nat's well-set figure, the nice colour of his suit and tie; she did not notice the colour of his eyes, it was only what the eyes told her about herself that interested her. Lily used people as mirrors. Suddenly a pair of small useless hands fluttered out, catching at the end of the stall. "Oh—" she said, and closed her eyes, "oh—the perfume makes me—"

Nat rushed and brought his chair. Faintly smiling, Lily Madonna sank into it.

Jane turned. "Got any water, mister? Or can I tip some out of this vase?"

At the suggestion Lily gasped a little and straightened. "I'm all right now."

"Course you are. Get up and let Ma have the chair. She's tired and will want a long spell with her lilies." She tilted the lovely one out, and planted the seat squarely beneath her mother.

"Huh, old girl," was Nat's mute comment, "you sure should have tagged your other girl 'Tiger.'"

Lily had no further return of faintness during the hour that Ma worshipped and Nat's pleasant voice poured the contents of the catalogue, from orchids to parsley, into her dainty roseleaf ear.

When at parting he put the catalogue into her hand, his fingers touched her fingers—his eyes met her eyes. That night, and for many nights, Ma Bunday, and Nat Tyler, dreamt of Madonnas, while Lily Madonna dreamed of the things Nat's eyes had said, and of how she could get another peep into them. Ah!—Ma's birthday was coming soon; she saw a way in which it could be arranged.

Lily was the only member of the Bunday family who ever had any spending money.

The Bundays lived in a mean little row of workingmen's houses, hooked together like a line of more or less dirty-faced children climbing Harry Hill hand in hand. The Bundays' house was a "middle child," and had a clean face. The late Pa Bunday's insurance barely covered the rent. Jane baked and washed and mended for the family of the overdriven Mrs. Swatt, and received inadequate pay at irregular intervals—when Mr. Swatt worked. Lily went every morning to sit beside a wealthy invalid who had servants in plenty but who employed the girl solely for the delight she had in her exquisite beauty. To watch the movement of Lily Madonna's lips as she read, or her rosy fingers playing hide-and-seek in some fine bit of lace she was mending—the shadow of long lashes on her cheek, the glints of gold in the glory of her hair—these were tonic to the invalid. Lily's money was easy-earned. On Saturdays she turned it over to Ma, knowing well that Ma's right hand would receive it, with a "Good girl, Lily Madonna," and Ma's left hand would slip back a generous coin for the girl's own spending. Moreover, Lily's invalid liked her tonic in attractive wrappings. She delighted in planning and giving her favourite pretty clothes. So Lily tripped up Harry Hill in raiment white and shining as her name-flower, while Jane trudged down to Swatts' in dark print with an apron of stout unbleached under her arm. Ma, standing on the pavement in front of the door, pressed reverent lips to the brow of her lovely daughter, but gathered Jane in motherly arms and slapped a kiss among the freckles. Together they would watch Lily flittering up the hill and Ma would say, "How'd anything so marvellous beautiful come to me, Jane, when Pa and me and you be so ordinary-faced?"

And Jane would reply, "Dunno, Ma. Maybe she broke loose from Heaven, or maybe your naming her after the lilies had something to do with it." Then Ma would say, "You're powerful comfortin', Janie," and little freckle-faced Jane would run down the hill with her wide mouth wider, and Ma would mount the three steps, pass through the parlour, drop another step into the kitchen, and two more into the garden, where her stunted cabbages and onions sat in melancholy rows.

"Hearten, me dears," she would say to them, "it's a grand slop o' suds I'll be givin' ye come washday." But neither dishwater nor wash suds could cheer vegetables and flowers starving in the impoverished soil that generations of cabbages and onions before them had depleted. For tenants do not fertilize other folk's ground, or perhaps, like Mrs. Bunday, were too poor to do so.

The Bundays' house consisted of a parlour and a kitchen, with a steep, black little stair squeezing in between, which led to an attic bedroom. When Ma breasted the stair squarely, her right arm touched one wall, her left arm the other, and the pinched steps squeaked under each footfall. Mrs. Bunday and Lily shared the big bed in the attic room. Jane had a cot in the corner. When, like today, it was hot, the attic was *very* hot.

Jane had done a big washing. She was sprawled on her bed resting. "What's up?" she exclaimed, as she saw Lily slip out of a dainty dress and lay a daintier one on the bed ready for use.

Lily Madonna took out the pins and shook hair like sunshine over her face and shoulders. "Brush it for me, Janie," she coaxed, "and I'll tell you."

When the long strokes were sweeping through the glory of Lily's hair, Jane said, "Well?"

"I'm going up to Tyler's nursery and get some Madonna bulbs for Ma's birthday."

Jane stopped brushing. "Oh, Lil! How splendid! How perfectly splen—" She choked a little because Mr. Swatt had not been working. She had no present for Ma.

"I suppose you couldn't—lend? I'll pay back as soon as Mr. Swatt gets his job."

"Sorry, Jane. Bulbs, show, cake will take all there is." Lily put on her shiniest and went out.

Jane wanted to cry: sniffed twice, jumped up, got Lily's catalogue and read: "'Madonnas...greedy feeders...require rich ground...plenty manure.' Poor Ma. Oh poor, poor Ma! It would almost be better if she did not have them."

"Janie! Run up to Dyatt's farm and get the eggs, will ye?" Seemed like the little stair loved to do something for Ma. If it couldn't squeak under her foot it echoed her voice softly.

"I'll go, Ma," was Jane's quick response. As she climbed Harry Hill she said, over and over, "Greedy feeders—rich soil—manure."

Mr. Dyatt was in his lower field, and he was spreading manure.

"Good day, Mr. Dyatt. How is Mrs. Dyatt?"

"Porely, Jane, very porely. Seems she don't hearten none between washdays."

Jane looked out across the rich field. The light in her brown eyes was mellow as the sun on the soil. "Mr. Dyatt, how many washes do you reckon would pay for a load of manure?"

"A load of manure? Nobody hereabouts buys manure. Folks takes and takes and takes the very vitals from the soil, but they don't put nothin' back, they just moves on."

"I'll do Mrs. Dyatt three washings for a load. That will give her a chance to hearten a bit."

Having clinched her bargain, Jane came singing down the hill with the egg-basket on her arm and overtook a radiant Lily. Old Tyler had appreciated Nat's telling of the woman who called her beautiful child for the lilies that were the pride of his heart. That and Lily's face won for her a grand bulb bargain, and Nat had shown her over the greenhouses and the gardens. When she paused for breath in the recital of her doings, Jane said:

"I got a present for Ma too."

"Where'd you get the money? What is it?"

"Didn't get money, traded washings. It's bigger and usefuller and smellier than your present. You'll see when it comes."

Ma's birthday was one grand day. Mrs. Bunday held the little bulbs between her palms. "Oh, Lily Madonna! I never thought as how I'd ever have any of my very own in this world. I thought Madonna lilies was only for the rich. Oh to sum all the power, and growth, and beauty, and smell, tied up in the wee things!" She laid her cheek down against the little white bulbs, realizing them into maturity and blossom. "Oh deary me, oh deary, deary me, if our soil was only a mite richer for the poor dears!"

Jane jumped up. "I'll be back from Dyatt's washtubs at noon, Ma. My present will be coming then. Here's on account," and she gave Ma a kiss for each of her years.

They had hardly finished their noon dinner of pork and the least emaciated of Ma's cabbages when Jane jumped up, exclaiming, "I can hear your present coming, Ma!" Dyatt's wagon rumbled up. Dyatt removed a bar, and Jane's hard-earned gift tumbled over the pavement.

"My lilies! My lilies! Oh, what a dear thought, Janie! An' the pore cabbages an' the onions too! It's beautiful to think of what my garden will be!" Tears stood in Ma's eyes.

"I call it *utterly filthy* and *disgusting!*" cried Lily, behind her handkerchief. "An insult to the street! It shames and disgusts and sickens me!"

"No, no, Lily," said Ma gently. "It be the very wholesomeness of the beauty—it be for nourishin'." Suddenly Ma's jaw dropped. "But—but, Janie—how ever's it to be toted back, when there ain't no through way?"

"All fixed with the fairies, Ma," laughed Jane, her nose mocking Lily's offended one. "You toddle off to the show with Ma, Lil. Your smeller, your eye, and your help aren't needed here."

Alone, Jane wasted no time. Ma's presents had a date in the back yard. There was only one way. Decked out in her worst, with Pa's old whitewash-spattered hat jammed down over her red hair, and armed with two buckets and a shovel, Jane attacked.

"Luck that the back door is smack opposite the front," she commented as she paved the direct route with newspaper.

Soon her young body was swaying to the rhythm. "Four shovels—lift—mount three—pace eight. Drop one—pace six—drop two—*dump!*" Over and over the process repeated itself. The pile sank slowly. The girl's arms ached.

"Does Miss Lily Bunday live here?" Nat addressed Pa's hat, bobbing behind the manure pile.

"One, two, three, four. She does, and she's out. One, two, three, four." The buckets lifted.

Nat held a dainty scarf out, tenderly, as if the precious thing were breakable. "She left this at the nursery."

"She would. Just chuck it inside, will you? I'm pressed." Without pause Jane paced the newspaper path, dumped, returned, set her buckets down with a clank, pushed Pa's hat back, and ran her fingers through her damp red hair. "Whew!" She straightened

her tired back. Suddenly her eyes popped. On Ma's work-table lay a dainty florist's parcel, and the smell of lilies wrestled with the smell of manure.

"Oh," she said. "For Ma? Oh, oh, won't she just—!"

"My father sent them," stammered Nat. "Miss Lily said it was your mother's birthday, and I saw at the show how she loved lilies."

"What a birthday—bulbs, and manure, and now these!" Her freckled hands halted in the middle of a clap. "What you doing?"

Nat had taken off his coat and was rolling up his sleeves. He grinned down at her. "Got another shovel, and some more pails?"

"Oh, no, please dress up again, Mr. Tyler, I really couldn't let you—it's my job. My present to Ma."

Nat's determination could not be shifted. So Jane insisted on Pa's overalls, and without further argument they fell to work, wasting no time on chatter. Soon Nat had fallen into the swing of "four shovels—lift—mount three—pace eight—drop one—pace six—drop two—*dump*."

When the rich odoriferous pile was in the back, and Jane was folding the papers and Nat brooming the pavement, and the bobbing hats of Ma and Lily had just come in sight, Jane smiled up into Nat's face. "I'd never have got through till Christmas, without your help." Flushed and smiling, she looked *almost* pretty. Then Lily came, and was wholly beautiful. "How could Jane let you?" she said, but her eyes added, "I am glad she kept you for me."

Then followed tea and birthday cake, and laughter, and love-making. The glowing loveliness of Lily Madonna. Nat's lilies filling the house with delicious sweetness. And Ma, the birthday queen, sitting before them, yet not there at all, but out, out in the lily world, carried there by their purity and shine. Perhaps something in the emptiness of Pa's overalls, hanging on the kitchen

wall, made Nat say, "I'm coming to dig the manure in for you—Ma," and blush, and say, "Good night, Mrs. Bunday," and blush again, happily, when strong motherly hands fell on his shoulders, and Ma said, "Thank you, Nat. Good night, my boy."

Old Tyler, sitting up for the boy he both fathered and mothered, saw that in Nat's eyes which made the face of Lily Madonna play hide-and-seek among the blooms in his greenhouses all night.

When the moonbeams back on Harry Hill lay still and white across the eyelids of Lily Madonna, Ma crept down the squeaky stair. In the quiet dark of the room below, the lilies were a vague blur. Ma drew a deep breath, lifted the best vase, and carried the flowers upstairs. "Sleepin' noses don't smell, Janie," she whispered as she passed the cot.

"I'm glad you brought them, Ma. Good night."

The grey head bent close to the red one. "The boy's clean gone on our Lily, Jane. Would any young man shovel manure his half day, just to get a glint of a girl, if he wasn't deep in?"

"No, Ma." Oh, kind moon that did not poke into the corner and show Jane's face.

Nat was budder and grafter for his father. This year the budding was not as successful as usual. Often Mr. Tyler surprised Lily seated on a box close to Nat in the long cool nursery rows.

Old Tyler shook his head. "The girl's too ornamental and the boy's too young," said he, and shipped Nat off to Agricultural College. He called on Mrs. Bunday. "A year apart won't do that young pair no harm, marm. It'll show them where they're at. Ho-hum, tadpoles will turn into frogs. It's lonesome without the boy, and—drat it!—there's the budding. Why can't tadpoles stay tadpoles? Pest 'em!"

Next day a freckled little person stood in Tyler's nursery, and, looking Mr. Tyler straight in eyes that till this moment had been unaware of her existence, said, "Mr. Tyler, do you think that I could learn to bud? Ma says I'm tolerable tidy-fingered."

"Then I believe you could," returned the old man, and he enjoyed teaching Jane, she was so quick and deft. Before long she was employed at the nursery earning a good wage.

"I'd sooner you did not tell Nat," she said to Lily, who wrote every Sunday, covering the sheet slowly, and looking here and there as if trying to scare up news. Mr. Tyler for reasons of his own did not tell Nat either about his new budder.

The year slipped quietly by. Lily's invalid was growing weaker, more irritable; Lily's money was not so easily earned now, and she was required most afternoons now as well as the mornings, to amuse and soothe her employer. Some Sundays she complained of being tired and did not write. Ma saw the look of hungry indignation on Jane's face the first time Nat's letter lay unopened for two days.

Ma's figure folded and unfolded like a huge accordion, as she bent and straightened over her garden. In a little round bed all to themselves, the lilies were blooming. Mr. Tyler had been to see them and pronounced them fine as his own. The cabbages were firm and round, the pumpkins plumping, the third crop of radishes trying to keep their blushes underground and not succeeding. Roots, bulbs, and cuttings found their way to Ma's garden through the kindness of Mr. Tyler.

"Give up, Ma, let the weeds and cutworms have a mite of a rest," called Jane. "Come away, I've made you a cup of tea." Jane had a half-day. Lily was with her invalid. The parlour was quiet and cool. Ma sank into her chair prepared to enjoy her rest and her tea.

Suddenly a whirl of white in the sunshine of the open door. "Oh, Ma! Oh, Jane! I'm married!" Lily burst into the little parlour, and, with a frightened cry, hurled herself into her mother's arms in a passion of wild hysterical weeping.

A swift look of hurt swept across Ma's face, even as her tears fell and her hands patted her lovely one. Her child, who had never been known to distort her face by crying.

Smash went the tray of china, and the tea Jane was setting before her mother. Nat's unopened letter lay on top of the family Bible. Jane longed to snatch it to her bosom. Instead, she seized the broom from the kitchen door and swept the food and the china and herself in a broken jumble down into the kitchen, and shut the door. The coal-scuttle was nearest; she sat down upon the coal and rocked herself to and fro. Lily married! Nat coming tomorrow! Poor, poor, Nat. "Jane, Jane," she cried. "Of course you're sorry for Nat. Nat that loves Lily so. He'll never come here again. He'll never want to see the beastly Bundays again." Then she jumped up from the scuttle, her spine taut. She shook the stinging salt tears from her face. "Maybe it's Nat Lil *has* married!" she gasped. "Lil said he was coming the end of the week and this is Friday. I must know! I *must!*"

She stuck her head under the tap. The roller screeched as she tugged the towel down and buried her face in the coarse crash. Bursting open the parlour door—"Lily!" she demanded. "Who did you marry?"

Lily did not look married at all, lying there in Ma's lap like a baby. She and Ma were both smiling.

"Janie, Janie! I forgot!" Lily sprang out of Ma's arms and ran to the Bible. From on top, and beneath, and between the leaves,

she took Nat's unopened letters. "They're yours, Jane, all yours. Nat sent them that way to help me keep the secret. I dassn't tell, because of her being so sick, and wanting her folks to think I was safe because I was engaged to Nat. Nat and I never were loves, Jane. It was only my face and those pesky flowers got in the way, just at first. Everything I wrote him was about you, only I did not tell about the budding because you said not to." Lily stopped for breath, and Ma took up the story.

"You see, Lily's invalid ain't got long, Jane, an' nobody dassn't vex her. Them gawpin' relatives was snoopin' round tryin' to fix a match between her son and his cousin. An' all the while he an' our Lily was lovin' these many months. Which his ma let her tell Nat, on the swear of 'em both it wasn't to go no further. Today the sick woman asks for parson, and the relatives, thinkin' the pore soul's dyin', snivels proper. And in comes Lily in her prettiest, and there's Joe an' the ring poppin' out of his pocket, an' it's done." Ma caught her breath, and on a quick gasp, with a beam that signified this was the crux of matrimony, she added, "They love *true*, Janie. An'—an' everybody's free—free for lovin'."

With her letters clutched tight to her breast, like a humming-bird on the wing, Jane swooped and delivered a kiss on Ma's cheek and one on Lily's, then darted up to the attic on a wide golden stair of joy.

"Goodness!" exclaimed Lily Madonna. "Am I me, or a lily, or a crocus, or—or Mrs. Joseph Haldean? And here is Joe, so I must be her." And she began to preen and straighten like a wonderful bird.

Mr. Tyler read the births, deaths, and marriages; folded the paper and groaned between every gulp of coffee. "Poor boy! Poor boy! But better he should know the cream wa'n't solid right

through than pine off later on skim. If only he had chose the one with the heart, now, instead of the one with the face! Well, we'll see. Step soft, Dad Tyler; hearts is touch an' go."

The old man's meditations were shattered by a shouting and stamping, and a hilarious Nat burst in. "Hello, Dad! No, don't bother draping your napkin over the paper, I read it on the train. Any coffee left?" He drank it steaming hot, holding the cup high, and crying, "Good luck to the bride!"

"How are the show blooms, Dad? Madonnas shaping well?"

"Right enough. I'm not specializing in Madonnas this year, Nat."

"Not specializing in Madonnas! But—Dad—everyone looks for 'Tyler's Madonnas.'"

"Everyone will *stare* at 'Tyler's Tigers' this year instead, Nat. Drat it, I'm sick of them greedy saints, wantin' this and wantin' that. Look what half the fussin's done for Tigers, lad." He led the way to the greenhouses.

Nat drew a deep, sharp breath when he saw the riot of joyous speckled faces, their crimson caps jauntily tilted—vigorous—sturdy—rich—sprightly-leafed—exultant! He strode down between the gay rows and threw open the door of the Madonna house. After the crude earthy smell of the Tigers, the sickly fragrance of the Madonnas was overpowering. There the Madonnas stood in their pale glistening purity—aloof.

Dad Tyler, watching Nat narrowly, saw his eyes pass from Tigers to Madonnas, from Madonnas to Tigers. "Pretty subtle for a boy of my years," chuckled the old man.

Reverently, Nat closed the door of the Madonna house, and turned to his father. "It was wonderful of you to understand, Dad. I—I was afraid you had sort of built the face of Lily Madonna in

here among your show blooms and would despise me for a turn-coat. It—it always *was* 'Tiger,' Dad, but it took a Madonna to show me. Do you mind if I run up to—to Harry Hill now?"

"Trot along, Nat. On the way, just drop through the budding rows, will you, and tell that jim-dandy budder of mine she can have the day off."

"O.K., Dad."

"He-he," chuckled Dad Tyler, "I done that dainty," and stomped through the lily houses to give orders regarding the cleaning out of a certain little cottage on the far side.

Pausing where Nat had stood, Tyler shook an admonitory finger towards his beloved blossoms. "Listen, you lilies!" he said. "This is a top-notch-year-at-Tyler's, and we're a-goin' to bust the record of all the lilies Tyler ever growed."

❧ WORSHIP ❧

THE BROCKS HAD a long pew at the top of the church. The pew had an opulent cushion and footstool upholstered in crimson. On Sunday mornings Mrs. Brock, stiff and demure, sat at the far end of the pew, and Robert Brock, comfortable and paternal, at the other. The much-curled heads of six little Brocks bobbed between—handsome, well dressed children.

Mr. Brock was a business man of integrity. He was also church warden. In the family pew he took the children's hats off and put them on again. He found all their places in the prayerbook and hymnal. If the long sermon got too wearisome he passed a bag of soothing sucker-lollypops down the pew. When the Bishop was nearing his Amen, Robert Brock dived into his pocket and took out a handful of pennies; like the early and late labourer, each child received a penny. Then Mr. Brock left his pew, crossed the chancel, and met his fellow church warden. Side by side they marched down the long centre aisle passing the collection plate. At the church door they parted, one turning right, one left; each took a side aisle. By the time Robert reached his own pew at the top of the church the children's six pennies were lost. Mr. Brock waited, holding the plate, while all the cracks behind the pew cushion were searched,

then the floor, even the prayerbooks and hymnals held by covers and shaken, while the big brass collection plate waited and the choir improvised an additional verse to the hymn.

MR. BROCK BOUGHT a great field lying some miles beyond the town, a cleared hummocky field that had been pasturage for a farm nearby. There was a two-roomed cabin in the field. Close to the cabin Mr. Brock raised two tents, cosying them with floors and siding. In this camp he planned holidaying his family during the long summer vacations, himself going back and forth to town in a rig with a handsome black horse driven by one of his office men.

Mr. Brock was well pleased with his new property. It was bounded on one side by the sea, having a good bathing beach for the children, on another side by the country road. On the other two sides right up to his fence grew dense pine woods which, after a stretch of forest green on top and purple underneath where the sun could not penetrate, met a high rocky ridge of hills which protected the camp from the prevailing summer winds. Sunshine played across the wide field all day.

Janet Brock was irked by camp life. She hated inconvenience, wasps, and brambles. The ants and mosquitoes bit her. But her children loved camp so much that for their sake she endured with only minor grumblings. She handed the provocations and inconvenience of camp over to Hannah, the cockney maid of all work, folded her pretty hands over her white forearms, and sat the summer through.

"MOTHER," SAID ROBERT, "we should not let the children's religious training drop because we are pleasuring."

"But, Robert, there is not a church within miles of camp."

Robert considered, his eyes roving his field: presently he noted a slight rift in the dark of the woods adjoining his property. He went to it and saw that a great flat moss-covered rock lay in the woods just the other side of his field. The rock was as large as a big room. Robert took axe and saw and cut a hole in his fence. Into the hole he hinged a little gate.

"I have made a church, Mother. Come and see, it is just the other side of our own fence."

"Robert! You know I cannot climb fences!"

"I have made a gate."

The children came from the beach. "Oh, Father! Is this a play-house for us in the woods?"

"No, this is our church. We will keep it just for that."

The Brocks entered the church and looked round. Janet said, "Robert, I could not possibly sit on moss nor pray among ants and beetles!"

"We will carry a chair out for you, Mother."

The trees grew so close together that all their underboughs were rusty for lack of sunshine, nor had they opportunity to grow thick massive boles. Red-purple and a foot thick was the best they could do. They receded back and back till they were lost in mystery, but the standing boles did not absolutely enclose like man-made walls.

There was the pungent sweetness of pines and earth in the air of this woods church. Janet said, "The place smells like a sepulchre!" The quiet of woods shivered her. She turned back to the bright rock. Its crevices were filled with patches of brilliant green licorice fern. The green yellow of moss on the rock was rich and deep and dotted with pink shepherd's purse and wild blue forget-me-not. Spiraea bushes grew round the edges of the rock, dropping rich

creamy bunches of blossoms whose weight bent their slender woody stalks, straining out towards the sunshine which filled the little rock chapel at high noon when the sun was overhead. A bold and brazen tiger lily grew on the edge of the rock. It had five blossoms on each stalk, blossoms with faces furiously splotched, and orange petals rolled back like the lips of angry cats.

THE NOVELTY OF having an outdoor church pleased the children, so Mrs. Brock made the best of it. A chair was brought out of the cabin and placed on the moss, and Janet felt regal sitting in it, her children grouped around her feet on the moss.

Robert was distinctly nervous the first Sunday when he took his place on a bare portion of the rock and fingered his prayer-book and hymnal. He missed the protection of the church, of the congregation, as well as of the Bishop. There was not anything man-made in this place except the chair upon which Janet sat. Boles and boughs dimmed and dimmed, receding indefinitely. There was deep quiet. Janet bowed her head, the children bowed theirs; still Robert did not begin. He fidgeted with his books. His tongue turned stiff. He wanted to bolt through the little gate back into his own field. The old house-dog lay at his feet. The trustful eyes of the old dog were the first thing to pull Robert together, looking direct and with trust into Robert's face. Janet, shading her face with her hands, was furtively peeping to make sure there was no creeping thing near her. She peeped at Robert, wondering at so long a pause, anxious to get it over, to go away even to the slight shelter of the little cabin. One of the children tittered, watching a battle between two ants down in the moss. Robert thought, "He knows Father is scared. My son shall not think that." Robert's voice rang out strong and firm.

"God is in His holy place; let all the earth keep silence." As he read his voice steadied.

"It was brave of you, Robert," said Janet as he helped her through the gate and carefully tied it. "I could not have done it before the children."

A visiting child once asked, "What is that lovely little place? Could we not go in there to play?" But the Brock children said, "No, that is our church. We do not go there to play."

TWO SUMMERS SPENT in the makeshift camp were enough for Janet. Hannah the cockney maid did the camp work, Janet did little but shoo mosquitoes, so she got bored and began to complain. Robert built for her a fine summer cottage far down the other end of the field close to the sea. The cottage had a nice kitchen, a great living-room, and plenty of bedrooms. Tents and cabin were abandoned. Janet's second-best piano was included in the comfortable furnishings brought from town for the new cottage. Janet could almost forgive insects for being insects now that she did not have to live on such intimate terms with them. She said, "Robert, now that we have the large sitting-room and the piano, it will not be necessary for us to wade across the hummocky field to that absurd rock beyond the gate? We can hold service in the living-room—piano, chairs! I think perhaps we *should* invite those children from the farm, too. The poor things have so few opportunities, and of course there will be Hannah too. An enclosed church with piano and real chairs will remove the familiarity I always felt a danger in that church picnic-style— everyone sitting around equal on the moss lacked class dignity."

"As you wish, Janet." But there was sadness in Robert's heart as he took away the little gate and replaced the boards of the old

fence, half envying the birds and snowflakes that could still continue to worship God out on the mossy rock in the woods chapel.

IN THE COTTAGE living-room the chairs were set in two stiff rows on Sunday morning. Near the door were four other chairs—three for the farm children, one for Hannah.

The farm children plodded ungraciously to service across the fields carrying their Bibles. Their mother made them come. They sat uncomfortably on the edges of their chairs, feet dangling, mouths open.

The Brock children exhibited superiority by pinching, hair-pulling, and tying their sisters to the chair-backs by the little girls' sashes, so that when they faced over to pray, chair and all went too.

Janet thanked God that *her* children were not stodgy and heavy like the farm children. Janet played the hymns. Her voice, always a little flat, sounded a little flatter enclosed between walls. Once she had had those long curved white teeth peculiar to Englishwomen. A Canadian dentist had replaced them with shorter Canadian dentures. Her frustrated lips gathered into a pucker. They met like the fluted edges of a cockle-shell. She had nice eyes but they were always grave. The children were proud of their mother, proud of her white idle hands, her straight back, and elegant ways.

THE SERVICE IN the cottage living-room was over. Janet and Hannah rose from opposite ends of the room, rubbing their knees a little. "Polish be 'arder nor moss, mum," remarked Hannah.

The farm children passed out the door. In slow lurching going they were nearly knocked over by a mob of young Brocks heading for the beach.

Hannah shoved the laps of the chairs under the dining-table. "Wuship be huntidity, mum, 'ymn books 'iggeldy-piglin' all hover the plice."

Robert and Janet went to sit on the cottage verandah.

Janet's eyes followed the dust-kicking heels of the farm children crossing the fields. "Robert! Oh, Robert, those dreadful children! They are playing toss with their Bibles, the ones I gave them on Christmas! Should we allow our children to be exposed—irreligion!—"

"Only show-off, Mother. Those youngsters are all right. Showing off for nervousness."

Janet sighed. "Our children for a pattern, the fine big room, the piano and the chairs, so different to the woods: I thought religion would—"

The clock in the living-room gave twelve slow raspy strikes. Like the piano, it was only the Brocks' *second*-best. Robert tallied his watch, slipped it back into his pocket, laid a big warm hand on Janet's knee.

"There are as many varieties of worship as there are kinds of time-pieces, Mother. Time himself is all that matters. Time who never hurries or slows. Time, time, time—time Hannah's dinner was ready—come!"

SMALL AND HER CREATURES

✖ WHEN I WAS LITTLE ✖

MY FATHER NEVER shot at living things. I love that memory of him. He could fire a gun. I only heard him do so once. A burglar was in our house...Father aimed at the sky.

Other children bragged, "My father is a sportsman, goes out to shoot deer and birds." I was proud that my father did not. He talked often about the birds of England which he had loved in his English boyhood. Young Canada had very, very few wild song birds when I was little.

We were picnicking in Medina's Grove. Waving a turnover that dripped jam towards a near bush, I said, "Father, there's a bird's nest in that bush!"

Mother said, "Don't drip jam, child!" Then half to herself she said, "The child inherits her father's passion for bird-life."

I am glad Father gave me that inheritance.

I SHALL NEVER forget the first full bird's nest I looked into. I was playing "lady" by myself on the old mossy rock in our back field. "Ding-a-ling!" I sang, and pulled at a bush intending to call on myself. It was not a play door that opened to my pretend ring but four yellow real bird mouths right under my hand. First I

thought they were tiger-lily petals blown into the crotch of the bush. Then I saw that they belonged to four little birds who thought the rustle of the bush was their mother come. When no mother's beak poked food into their throats, they shut up, disheartened. The nest was under my eye level: I could look right in. I looked and looked. Every day I came back to look again, until the birdlings had fledged and were away.

A YELLOW WARBLER built in our lilac. I went closer and closer every day, till the bird trusted and did not fly off her nest at sight or sound of me. By and by she used to come across the lawn to meet me, pecked from the little dish of food I carried for her, flying as she fed. When I set the little dish in the bush, she finished feeding, filled up the children as I stood there, then covered them with herself like a cosy blanket. If I laid a finger on the edge of her nest, she pecked at it. That warbler nested in our lilac-bush for five years.

IT WAS MY WORK and my joy to tend the fowls in our cow yard. I had a "chum rooster" who was special. I called him Lorum. He came in a coop of chickens Father bought to fatten. This little fellow was woebegone; everybody pecked him till he was half naked. They would not let him feed. At mealtimes he slunk into a corner, hungry. He had spirit, but he was so much smaller than the two dozen rest.

I was sorry to see his tail and wings and heart all drooped. When I fed the others I took a good shovelful of food over into Lorum's corner and sat with him while he ate. The rooster gave me his whole heart in exchange. He fattened and was soon sleek and dapper. A small-boned bird, black Spanish, with a double

rose comb, he was very handsome and, with me behind him, could whip any rooster in the yard.

Lorum waited, waited always by the cow-yard gate listening for me to come. There was such gladness in his neat, fiercely spurred feet as he ran to meet me, wings spread to make his hurry quicker. He flew to my wrist, but his claws gripped too hard, hurting me if he clung tight to balance as I walked; so I sat down on the wood pile and he got into my lap and took first helping from the food dish. He liked just being there better than he liked the food. We were really chums for years, then suddenly Lorum disappeared. I searched and searched. When I discovered that my sister, thinking Lorum would be too tough to eat, had sold him to a Chinaman, I flew into a rage so wicked-tongued that it was an occasion for the riding whip. I just screeched. I did not care how I shamed the family. I did not care a bean about the whip or about the wicked words. I was furious about Lorum—my Lorum.

❧ A DEBT ❧

MRS. LEWIS'S SITTING-room was delightful. Sun streamed across blooming plants in the great bay window. A fire always blazed in the open grate; before it, on the mat, sprawled dogs and cats. Mrs. Lewis's low easy chair was placed on one side of the hearth, the Captain's bigger and more roomy chair on the other. A terribly old clock ticked the minutes into nowhere, sitting between the photos of Mrs. Lewis's father and mother on the mantel. The rest of the room I do not remember, except for the best thing of all: an inside window overlooking a conservatory on a lower level of the cottage.

Flowers loved to bloom for Mrs. Lewis. All in among her plants she had birdcages filled with birds that the Captain had brought her when he came home from strange countries, but mostly she had canaries. The flower scent, the singing of the birds, came through the window and made the sitting-room one great gladness.

IN A WIDE CAGE just below the sitting-room window a mother canary was nesting. She had four eggs. The next time I went to

see Mrs. Lewis, the mother bird was resting on the edge of the nest poking food from her own bill into the mouths of four tiny, naked, wobble-necked birdlings. She did not mind my staring but went right on poking till the little ones were full. Then she sat down on top of them, fluffing her feathers—not to hide them from me, but to keep the birdlings warm. She knew I was glad and proud for her.

MRS. LEWIS NEVER knew how obliged I was to her leg for breaking and laying her up. She sent for me.

"The Captain will lift the cages down, my dear, if you will tend my birds."

If England's Queen had asked me to dust her crown, I could not have been prouder. The leg took six weeks to mend. I tended the birds. The nestful of babies were almost as big as their mother when Mrs. Lewis came into the sitting-room, walking with a stick. We stood by the window looking into the conservatory, right into the cage full of young birds.

"Choose, my dear. You may have whichever one you like best."

"To take home and keep for mine?"

"Yes."

I went crazy-happy. The only live creature I had ever owned before that was a kitten. I had always thought Mrs. Lewis pretty, and she was—but now she looked to me just beautiful. I chose the one with a top-knot and took him home and called him Dick. I loved him.

DICK WAS TAME and had a strong, lovely song. He loved me as much as I loved him. If I was away from home for a few days he

fretted and would neither sing nor eat. As soon as I came back he would spring to his perch and sing.

One morning early, early before I waked, the catch on the tray of Dick's cage gave. It was hanging in the conservatory and all the windows were open. Frightened and bewildered at the clatter of the falling tray, Dick fluttered out to unwonted freedom. The world must have seemed wonderful to him in its early freshness. He was strong and flew on and on, irresponsible, and not thinking of direction. Suddenly he tired and found that he had forgotten the way back.

When I found Dick gone I cried myself frightful, couldn't stop. There was not an uglier, more swollen-eyed child in Canada.

Our doctor's wife was Mother's friend. Mother told her about my terrible crying and how she could not stop it or comfort me.

Next morning I was in the garden, my face down in the dirt under a lilac-bush, crying for Dick, when I heard:

"Hi there, little woebegone!"

I looked up and there was Doctor Jim's buggy at our gate.

"Hop in," he said, but I stood at the step hesitating.

"My pinafore is pretty dirty."

"Nothing to your face! Tears and dirt have striped it like a zebra! Scrub it on the corner of your pinafore and hop up."

I climbed in beside Doctor Jim.

"Where are we going?"

"To St. Joseph's Hospital."

I was frightened. I had never been inside a hospital. It was a place where doctors cut people up, took out bad pieces and sewed up others. Was Doctor Jim going to sew up the corners of my eyes so that they could not cry any more? I was very quiet as we drove—scared.

Doctor Jim was very big and clean. I was little and very dirty. We walked down the long corridor of the hospital hand in hand. Sad plaster saints looked down from niches in the wall. A nun met us, led the way into a tiny waiting room. The Virgin Mary and St. Joseph were there—plaster, of course.

"Bring that bird, Sister!"

The nun was gone only a second. She came back and in her hands was a cage and in the cage was Dick!

Dick flew towards me and beat his breast against the bars of the cage; then he sang.

"Dick! Doctor Jim! Sister! Oh! Oh!"

"Your old men will miss their new toy, Sister. It delighted them that he came to the hospital, to the window of their ward, and asked to be taken in."

My heart tore. Pushing the cage back into the nun's hand, I said, "They can keep him . . . they are old and sick."

Doctor Jim put his arm around me and I hid my face in the rough of his coat sleeve. I did not feel kind, or generous, or brave—only achingly greedy, wanting Dick.

The nun put Dick's cage back into my arms.

"The bird is yours, child. You are the bird's."

Did I imagine it or were the saints really smiling in their niches as we passed under them going down the long corridor?

THAT WAS THE original little old St. Joseph's Hospital. St. Joseph's has now swelled into an enormous institution; there are labyrinths of corridors. I have been wheeled down them many times. Plaster saints have looked gravely down, but none have ever seemed to smile as gaily as those others long ago, when I have passed going to some quiet room to lie and heal.

A NUN STOOD AT my bedside cheering me with chat. I said, "Last time I was here there was a canary hanging in the corridors. He sang beautifully. I loved to listen."

The nun said, "He belonged to an old sick priest. When the priest died the sisters at the convent took his bird."

"I have an aviary at home where I raise birds."

The sister breathed quick. "Oh, do you ever have one to give away? How I would love a bird to sing to the people on my floor!"

When I got better and went home I looked through my aviary. The best young singer I had was marked almost exactly like old Dick. I took him to St. Joseph's and gave him to the nun.

𝕏 DUCKS AND FATHER AND MOTHER 𝕏

SMALL RAISED A BROOD of eight ducklings—she watched them grow from oblong blobs of bobbing yellow to slick-feathered magnificence, watched them pass through every stage of gawky ugliness, drab, rough, ungainly, shovelling in food with voracious developing gluttony, watched their eyes turn from staring beads of black to keen shrewd glitter, set in cheeks which could be tipped, one up, one down, so that they could regard the heavens and the earth simultaneously. Small saw quick peep and flat patter change into quacks and rolling waddles.

There were four ducks and four drakes. The ducks were quiet mottled brown, the drakes gorgeous—dashes of green and blue set among grey and browns that made them seem brighter, short legs and wide-spread feet leaving on the mud imprints like tiny kites. The drakes did not quack, but from their wide-open beaks came long musical chirrups. Their chiefest glory was their heads and necks. Peacock colours, full of sheen and glint. Smooth as satin, rough as plush as the drake's mood changed.

On land the ducks were comical, tipping this way, tipping that—breaking up their food in slovenly hurry, slapping down

their clumsy feet—shoving their pothook necks forward, complaining with boisterous, clattering quacks, rushing to the pond and launching with a glide that was grace itself, breasting the water with a joyous push and scarcely a ripple, only an exultant kicking away of the land behind them, drakes leading—eight perfect and unsinkable boats, doubled by eight perfect reflections as bright and smooth as their realities. In a twinkling there were eight headless half-ducks the shape of Frenchmen's well-trimmed beards, kite-like feet and shovel-beaks rippling the water, stirring the mud. Small loved her beautiful ducks.

On a day so splendid that it hated to go to bed, Small came to shut her ducks up for the night, eating a great apple, running, singing—these all together took great breath, but young things breathe easily, young hearts break easily.

Apple fell, song stopped, Small stood rooted. Blood! Blood! She could not scream; as she ran she had heard chop! chop! The axe flashed again, guided by a rough, hairy hand, a hand she had held to, trusted. The hand tossed the bunch of quivering feathers upon the ground, wings spread—there was a flap or two, a lovely green and blue head lay in the dust, separate. Two other heads lay there too—more quivering bodies, spread wings and flopped legs. Burning hate seared Small's heart. She rushed into the house.

Small's mother sat at her machine sewing. Her father read his paper.

"Richard, this must not be!" The Mother opened wide her arms to Small.

The Father shifted uneasily. "Nonsense!" he said. "Small must learn."

❧ FATHER IS A CANNIBAL ❧

"THE COW HAS A surprise for you in the back yard, children. Come and see."

The breakfast bell rang as we trooped behind Father. One could not imagine the dear, slow old cow giving or taking a surprise—she was always so calm. But there it was, the loveliest little image of herself, brown and white and very topply on its legs, which were spread out like the legs of a trestle. He was standing under the cow's chin and she was licking his hair all crinkly. His eyes were bluish, and stared as if he were too surprised to see, but he had the friskiest little flipping tail. The cow was delighted with him, and so were we.

Soon the calf was bigger and stronger than any of us. His legs were straight under his body and his eyes saw everything. Bong shut the cow out into the pasture and the calf stayed in his pen. At first the cow bawled furiously and the calf bawled back, but we went to pet and play with him and he was happy, so the old cow nodded her way off to the far corner of the field where the grass grew best. Bong taught the calf to drink out of a bucket. The calf was clumsy and slobbery over learning, and made Bong so mad his pigtail shook loose; he unwound it and rebound the

long plaited silk end tight round his head. His clean apron was all spoiled and he said, "Calf velly much bad!"

We loved the calf; he followed us all round the yard. He had toothache in his head where he was cutting horns, and butted us to make us rub the hard knobs. When he was a quarter as big as his mother, he disappeared. We had played with him before our walk—when we came back he was gone. Somebody must have left a gate open. Everyone said they had not. Bigger looked so wise that, if she had not been so dreadfully good, one might have suspected. Middle looked worried and uncertain. Dick was too little to reach the hoop over the top of the gate. We were very unhappy, not only for the calf, but because Father was so fearfully severe about gates, and we dreaded the time when he would come home. The extraordinary thing was that neither Mother, Bong, nor the Elder (who was our grown-up sister) seemed upset about the calf, nor at all disturbed at what somebody was going to get when Father came home. Bong sang his usual song to the cow as he milked. He cleaned out the calf's pen and shut the door. Nothing happened. When Father came, he took his tools and went to the garden as usual.

Three or four days passed; we had half forgotten to wonder, and Doctor Reid was asked to dinner. The Doctor's graces were just as long as his church prayers, and his *s*'s sizzled just the same. Of course he was helped first—he told so many stories that dinner got on very slowly. If the girls had a great many home lessons they kept a book in their lap and learned out of it when Doctor Reid came to dinner.

In the middle of Doctor Reid's funniest story he stopped. "Delicious veal, Mr. Carr!"

"Home-grown, Doctor. No butcher's skim-fed calves for me."

My knife and fork clattered into my plate. Mother looked up at the noise. "I think I am going to be sick, can I go?"

Out on the chopping block I took my head in my hands.

"Feel better?" asked Middle.

"Worse."

"Well, Small," said Bigger, "you know we have not had permission to go to the cherry tree, they are still very green."

"'Tisn't cherries. It's two disgusting things I've found out."

"Uh-huh," sighed Middle, "sulphur and treacle! It's time, I s'pose; always happens this time of year."

"It isn't sulphur and treacle, it isn't cherries, girls, it's veal is calf, and our father is a cannibal!"

"You wicked, wicked child! Meat is different to people. What did you think meat was?" said Bigger.

"Stuff sold by butchers, like bakers sell loaves. Did you know we were eating our calf, Bigger?"

"I guessed."

"Did you know, Middle?"

"I knew veal *was* calf, but I did not think it was our calf."

Still feeling queer about the knees and middle, I got up.

"Where are you going?"

"To steal Father's best cabbage for the cow. I'll throw it—I couldn't bear to go into her stall, she has such a big sniff. If she smelled her calf on my breath—oh, girls!"

❧ THE CURLY COAT ❧

MOTHER HAD A LONG coat of black astrakhan. It was too bad that whenever the weather was cold enough for Mother to wear that coat it was too cold for her to be out, because she was ill. So the coat hung in the cupboard, limp and empty.

One winter Bigger and Middle grew so fast and wore their winter coats so hard that when it came time to hand them down they were too dilapidated even for me. My old coat split too, because I was fat. There was too little winter left to buy another coat that year which I would outgrow during the summer. So Mother took the curly coat and cut it down to fit me. She put a pretty new lining in for fear I'd feel bad about having to wear a grown-up's cut-down coat—but I was proud. It was a splendid coat. No other girl in school had such a curly lovely material. I saw them run fingers down it as it hung on the cloakroom peg, caressing it as if it were a puppy, offering to hold it while I got in. I felt like Father, who always had his coat held while he put his arms in the sleeves. I put my arms in slowly so that all the girls should have a chance to see the pretty lining while it was being held.

I finished the winter out proudly. There were ever so many coats like Bigger's and Middle's, but none like mine. There was

one peg a little apart from the others and I hung my coat on that. I said to myself, "My coat is so good it will never wear out. I hope it won't finish till I am quite grown up, then I won't have to wear out any more of Bigger's and Middle's."

Spring came and so did spring clothes. Sometimes I would think, "How splendid it will be when winter comes and I can snuggle down into the curls of my winter coat!" But next winter the style changed, all the girls came to school in short jackets. Bigger and Middle had them too. I felt as dowdy as a fox terrier whose tail has not been docked. I hated the curly coat, which came to the bottom of my skirt.

One day I put on the coat, got Mother's shears, stood on a chair in front of the mirror, and chawed the scissors through the curls all round my middle. As I twisted, the shears zig-zagged. It looked terrible. The skirt of my coat fell to the floor just as Mother came into the room. I said, "Oh!"—trying to sound ordinary. "Nobody wears tails this year, Mother."

"So this snake-fence effect is the style, is it?"

My face burned and I looked down at all the black curls round my feet. I cried, "What'll I do? Oh, what?"

"Wear it."

"Everybody'd laugh, I couldn't!"

"Sew the tail on again, then."

"Couldn't I wear my summer coat with a jersey underneath?"

"No."

I sewed the tail on; but, though I pressed and pressed, there was a hideous lumpy ridge round my waist and the curls twisted all ways. Going to school, I lagged so nobody would be walking up Fort Street Hill behind me. I carried all sorts of unnecessary books to school in my arms so that my waist would not show. I

tried to persuade Bigger and Middle, "Let's have fun and walk Chinaman-way—one behind the other." (If the front and back were hid the sides did not seem so dreadful.) But Bigger said, "We are not Chinamen but young ladies and must walk as such." I was angry—wouldn't keep step for that, but dropped behind and got late marks on my report. That was more trouble. Wasn't I glad when spring came and Mother told me to hang the curly coat on the back of the store-room door.

I had two summer coats—Bigger's and Middle's of last year. They were tidy, careful children and kept their clothes nice.

All that summer I hadn't one trouble; then came winter and Mother said, "Winter has broken suddenly before I have prepared. Fetch out your curly coat."

It was not there, it was not anywhere. Everyone looked, everyone waited for me to confess; Bigger had ever so many texts to fit. Nobody accused me, but they all made it plain that they were sorry I had not the courage to confess. It made me feel dirty. I really wished the miserable coat would turn up. I'd rather have worn it than the disgrace. Bigger and Middle got new coats, I had an old patched one—too tight. We got through winter.

At spring cleaning the drawers of a chest in the store-room were pulled right out to be brushed behind. Out fell piles and piles of chewed-up black curls and little bits of the pretty lining Mother had put into the curly coat. From the middle of it darted a mother rat and there were four little pink naked rats like sausages in the nest.

Mother called the cat and me at the same time, and mixed our names. Everyone stopped looking disgust at me, I felt as if I had had a bath. Mother bought me an *entirely* new coat, although the winter was half over.

❧ WAXWINGS ❧

THE WAXWING WAS A migrant, new to Victoria. Different varieties of birds were shyly following man as the country opened up. They shunned our deep dark forests, preferring the new-cleared land, the protection of barns, voices of humans, of cows, horses, and dogs. These sounds reassure birds in strange places. Back in the forests were hawks, owls, eagles. Our native birds (other than edible ones) did not know fear, nor about the guns that men carry.

A man neighbour knocked on our door. Under his arm he carried a gun.

"I ask permission to shoot in your field," he said to my sister. "There is a flock of waxwings just settled in the big cotton-poplar tree. I want a specimen to add to my collection of stuffed birds."

"Say no! Don't let him shoot! Don't let him!" I whispered behind my sister.

"Be quiet!" she bade me, pushing me away from the door, and gave the man permission to shoot.

"Bang!"

Again the man knocked at the door. Delight was in his face. From his hand, each bird dangling by a leg, swung a great bunch of blood-dabbled, feathered death.

"Wonderful luck! Brought down the whole flock. Two only got away—grape shot. Sixteen from which to choose my specimen. Taxidermy is my hobby."

"You beast! You murderer!"

My sister clapped a hand over my mouth before I could say more, pushed me into the pantry and shut the door on me; but not before I had seen the wounded breasts, blood-dripping beaks—blood the same colour as the strange red sealing-wax marking on each loose-flopped wing, the mark that gave waxwing his name.

"Look, look!" I screamed as the pantry door closed. "Look! The brute has not even killed decently!"

One lovely head, eyes fast glazing, raised itself from the lifeless bunch, looked at me.

It was an occasion for the riding whip. I had insulted a neighbour in my sister's house!

I went into the field and cried over the spilled blood and scattered feathers of the waxwings. "Crock" came to me there, all hops, flaps, throaty chortles of distress at my trouble. The destruction of his fellow birds was beyond the crow's comprehension. He could sense, though, the sorrow of the human he loved: that disturbed him.

WOO'S LIFE

I have not tried to write a book of funny monkey stories, the aimless, helter-skelter ways that appear to be common to monkeys. I have tried to show the apparent reaction of my particular monkey to domestic life and to humans and the reaction of humans and domestic creatures to Woo, my small Javanese who lived under close, loving observation in my home for thirteen of the fifteen years of her life.

❧ BUYING WOO ❧

THE PET SHOP owner thought the apex of her troubles was reached in the Customs; now that the shipment was cleared, the crates standing in the centre of the pet shop floor, she realized that this was not so—there were the monkeys! From the pile of boxes and cages on the floor came mews, squawks, grunts—protests of creatures travel-worn and restless. If a crate was quite still, things were bad.

Finches, canaries, love-birds, parrots, Siamese cats, squirrels, and, at the bottom of the pile, monkeys, gibbering, beating their fists upon the sides of crates demanding immediate release.

"You monks must wait," said the weary woman wondering how their bedlam was to be endured. "Your cage is not ready." However, as makeshift she rolled an empty barrel from some-where, nailed a heavy wire parrot cage over its top and manoeuvred the monkeys from crate to barrel. Two fair-sized monkeys rushed up into the cage, delighted with release from cramping dark, squeaking, thrusting hairy arms through the bars, grabbing hammer, nails, packets of bird-seed, the tail of a bantam rooster—anything that could be reached. I, waiting to buy bird-seed, saw a tiny little black face pop from the dark of

the barrel to be immediately pushed down by the heavy hind foot of one of the big monkeys. Time and again the little face, a tuft of surprised Kewpie hair peaked on the top of its baby head, tried to get a peep at its new environment, only to be forced back like a jack into its box.

The pathetic little face haunted me. Going to sleep I thought about it and in the night when I woke.

When morning came I went to the phone calling the pet shop.

"Is that tiny monkey boy or girl?"

"Girl."

Suddenly I wanted her—I wanted her *tremendously.* Of course, I wasn't going to buy a monkey, but I asked, "What is her price?" My voice went squeaky with wanting. The woman understood: she had heard that "wanting squeak" before.

"Buy her. She is a *very* nice monkey and the big ones bully her."

"But my family! If I paid so much money for a monkey!"

"Listen, everyone is entitled to some fun. Would you consider even trade for one of your griffon pups?" (She knew my kennel.)

Good luck forever to that understanding woman! The deal was made. She would sell a "griff" quicker than a monk.

Pearl, my kitchen maid, loved animals as I did. I told her first.

"A real monkey, glory be! How soon can I fetch it?" Within an hour Pearl was racing down the street carrying a small parrot's travelling cage and bursting with excitement.

I heard them coming up the stairs just as we sat down to lunch—my sister Lizzie, a man whom we boarded, and I. Pearl's face was absolutely apoplectic. She placed the cage upon the floor.

Dead silence! My sister's eyes popped like a Peke dog's.

"Woo!" announced a plaintive voice from the cage. "Woo, woo, woo!"

"Your new niece, Lizzie!" I said, brave in the knowledge that my home was my own, yet half scared of family criticism.

My sister pushed aside her soup. "Milly! I never, never, *never* thought a relative of mine would sink to a-a-a baboon!"

The boarder's lips always leaked when he ate soup. In the intensity of his stare he entirely forgot his serviette. Soup splashed from his spoon back into his plate, plop!

"Er, er, er, er!" (Ordinarily he said "Er" only twice to climb to each sentence.)

"Er—er—er—er it's a monkey!"

The monkey decided to investigate us. Sticking one hand and one foot out of each side of the narrow cage she propelled herself across the floor. A walking cage looked so comical that a laugh even squeezed out of Lizzie—she cut it short with, "How much did you pay for the preposterous creature?"

"Even trade for a griffon pup."

"A griffon! The idea!"

You'd have thought that I had traded a diamond necklace for an apple, though Lizzie always *pretended* to despise my little dogs.

"Your house will smell! Everything in it will be smashed! Your friends will drop away—who wants to 'hobnob' with a monkey!" This awful fate trailed back at me as sister Lizzie rushed down my stair returning to her own chaste house and leaving me to contemplate the wreck I had made of my life.

The boarder, who set great store on the "griffon dogs," groaned, "Er—er, a griffon for a monkey!" and went off to his office.

Pearl and I sat on the floor thrilled by the absorbing strangeness of our new creature.

My sister Alice took the first opportunity to come from her house round the corner to inspect my new queerness.

"Everyone to his own taste," she shrugged. "Monkeys are *not* mine."

SO WOO WAS INTRODUCED to my sisters and took her place in our family circle, no more a commercial commodity, but an element pertaining to the family life of the three Carr sisters.

Pearl and I spent that afternoon nibbling around the edge of something unknown to us. I had tamed squirrels, crows, coons, even a vulture—these creatures, like myself, were northern bred. This lightning-quick, temperamental, tropical thing belonged to a different country, different zone, different hemisphere. We were ignorant as to what liberties we dare take. If thwarted, Woo opened her mouth, exhibiting magnificent jaws of strong white teeth, jaws so wide-hinged that you could see her wisdoms (if she had any) and right down her throat. The boarder asked nervously, "Er—er—was it King Something or his son that died of monkey bite?"

I put the monkey into a large parrot cage. She snatched ungraciously all that we offered, food or play-things, grimacing back at us. When night fell she began to miss the warmth of the other monkeys, for though they had tormented her by day, they had been willing to pool cuddles at night. "Woo, woo, woo," she cried, and could find no comfort in the hot brick I offered or in Pearl's old sweater or in the boarder's third-best hat.

"Er—er—tell her to curl up in the hat. Er—er—it's a good hat."

He said this as if I were a monkey interpreter. But I had no monkey word to comfort the lonely little beast other than to repeat her own sad wailing, "Woo, woo, woo."

I had intended to call my monkey Jemima, but she named herself Woo that first night and Woo she remained for life.

Near midnight, she rolled herself up in Pearl's sweater and slept. I turned out the light, tiptoed from the room. A jungle stranger had possession of the studio.

Even restricted in a cage she was a foreign, undomestic note in my humdrum house!

There was a small collar on Woo's neck when I bought her. She had never known the pull of a chain. Any restraint, any touch of her collar infuriated her. By keeping a few links of chain always suspended from her neck I soon accustomed her to lead. Then I could take her into the garden.

Woo was teachable. Before I had owned her a week she got away from her chain in the garden.

"Goodbye, Woo!"

I was sad. I thought, of course, she would make for the woods in the Park nearby. No, Woo dashed up my stair, sat waiting on the mat to be let in. She had accepted the studio as her home. That quick response of love and trust entirely won me.

❧ THE HOUSE ❧

I OWNED A SMALL apartment house, living myself in one of the suites. My suite had a large studio with a long stair down to my garden. The small garden in front was for tenants. The big garden behind was mine. Behind it again were yards and my kennel of griffon dogs. Being a landlady was never agreeable to me, but having a kennel of griffons was joy.

When my tenants heard that I had acquired a monkey they looked at one another.

"It will smell," announced Mrs. Smith.

"It will run amuck—destroy," asserted Mrs. Jones.

"Screech and bite!" said Mrs. Robinson. They waited and watched, and none gave notice. In the thirteen years Woo lived in my apartment house, no tenant ever had reason to complain about Woo. An old lady rose from her bed at three one morning, groped her way to the basement because she heard the monkey cry out. I was away once and a man tenant sat on Woo's basement wood-pile daily.

"She was lonesome," he said.

Ladies donated small mirrors from old vanity-cases, cherries, grapes, candies—monkey-loved dainties. Woo found her way to

all hearts—merry, unexpected Woo! Her quick actions, her unpredictable quality attracted people. Woo wove herself into the atmosphere of 646 Simcoe Street, accepting attention with regal indifference.

As soon as Woo became used to her chain, I led her down to the dog yard to meet my griffons. The rush of dogs checked when they saw her. Woo scrambled to my shoulder screeching. The dogs stood circled in amazement at this queerness clinging to my collar with almost human hands! Dog noses wiggled at her foreign scent. They resented her cling to me. Woo gripped my collar with a foot, leaving both her hands free to beat at the dogs. They kept their distance—she had to content herself by making grimaces at them. Then she saw the earth and scrambled down in an ecstasy of joy, feeling, smelling, tasting the delight of soil and grass after cage confinement! She turned the stones over and found earwigs and beetles, crunched them with keen relish—dogs were forgotten. I chained her to the fence while I did kennel chores.

When the monkey's appetite for insects was sated, she sat down and looked about her. The dogs, attending to their own affairs, had forgotten her and tumbled over each other in play. Woo, watching, felt lonely, isolated. She stretched out a tiny black-palmed hand and with careful precision selected a young dog of about her own size, caught his stubby tail in both her hands and dragged the surprised pup to her side. A smart twist and she had turned him right about, loosing her grip on his tail to seize his whiskers. Levelling her eyes to his, Woo stared straight into them, mouth open, eyes glaring. The pup did not flinch but gave her stare for stare. The human grip of those hairy little hands made an impression. The pup (Ginger Pop) sat down beside Woo. She let go of his whiskers and began to attend to his

coat, parting the hair, combing it through her fingers, searching among it for tiny flakes of skin that have a salty taste. (It is for these that monkeys are always searching, not, as is generally supposed, for fleas.) Ginger Pop loved the feel of her gentle hands. From that day he and Woo were inseparable companions, romping and playing like a couple of puppies. The rest of the dogs Woo ignored and they kept at a respectful distance from her gripping fingers and nipping teeth.

❧ WOO'S APPEARANCE ❧

WOO WAS PROBABLY under two years old when I got her. Trim, alert, dainty, her actions were smart and quick, her coat shone with health—she kept her greeny-brown coat immaculate.

Woo's hazel eyes were set close together and shadowed by bushy brows growing on a prominent ridge of bone—brows which were capable of wide movement, jumping up on her forehead or scowling down over creamy white eyelids which she lowered if humans stared directly at her. Monkeys only give stare for stare when their anger is roused; then a blazing fury burns fiercely at their opponent. The whites of Woo's eyes were dark brown, the irises clear and golden. The palms of hands and feet smooth, soft and black. Her small pointed face was black with a long, flat nose, wide, thin nostrils dilating when she was angry or excited. A fluff of whisker trimmed each cheek. Clean-eyed, clean-nosed, clean-mouthed, Woo washed her face as a cat washes, but, instead of the inner side of a velvet paw, she used the back of a doubled-up fist as a wash rag. She was very neat about her hands, licking them, scolding at any grease or stickiness, using grass, leaves or pinafore to clean them on.

This reminds me of Woo's clothing. Monkeys are liable to T.B. in our climate. I wanted to keep Woo out in the open as long as possible. I decided, therefore, when she began to shiver that I must make Woo some clothes. My first attempt was a dress of soft blue flannel. I fashioned it like a doll's dress. Woo was no stuffed dummy. The moment my back was turned she ripped the flannel dress to shreds—nothing was left but the collar-band.

"Flannel is apparently unsuitable," I remarked to Pearl.

"You did not allow enough straddle."

Pearl was right. My next attempt was short—wide, as a ballet skirt. Made of stout tweed coating, it had short sleeves. Woo chewed the woollen material into holes, so I made little flaring red duck aprons that she could not rip. These, over her warm tweeds, were cosy. Bobbing around my garden, she looked like a poinsettia bloom. She chewed off all buttons, undid hooks. So I buckled her garments at neck and waist.

Crows and robins visiting my cherry tree found one scare-crow that was no sham. The cherries beyond reach were Woo's. She sat the tree top—a queen. Amazed crow, baffled robin sat on the fence consulting.

❧ WOO'S CALLS ❧

MY MONKEY'S CALLS were strange and varied. Each had special significance; each seemed to come from a different part of her—high-pitched whoop of pleasure, deep stomachy grunt of anger, coo of contentment, grating croak of alarm, chirrup of inquiry. For me alone she kept an affectionate lip-gibber, interwoven with a kissing sound and always accompanied by a grin. If I caught her in mischief she went through a series of swayings, writhings, and apologetic kissing, throwing down what she had stolen. If anyone else caught her she clung to her theft and showed teeth.

Woo came upstairs for part of every day. She had her own corner in my studio. The wall here was protected, for she loved to dig holes in plaster. Chained to a ring in the wall under an attic stairway she could reach my bedroom door which opened from the studio. She learned to open it by climbing up the post and clinging with her hands, then a large hind foot grasped and turned the door-knob.

The dresser was her delight; hand mirror, hair-pins, powder, combs, perfume, hair wash, pills—nothing eluded her investigation. Each article was scrutinized, then flung onto the floor while

Woo sat holding the hand mirror with her feet and her hands felt behind for the *other* monkey and her lips kissed and kissed.

THE PET SHOP LADY was going on holiday.

"My assistant is afraid of monkeys," she said. "My poor Mitsey!"

"Bring Mitsey to me. Woo will love a companion monkey."

Mitsey came to spend a week with Woo! The two little monkeys sat one on either end of a bench in front of the fire scowling furiously—Mitsey shy, Woo jealous, holding her Ginger Pop away from Mitsey. If he gave so much as a sniff toward Mitsey, Woo smacked him. The space on the bench between the monkeys narrowed and narrowed. At the end of an hour they were hugging, though Woo still held Ginger Pop gripped by one ear.

WOO'S CHERRY TREE was flowering. I dressed the two little monkey girls warmly and chained them in it. They played hide and seek among the blossoms. I took them to a beach and they fished in the rocky pools for crabs. They tossed stones, chewed sticks, chased sandhoppers. Yet, strange to say, Woo did not fret when Mitsey went away. The mirror monkey, Ginger Pop, myself satisfied the need for companionship.

Once a lady brought her two pet monkeys to my garden to visit Woo. The three monkeys screamed and sulked; there was anger and bedlam, beating fists, hate, grimaces. The lady pitied poor Woo having no monkey companions. My own belief is that Woo preferred the companionship and admiration of human beings. The friends Lizzie predicted were going to forsake me did not, nor did my house smell of monkey.

Monkey tempers are inflammable—so is mine. I would not have Woo teased! She was a sweet-tempered monkey. She nearly

cost me one friend but not quite. The woman despised Woo, and me for keeping her. She said a few hateful things. I ignored them and Woo ignored her.

Soon people accepted Woo as part of an artist's queer equipment. Some of Woo's stupid critics might well have learned, from my monkey, ingenuity, thoroughness. Woo's investigations were never superficial. Every object must be felt, smelt, tasted, pulled to pieces before her curiosity was satisfied. Only when she had completely wrecked a thing did she toss it away as having no more interest.

✁ THREE SISTERS ✁

THREE WOMEN COULD not be more different in temperament, likes, choice of friends than were the three Carr sisters. Each had her own house, interests, friends. Lizzie was a masseuse, Alice had a school, I was an artist.

When I acquired Woo, Lizzie protested, Alice shrugged, I gloated—Woo accepted both family and domesticity.

When evening came and the hum of our busy lives quieted, one or the other of the Carr sisters could be seen running across to visit the others. Our three houses were within a stone's throw. If the visiting sister was I, a taggle of dogs, a Persian cat, and the monkey followed.

The creatures loved this between-lights visiting. When first I got the monkey, my sisters sighed when they saw us coming.

"Must they all accompany you, Milly?"

I replied, "*Every one.* The creatures expect it."

Woo soon slipped into place, becoming a part of the habit, and no remark was made when she followed the dogs and me into my sisters' houses.

FIRST WE CAME TO Alice's school. It was set in a gravelled play-yard with garden beyond.

As my house abounded in bird and beast, so Alice's abounded in children. Her cottage sat like a wide, squat hen, and the hen in turn was brooded over by a great western maple. At this evening hour there would be a circle of children cheeping round the great open fire in the school room. Cribs full of sleeping cherubs were tucked away under the low-spread wing beyond. My sister "slept" and "ate" as well as taught children.

Alice's kitchen door always stuck, then burst open violently. There were squeals of, "Shut it, shut it!" while the griffons, the cat, the monkey, the wind, and I poured in.

For economy of space a porcelain bathtub was plumbed under Alice's kitchen table, the top hinged up. What with tub, cook-stove, sink, wood box, and cooking utensils, there was not an inch of spare room. A stool wedged itself between bathtub and door. On this dogs, cat, monkey, and I all piled, crushing ourselves under an overhanging china cupboard. Alice rubbed down one child before the cook-stove and the next one soaked. If the child in the tub was biggish, she let down the table-top so as to dim herself. There was space between the edge of the tub and the table-top for Woo to squeeze.

"Eek, eek, ow! Woo's drinking my bath!"

"Oooo—she's stolen my soap! She's tearing my washcloth!"

I pulled Woo out. Then my sister's big dog growled because Woo was after his bone. It was difficult to adjust all these troubles without treading on a child, a dog or the monkey's tail. Sweater sleeves and child-pyjamas whacked from the clothes-line strung

across the low ceiling. Alice was always calm. Monkey, dogs, children! The greatest of these were children. If *my* creatures amused *her* children Woo was all right. She always had some special treat—a candy or some cherries or grapes—in her cupboard for Woo. Monkeys might not be *her* choice but she was kind to mine. Woo regarded Alice as a goddess of eggs and bananas and loved her next best to me.

Once only I saw Woo angry with Alice: in the crowded kitchen Alice trod on her tail. In a fury the monkey grabbed the strings of Alice's apron, hoping that they were as sensitive as her own tail. Woo tugged and squealed; for the moment the goddess of eggs and bananas was dethroned.

Every Christmas Alice filled a child's sock and hung it with the children's for Woo. The children screamed with delight watching Woo unpack, appraise her presents. She chewed a hole opposite each object in the sock and pulled out the goody, scrutinizing, smelling, licking, tossing it away with a grunt of scorn if it did not please her.

IT WAS QUITE DARK night when we passed through the gardens which linked my sisters' places and came to Lizzie's house.

"All wipe your feet!" Lizzie shouted.

No house ever shone as Lizzie's did. Every moving object cavorted in the shine of her piano and in the brass coal-scuttle, copper kettle, andirons, and fender. Woo was in her element, kissing the reflected Woos, cooing and jibbering to them.

"Milly, don't let her slobber over everything!"

Lizzie got a spotless duster out of a little bag and erased Woo's kisses.

"Here, Woo, sit on this nice stool."

Woo scorned the wooden stool that the black-bottomed kettle sat on. She rolled over on Lizzie's blue rug, warming her tummy in front of the fire. She knew that Lizzie was a little afraid of her. She was a little afraid of Lizzie too, but flaunted indifference, bravely shaking the edge of Lizzie's snowy apron till the starch rattled, staring Lizzie in the eye and showing every tooth.

"Nasty little beast," scowled Lizzie and bowed as beneath a cross. Woo was one of life's chastisings. Lizzie was pious—chastening thrilled her. It amazed and pained her that one of her family could have chosen a pet so incomprehensible as a monkey. Artists she supposed *were* queer, but owning monkeys out-topped every other queerness.

The walls of Lizzie's room were smothered with neatly framed good-behaviour recipes and with photographs of missionaries dead and living—missionaries bestowing Bibles upon naked heathen, missionaries dashing up raging rivers in war canoes to dispense Epsom salts and hymn books to Indians, missionaries seated under umbrellas taming Hottentots. Of course, one did not *have* to look at the photographs, but when, as so often happened, a missionary sat in his flesh and blood before Lizzie's sitting-room fire, that was different. Female missionaries drew their skirts up to their necks and shrieked as if Woo were a reptile. Male missionaries usually quoted texts about the devil, as if there was some connection.

If they had been invited to tea they stuck it out; otherwise they hastily left, unless they saw that Woo and I were making a quick get-away, which we usually did to relieve my sister's embarrassment.

What with massage, missionaries, and good works, Lizzie was a busy woman and a good one. She never left you in doubt about

your shortcomings, but was always the first to rush to your help in trouble. She did *not* flatter us to our faces; but the dogs and I—and soon too the monkey—knew that she was the Carr family's backbone in time of trouble.

I BEGAN TO NOTICE that Lizzie was watching the monkey closer and closer, asking questions about her. I realized that Lizzie was using Woo in her work, hoarding Woo's funniness to amuse some small patient under painful or tedious treatment, using her, too, to win a smile from some weary, bedridden old soul who had nothing but a ceiling to look at and no fun in her mind at all. Lizzie would say, "Milly, take the monkey to visit old Mrs. So-and-So. Woo will while away a weary hour for her."

Yes, in spite of their avowed aversion to monkeys in general, my sisters were *using* mine—one to cheer patients, the other to amuse children. Unsuspecting little Woo had a place to fill in the Carr family, a part to play in the big thing that is called life.

✎ MY GARDEN ✎

FOR THE TENANTS there was the small front garden. The back garden was for me and my creatures. I had created it from a hummocky, wild lot—built my apartment house so that the windows of tenants did not overlook me. Tenants' wash-lines *did* have to roll, high out over my lawn, but the Smiths, Joneses, and Robinsons did not have to occupy their undies while they flapped over my head.

In my garden were fruit trees and lilac, great eastern poppies, lavender, daffodils, jasmine, hollyhocks, fox-gloves—all the homely old flowers. The lawn was comfortable, with seats and hammock. Beyond the garden were the kennels and yards of my griffon dogs. When I sat in my garden the dogs and monkey rolled and played on the grass about me.

In the centre of the lawn stood a big cherry tree. When Woo came to live with me she took possession of a little shelter box I put in the tree. Woo thought herself queen of the gardens, which she was, and the hub around which life in our garden moved. When visitors came there to see me, they went direct to Woo's tree as people entering a room go straight to an open fire. Even those people who disliked monkeys demonstrated that Woo was

the most vital spot in my garden. The human-shaped hands obeying a monkey brain differed from the vague scraping paws of a dog. Ability to cling, to hold, to pick things up, the neatness and precision of those strong slender little fingers, perplexed the dogs, amazed people. Even Woo herself appeared to be surprised at her own hands, holding them up, looking at them intently. Nothing so delighted her as for me to play "This little pig went to market" with her fingers and toes. She held up first one hand and then the other, watching the pigs being told, thrust out one and then the other of her large, flat feet with short, wide spread of thumb and sat absolutely still and absorbed, listening. When the game was finished she rolled the furry backs of her hands uppermost, looking at them seriously, then at their smooth black palms—well washed, always clean. Her hands were not cold and clammy like most monkeys' but powerful, warm little hands. Often at night I went to her sleeping-box and took one of the soft, warm little fists cuddled under her chin in my hand. She looked at me with sleepy eyes, yawned, murmured, "Woo, woo."

❧ WINTER QUARTERS ❧

WOO'S WINTER QUARTERS were in my furnace room. She had two sunny windows; a narrow lawn lay between them and the street. People walked up Simcoe when they went to the Park, especially to see Woo in her window—not children only. A war cripple whom my sister massaged told Lizzie, "I come down Simcoe Street because of a jolly little monkey in a window there." A cranky old woman who was walked daily by two elderly spinster daughters, coy as Woo, always paused to commiserate with "the poor little captive!" Children begged, "This way, please, Gran, so we can see the monkey." Woo grimaced at them all. She loved admiration, but pretended to respond with *blasé* indifference.

When summer came I moved Woo into a garden shed at the back to sleep. She sat in her cherry tree all day. Her street audience were angry. They said, "Is the monkey dead?"

"No, I have moved her to the back garden for the summer." Muttering something sour, of which I heard "selfish, greedy," they stalked by my house, morosely glowering at Woo's empty window.

Woo was no more than eighteen inches high when she stood upright, not twelve when she sat with her spine hooped monkey-wise. Yet this little bundle of activity wedged herself into the

consciousness of the entire neighbourhood. I, twenty times her size, owner of an apartment house, payer of taxes, did not make such an imprint on my locality as my monkey did. In *every* house was a human not unlike me. No other house in the district had a monkey. My house was known as the "monkey-house."

Woo loved summer quarters; her sleeping-box was nailed to the shed wall. She could open and shut the door of her shed at will. She tore shingles off the roof, smashed her drinking cup through the window, undermined the foundations, ripped boards off the floor hunting for earwigs. No dog except her beloved Ginger Pop was allowed to enter her shed, no cat, no fowl whatsoever, no human being but me. My sisters tried it once—this is what happened:

I was ill, tucked in bed down at Lizzie's house. Lizzie loved to fuss over sick people, even cheerfully accepting care of furnace, beasts, and tenants as part of your cure.

She returned from doing my evening chores. "That evil creature has ripped the woollies from her sleeping-box and she will not let me go into her shed to tack them up again! What shall I do?"

"Let her sleep cold."

"No, Milly, no! Woo is tropical," protested my sister. "She will surely take a chill. Oh, dear! If only the beast hadn't such rows and rows of teeth when she is mad!"

"I'll tackle her—Woo likes me," boasted Alice and sailed forth armed with banana, egg, and candy.

Alice did not come back. Dark came. Lizzie was about to make a trip of investigation when Alice came in pink and riled. "Huh! A monkey's prisoner! Never thought I would be that!"

"What happened?"

"Woo grabbed the banana—while she was eating it I went into her house. The creature shut the door on me, held it fast,

making evil faces if I tried to open it. I wondered how long it would be before anyone missed me—and my children waiting for their tea, the poor little things!"

"How did you get out?"

"Candy in my pocket. I pushed the door a crack open and flung the candy wide—Woo tore—I bolted. Children hungry because of the senseless whim of a gibberer! Milly, why must you..."

We all laughed. Nobody *could* really hate that merry creature Woo; her pranks warmed our spinster middle-aged lives.

❧ MRS. PINKER'S VISIT ❧

WOO HAD NOT BEEN with me long when Lizzie said, "Mrs. Pinker is coming to town. She wants to stay at your house, but she hates monkeys."

"Too bad for Mrs. Pinker!"

"Are you going to let a monkey ruin your business?"

"Love me, love my monk."

Mrs. Pinker came.

"I hear there is a monkey in the house! I don't like monkeys— disgusting, smelly! Saw enough of them in that hotel in Madeira! Impossible! . . . The loathsome creature owned by Lady Melville, the Duchess of Whitewater's horrible 'ringtail'!"

"How came the management to allow it?"

"Titles and tips, my dear."

Mrs. Pinker liked my house. She enjoyed the big studio's great window, open fire, dogs, cats, parrots.

Sometimes I said, "Why sit in that straight, hard chair, Mrs. Pinker?"

"The little people" (meaning dogs and cats) "have the 'easies,'" she replied.

"Nonsense! Creatures readjust themselves easily," and I would tap the beasts onto the hearth rug; Mrs. Pinker thought me cruel.

During Mrs. Pinker's visit I kept Woo below. Her Ginger Pop was in the basement to keep her company.

"Where is this monkey?" asked Mrs. Pinker peevishly.

"In the basement with Ginger Pop."

"I won't have the creature banished because of me! Bring her up."

"Woo is all right down there."

"Bring her up!"

Woo dashed into the studio, took her favourite place by the fire. When she saw a stranger, she made a face and let out a squeal immediately, conscious of Mrs. Pinker's antipathy.

"So!" said the old lady. "You do not like me, eh, Woo?"

Woo spied Mrs. Pinker's ball of knitting wool and made a grab.

"No! No!" protested Mrs. Pinker.

Woo hugged the wool ball and gibbered.

"Drop it, Woo."

The monkey grinned at me and threw the wool down. Mrs. Pinker stooped to pick it up. Woo gave her hand a stinging slap. The old lady rubbed her hand thoughtfully. She began to knit.

I chained Woo in her corner. Ginger Pop went to sit beside her. Soon they were scuffling in play like two kittens. Mrs. Pinker put aside her knitting. Tears of laughter ran down her cheeks as she watched the two fool each other. I had never heard Mrs. Pinker laugh so hard as when Woo, stealing my handkerchief, polished Ginger's nose with it.

Mrs. Pinker requested that Woo be brought up each day.

"But you hate monkeys, Mrs. Pinker."

"Well, I like to laugh."

Next thing I knew, Mrs. Pinker was knitting a diminutive woollen sweater.

"It would be best for you to do the measuring and fitting, my dear," she said. "I wish it were not so sombre a colour...very good wool—same that I made a sweater for my son of. It will be cosy for Woo's winter walks."

After the sweater was finished Woo went walking with the dogs and me. Mrs. Pinker was dissatisfied. She went to town and returned with bright scarlet wool.

"Far more becoming," she said, holding it against Woo's green-grey fur. So Woo got two sweaters.

I went sketching in the Park. I took Woo in her scarlet sweater and chained her to a tree while I worked. When I came to loose her a tiny scarlet sweater hung empty on the tree top. Woo lay flat along a willow bow almost the exact colour of her own fur. I never told Mrs. Pinker. (I am convinced that, especially in strange environments, monkeys select a background as near to their own colour as possible.)

Mrs. Pinker was ill. The doctor came. As he passed through the studio, he saw Woo.

"Oh, a little monkey! I shall make her acquaintance on my way out."

The monkey jumped to the doctor's knee, interested in the shiny clasp of his bag. He showed her his torch, spent a half-hour trying to teach her how to turn it on. Woo was stupid, would not learn, was furious when he took it away, opening her mouth, staring him in the eye, jerking her head this way and that, slapping at him.

"Woo," said the doctor, "if all patients would open their mouths to that extent, it would put the X-ray out of business."

"What was the doctor doing so long in the studio?" asked Mrs. Pinker.

"Playing with the monkey."

Mrs. Pinker was peeved. "Ten minutes for the old lady, half an hour for Miss Woo!... Huh!" She twitched the bedclothes over her shoulder, turned her face to the wall.

❧ MATERNITY ❧

WOO WAS A NATURAL mother. Sisterhood did not appeal to her. Ordinarily she ignored the griffon ladies but, let one of them have a litter of pups, and Woo was all coax—begging to share.

Cooing to the side of the box, pleading for just one peep— presently her hand would steal over to touch a pup. The mother dog growled, snapped!

When the pups grew and the mother left the box more, Woo, watching her chance, crept in and drew the pups close, cuddling, crooning, gibbering, kissing as she kissed me or kissed herself in the mirror. When the mother dog returned Woo would not give the puppies up. The dog then would come whimpering to me for help. It was the same with the old yard cat's kittens. Woo clutched them to her with ecstatic hugs, ignoring the spitting mother cat.

"It's a shame," I said, and went to Vancouver to talk with the keeper of the monkey house in Stanley Park.

Lizzie looked after my creatures and the furnace in my absence. I returned to meet a furious, purple-in-the-face Lizzie coming out of the basement, picking gobs of sopped bread out of her carefully arranged grey hair. Milk trickled down her cheek.

"Abominable brute!" she exploded. "I stooped to feed the furnace; she crept along the pipe and deliberately emptied her food cup into my hair!"

I offered soothing and appropriate apologies. "Won't your little patients enjoy that," I said.

"Huh! How did you get on in Vancouver?"

"The keeper says monkey-breeding in captivity is very risky; often the mother, the baby or both die."

"Then don't risk it, Milly; don't! Let well enough alone."

So Woo had to cramp her maternal affection into loving other creatures' babies. She handled the pups and kittens so tenderly that the mothers gave up protesting, and Woo philosophically accepted adopting in place of bearing.

⚘ WOO AND LIZZIE ⚘

LIZZIE WAS DRESSING for work in frantic haste. Her fresh uniform lay upon the bed awaiting the mother-of-pearl links she had removed for its washing. They sparkled on the dressing table and caught Woo's eye.

Lizzie said, "Put those links in my dress, Milly," but before I could reach them they were in Woo's mouth.

"Oh! Oh! She's swallowed my links!" screamed Lizzie. "They are in her stomach. I am late now. How can I go gaping? Oh! Oh!"

"They have not got as far as her stomach yet. I can see the shape of the links through the thin skin of her cheek pouch. Open up, Woo!"

The monkey grinned at me, gibbered. I took her paws in my hand, put my finger under her tongue and fished out the links.

"Ugh!" Lizzie dropped them into the water-jug. "Ugh! Monkeys!"

The links plopped and gurgled. Lizzie rushed them into her uniform. Lizzie and Woo ignited each other, both were quick and peppery.

LIZZIE SUPPED WITH me on Sunday nights. I always brought Woo upstairs. In spite of their spats they amused each other.

I heard, "Spit them out, spit them out, Woo!"

I came running. A little grey packet that had been full of carpet tacks was empty. Woo's mouth was so crammed she couldn't even gibber. I rescued all the tacks I could, but the monkey showed great distress—so did Lizzie.

"Foolish beast!"—then, "Poor Woo, poor, poor Woo! Do they hurt your throat?"

I ran my finger round behind Woo's tongue. No tacks. The monkey took my finger, pressed it to her gum. I felt a sharp prick—a splinter of bone was wedged between her teeth. I pried it out. Woo was most interested. She held my hand and scrutinized the splinter.

"That monkey is smart, Milly, taking your finger and putting it on the prick. A bad, bad monkey—clever though."

⚒ WOO'S ENEMIES ⚒

OF COURSE WOO had enemies. The cackling laugh of the parrot, Jane, crazed her. The fact that both were tropical creatures did not link them. It was the human peculiarities of each which annoyed the other. The parrot's words fooled the monkey; Woo's grasping hands enraged the bird—hands that stole food out of the parrot's cage and wrenched feathers from her tail. The hate between parrot and monkey was bitter.

Woo's other enemy was Adolphus, the big grey Persian cat whose dignity enraged Woo. She tore a fistful of silver hair from Dolf every chance she got. Dolf let her feel the barbs under his velvet paw. He spat, hissed, struck. His slaps were less hefty than Woo's but they ripped. Woo teased Dolf by pulling the cushion from under the old cat, drinking up his milk.

When Ginger Pop became adult there were triangle affairs in the kennels. Koko resented young Ginger. Each dog fought hoping to kill. Koko had advantage of weight, Ginger of youth. Anger rattled grimly. Woo championed Ginger Pop. Screaming like a mad thing she rushed into the swirl of battle and held on to Koko's stump of tail with both hands, tugging with all her strength to pull him off Ginger. She beat him, bit his heels. All

three combatants screamed. I rescued Ginger who was very small and came off worst. Woo attended to Koko. Sitting square in front of him, taking firm hold of his whiskers, she grimaced in his face, shook, cuffed the old dog giddy, and so abashed him that he shrunk off and hid. Koko never rounded on Woo; he treated her with the same tolerance with which he treated his kennel ladies.

� MONKEY LOVE ✖

THAT THE MONKEY loved me I could not doubt. She did not show her love for me in the same way that she showed it for Ginger Pop. He, an animal, was in her own class; I, a human, was something else. Under human gaze Woo assumed false behaviour, became self-conscious. She sensed the superiority, the amusement a human feels towards a monkey, a giggling, stupid human, retreating if Woo looked, stretched a hand towards him. He said, "Horribly human! Disgusting little beast! Perhaps there is a half-brain behind those grasping, holding paws!" rating the monkey as a degenerate branch of the human race instead of an intelligent animal.

If I had been away from Woo even a short while, and she heard my returning footsteps half a block away, she gave high-pitched whoops of delight. Yet, when I came close, she looked the other way or became absorbed in an earwig, not rubbing against me like a pleased cat, nor jumping up like a glad dog, gazing over my head at any object rather than at me. Yet I could feel her quiver of awareness and delight that I was near. For Woo I embodied love, food, warmth, and protection. Frightened, she rushed to me and

clung; hurt or sick, she wholly abandoned herself to my care; in strange places she wanted to hold onto one of my fingers; caught red-handed in some mischief, she rocked herself back and forwards, mouthing and grinning apologetically—a dear grin which Woo kept for me exclusively.

❧ THE FOX FUR ❧

WOO'S RAGES SPLUTTERED up and went out like struck matches. Open angry jaws, spread nostrils, clutching fingers, jerking head, grunts! Next moment, all forgotten.

Woo was intensely loyal to the few she loved.

I saw this loyalty put to severe test once.

A visitor to the studio loosed the fox fur she wore and bounced it at Woo. Terrified, the monkey screamed and rushed under the sofa. Ginger dashed to see what was wrong with his chum. The visitor pinched the white fox onto Ginger's stumpy tail. The pinch, the glassy stare of its eyes, the persistent following of the dangling fur crazed the dog; he dashed around the studio. With a scream of regular jungle rage Woo bounced from her hiding. She forgot her own fear in rushing to rescue Ginger, biting, tearing at the fox, at its stupid false head and dangling feet. Now it was the visitor's turn to yell and rescue her neck-piece.

MANY ARTISTS FROM Seattle visited my studio—professors, art teachers in the University of Washington—often spending weekends. It amused these staid educators to stay in a house in which

there was a live monkey. First thing they asked was, "How is the monkey? Do bring her up to the studio."

These visitors loved beach picnics and they always wanted to include Woo. They knew Woo was as keen a picnicker as any of us. Sitting on a log with her skirts tucked demurely round her, the monkey accepted her share of the food gently and graciously, drank milk from her own tin cup, suddenly hurling the cup away. A wave of wild beast possessed her. With a crazy screech and a flutter of domestic petticoats, she would skim across sand and drift. Who knows but some old, scarred log, after bobbing across the seas from Java and beaching high and dry in British Columbia, had spoken to Woo, had set some hereditary thrill quivering through this little Javanese. Ginger Pop would trot after Woo. When she had worked off a little steam she sat down and Ginger sat beside her.

"Woo, woo"—the pair returned to our picnic. Woo contentedly played, tossing stones; the little dog watched gravely.

ON THE GRASSY slope of Beacon Hill I saw a comical sight: two dignified professors down on their hands and knees stalking grasshoppers to please the appetite of a diminutive scarlet-aproned monkey.

"Here's a beauty! Woo!"

"No, take mine: my hopper is the fattest."

The imperious Woo grabbed a hopper in each hand. Munch! Munch! "Woo," she said. "Woo, woo."

The professors dusted their learned knees, pleased that their offering had been accepted. I snapped Woo's chain to Ginger's collar and, coupled together, dog and monkey raced home, unled, the professors and I demurely following.

❧ CANADIAN CLUB LECTURE ❧

OUTSIDE, EVERYTHING DRIPPED; inside all gloomed. The monkey's scarlet apron was the only gay spot this grey day. She sat warming spread toes in front of the studio fire. Ginger was alert for play, but Woo was pensive.

The telephone whizzed, "May I bring a stranger to your studio?"

"Artist?"

"No, writer."

"Sure, come on!"

The stranger, a woman, asked me to show her some pictures. They interested her.

"Tell me," she said, "why have I not heard of your work? I have been in Victoria for months and I have enquired repeatedly, 'Are there no artists?'"

"Victoria hates my painting. She resents the more modern way of seeing that I learned in Paris. No place is more conservative in art than Victoria."

"Have you given Victorians a fair chance to see it?"

"No. The few who come to my studio are so depressingly antagonistic—ridicule, loathe it. I don't care whether it pleases them or not. I am not changing back fifty years to please them!"

"Well, Victorians are going to see it now. I am going to rub their noses on canvases whether they like it or not and you are going to give a talk on the newer way of seeing—give it before the Women's Canadian Club!"

"I couldn't! Oh, I couldn't!"

But within a week I found myself booked to give that talk plus an exhibition. Alarming ordeal! No wonder my watch on Woo was slack. While I scribbled notes a stealthy foot stole towards my paint-box, a firm supple tail whipped the large tube of yellow paint towards her foot, her foot gave it into her hand—silent bliss.

I glanced up from writing. "Woo! Woo!" Monkey, rug, and bench were yellow as daffodils; the torn tube lay empty. Woo was obviously beginning to feel very ill.

My talk flew to the four winds. All day I hung over my monkey. I washed inside as far down as I could reach with gasoline rags. I gave emetics and physic. Woo submitted, pocketed the physic in her cheeks and spat it out later. She lay across a hot bottle in my lap.

The veterinary said, "No good my coming out. She would not permit a stranger to handle her. You have done all there is to do. If she lives through the night she'll make it—very, very doubtful!"

The sponsor of my talk rang up.

"How goes the talk?"

"Gone! The monkey's dying."

"You can't let me down! All arrangements made—day after tomorrow. You couldn't!"

"If Woo dies, I shan't talk!"

My sponsor had enlisted the help of a Dutch artist to hang the exhibition.

He phoned, "Dis talk, she is ready? De picture, she ready too? Tomorrow I hang."

"No exhibition—no talk—my monkey is dying!"

"So? What ails leetle monkey?"

"A whole tube of aurioline yellow."

"Dat monkey, she eat?"

"Yes."

"Bad, ver', ver' bad. Yellow most poisonest of all paint. Leetle monkey die for sure—too bad!"

"Goodbye." I slammed the receiver down.

Woo did *not* die. She was violently, yellowly sick; then she sat up, shook herself, and ate grapes.

Early, early in the morning my sponsor's voice quavered through the phone, "Woo?"

"Aurioline came up—going to live—am working on my speech."

"Thanks be..."

The talk went over on the crest of such happy thanksgiving it made a hit. The credit belonged to Woo's tough constitution.

✂ SEWING ✂

I SAT BY THE STUDIO fire patching one of Woo's dresses; the dogs and monkey were sprawled round, sleeping. Woo sat up, stretched first one leg and then the other, yawned—every hair on her body stood at attention; she shook a great shake, beginning at her nose and ending at tail-tip. When every vibrating hair had settled into sleek oneness again, she jumped to the arm of my chair and scrutinized the needle going in and out of the cloth. "Woo," she murmured. "Woo, woo."

"Want to sew?" I handed her a pin and a piece of rag. Woo pushed the pin through the cloth; the head stuck each time. Angrily she tossed away pin and rag. I left the room for a moment. Woo was slipping from the table as I re-entered. In her hand was the needle with which I had been sewing and which I had stuck into the pin-cushion on leaving the room. It was the only needle in a cushion full of pins. Woo picked up her rag, began to sew, each time painstakingly drawing the needle right through the cloth, sometimes helping it with her teeth, but always bringing it out on the opposite side to the one on which it went in. She would *not tolerate* thread in her needle: it snarled.

For several weeks Woo's favourite occupation was sewing. It absorbed her for an hour at a time. Suddenly she tired, threw away the needle and rag, finished with needle-craft for good. That was Woo's way.

For the sake of variety I sometimes chained Woo to some movable object that she might wander round the garden and hunt insects. The article must be bulky enough that she could not lug it up the studio stairs—Woo's one desire was always to get into my studio.

One day I fastened her to a lumbering chair of wood. The chair was heavy and bulky. After proving that the cumbersome thing could not be got up the stair, Woo sat and thought. At the far end of the garden was a loaded apple tree—red, juicy apples. Woo had all the apples she could eat. It was not the fruit she wanted, but the pips at the core. She would destroy dozens of apples simply to get their seeds. She began tugging the chair, intent on reaching that best apple tree. She pulled, she pushed; the chair legs stuck in the grass roots. Then she tried heaving the chair over and over. Had she been able to steer straight, each flop would have brought the chair one length nearer to her goal; but the old chair flopped this direction and that. The tugging, grunting monkey paused every little while to eat an earwig. After a long, long struggle the chair toppled under the tree. Woo sprang, only to find that her chain would not allow her to climb out to the end of the boughs were the apples clustered.

No gallant serpent being in my garden to hand apples to little Eves, Woo got down, over and over went the chair till at last it was directly under the fruit, the chair on its side. It was still too low for her to reach the apples. She stood the chair upright, climbed the seat, climbed the back, reached for the biggest

apple—too big for her hands, it dropped at touch, bumped Woo's head.

"Ooo-ooo-ooo!" She caught the fruit before it rolled beyond reach, gripped it in both wide-spread feet and burrowed for pips.

I SAW WITH AMAZEMENT my monkey's perseverance again. One sketching trip, I hired a cottage high up a steep bank. I took dogs and monkey to the beach while I worked, fastening Woo's chain to a derelict preserving kettle which I found among the drift. Soon the monkey tired of dabbling in the puddles. Her brain connected my being on the beach with the cottage being empty and the joy of rummaging unchecked.

She began lugging the great kettle over a wide stretch of drift between sand and bank. Mounting each log laboriously she hauled the kettle up on her chain, hand over hand like a sailor. She took it over dozens of separate logs, at last coming to the wooden steps that climbed the bank. Up, up, monkey and kettle toiled, kettle registering each step with a clank. Bushes beside the steps caught the chain—Woo patiently unwound it. She came at last to a small flat landing. From there a steep clay path ascended to the cottage door. Woo made the discovery here that if the kettle were put on its side it could be rolled. After a brief rest she started to roll it up the steep path, but on a hill the old kettle was other-minded. Dragging Woo with it, from top to bottom it rolled down the entire stair, defeating in seconds Woo's hours of toil and landing just where they started, the kettle spun and settled.

"Ooo!" said the monkey. "Ooo-ooo!"

All concentration was jerked out of her. Picking up a foot she extracted a splinter. She then fell to catching sandhoppers—a tired but not disheartened monkey, kettle and climb entirely forgotten.

❧ GINGER POP DIES ❧

GINGER POP TOOK fits and died. A perplexed Woo searched garden, basement, and studio. Old Koko relaxed now that there was no one for him to vanquish.

Woo was without a dog chum. Both creatures found life flavourless. As the months rolled by they drew a little closer on the hearth rug. By and by Woo's small quick hands were parting, arranging Koko's hair as they had done Ginger's. The old dog liked it. They settled into a comfortable middle-aged companionship.

Woo's cherry tree was dripping dew these autumn mornings. The roof below the studio got first sun. I chained the monkey there. Old Koko got the habit of climbing the studio stair, strolling over the roof, flinging himself down in front of Woo as an opulent old aristocrat might throw himself into the barber's chair. Woo, important, efficient, bustled to work.

I now coupled Woo and Koko when we walked. He was the only dog other than her Ginger Pop that Woo ever permitted to lead her. Woo took mean advantage over the old dog too. When out she liked to sit down periodically and look north, south, east, and west. The dogs and I got smaller and smaller; Koko was frantic to catch us up. Woo saw to it that she made her pauses

where there was a bush or post around which she could wind her chain and securely tether old Koko until she was ready to move on. It was vain for him to strain and tug at the lead. Woo sat.

When we were out of sight entirely, Woo got panicky—her deft hands undid the chain. With flying petticoats she came tearing. It was all old Koko could do to keep up.

Koko aged faster than Woo. When I saw that to lead her was becoming a burden to him, I did not couple them any more. At the age of thirteen old Koko died and Woo settled down to second widow-hood. She did not look at, nor attempt to fix, the coat of any dog for one whole year; and then one day I dressed a griffon pup up in her dress. Woo watched, interested; she felt him, smelt him, cuffed his ears, pulled his tail. Then she took hold of the loose flesh of his wrinkled cheeks, tried his mettle as she had tried Ginger's, by staring into his eyes, opening her jaws, twisting her head this way and that with alarming ferocity. Griffons are game little dogs: the pup gave her stare for stare. With a gentle cuff or two Woo let him go, having accepted this "pup" as the boy-friend for her declining years. "Tantrum," the deep red, smooth-coated third dog-love of Woo's life, was a sprightly, handsome little griffon.

✄ PICTURES, KEY, BANTAM ROOSTER ✄

GIVEN AN OLD MAGAZINE, Woo would turn the pages till she found a picture, then make a long staring pause. I wondered whether the monkey recognized objects in the flat. I gave her a book of high-coloured monkey pictures; she was not interested. Just turning the pages seemed to please her. One day she ate half my dictionary, drank a bottle of ink, and chewed up my pen. I was mistrustful of Woo's literary appreciation.

In an old magazine she came across a salad advertisement—coloured, realistic fruit and vegetables. She licked a florid tomato, bit into the pictured fruit, nipped it all over (no nip at all on the background). With a disgusted grunt she turned the page, regarded the holes she had pierced, and threw the book away.

One morning Koko took a juicy bone up onto the roof when he went to be barbered. Woo seized the bone and forgot Koko's coat. Her hands were soon greased. She hated grease. Putting the bone on a ledge beyond Koko's reach, Woo climbed over the roof's edge. Gripping the gutter with her hands she stretched out a long back leg and caught a towel hanging on the clothes-line, tweaked till the clothes-pins flew. Taking the towel to the roof

she got the bone and wrapped it up in the towel, wiping her hands free of grease. She then chewed a hole and gnawed her bone, holding it in the towel.

As long as her desire was not jolted in any way Woo had quite a power of concentration; let anything distract her and she forgot her goal.

As she could unfasten every kind of clip I resorted to pad-locking her chain to her anchorage. The key fascinated her. I tied it to a big iron handle. Woo stole the handle, chewed the string, and took the key, hiding it in her pouch. Its glitter fascinated her. She would not give it up. I offered a banana in exchange. She wanted the banana and she wanted to go to bed. She knew the key was necessary before I could loose her. Time and again she took it out and looked at it but kept out of my reach. She wanted bed, she wanted the banana. Finally she held out her hands, gib-bering, threw the key, seized the banana! Before I could pick up the key she darted, grabbed, carried it to a part of the roof she knew I could not reach!

MY BANTAM ROOSTER and Woo had a fight, the most comical I ever saw. A hen stole a scrap from Woo's food dish. Leaping from her tree Woo tore the tail off the small hen. His hen's squawk, seeing her tail in Woo's hand, enraged the rooster. He rushed upon Woo like a hurricane, wattles scarlet, ruff sticking out round his face like a halo, leaving the back of his scraggy neck naked. The rooster struck at Woo with beak and spur.

Woo was afraid for her eyes. Each time he attacked she ducked her face into her petticoats so that the bird flew clean over her. When he grounded, the monkey darted, snatched a

handful of feathers from him. I tore them apart—both meant killing.

The monkey used her petticoats for defence as naturally as if they grew on her.

❧ ORGY ❧

SPLENDID HEAT ROARED up my radiators.

"I shall compliment the dealer on this coal," I said.

Before noon stoke-time all the pipes were dead. I went to the basement. The basement had a glass door.

Woo was too absorbed either to see or hear me come. She was walking around carrying in her hands a tin of liquid tar. Every few steps she paused to pour a little tar into any receptacle handy. I saw a black trickle run into my garden hat, which, along with everything else that had been hanging on the basement walls, she had torn down.

The moment my shadow appeared, Woo saw me! Carefully setting the tar can on the floor, she glided into the furnace room. I picked my way among tar puddles. Woo was already seated innocently on her window-shelf gazing intently over the tree tops, hands demurely folded in her lap; a loose end of chain dangled from under her chin, another gleam of chain hung down the wall. The ash door of the furnace was flung wide, ashes were raked all over the cement floor. The water-glass egg container yawned on its side, rivers of water-glass ran among the ashes. Egg yolk dripped from the sides of the furnace, from the walls of

the room, from door and windows. The coal pile was an omelette. Every bottle in the basement was uncorked, contents had been noted, and either drunk or spilled!

A paper sack containing lime had been emptied into my nail-box, nails stuck out of the lime like little black sticks out of a snow-drift. My geraniums had been transplanted on their heads in eggs and coal. Not a flowerpot was whole.

"Woo! Oh, Woo!"

She neither turned, looked, grinned, nor gibbered. She had had one *good time* and was glad! Stillness brooded over the chaos. Suddenly she caught the broken links of chain, stuffed them in her mouth, gnashed the steel defiantly. Yet I saw that she trembled. I took a split ring and mended the broken chain. She watched. Never had the whites of her eyes looked so uncannily not-white, never her eyelids seemed so uncannily creamily white! Her eyebrows rested far up on her forehead like those of a tired, tired, old woman. The little pointed face made me think of an old farm-wife I once knew whose drunken husband so terrified her that she used to run and climb into the tree where her turkeys roosted, peering down at the man through the dusk, her crouched form little bigger than that of her tom turkey.

Woo anticipated a spanking. She did not get it; the spank evaporated from my fingertips! What Woo knew about spanking she had not learned from me. I had seen the hefty black hand of a mother monkey beat her little one; I had seen the big monkeys at the pet shop punish Woo.

She had enjoyed one big blissful orgy! The tantalized curiosity about everything in my basement that lay beyond her chain's length was satisfied at last. Humans had taught Woo to connect the words bad and fun or she would have been delighted with

her exploits. In the jungle there is no good and bad, no con-
science to tweak.

Poor little Woo! Captivity taught you good—bad.

Woo watched me clean the basement intensely interested. When
I looked at her she turned away her eyes. I offered some cracked
eggs; her passion for eggs was sated for the moment. The basement
decent, the furnace pipes warm, Woo jumped to my shoulder,
cooed softly in my ear—luxuriously she stretched her body along
the hot pipe and warmed her tummy. Maybe conglomerated soap,
blueing, disinfectant, linseed oil, turpentine, worm medicine,
mange cure were not sitting quite comfortably there.

I am glad I did not spank Woo, glad she had one huge orgy.

✂ TEA PARTY ✂

I GAVE A PARTY IN my garden. Every guest greeted me, then went direct to Woo as if she were joint hostess. Woo in her tree was excited and very self-conscious at seeing so many people.

Everyone said, "Hello, Woo!"

She did not look directly at anyone but rather over their heads. As each new guest came through the garden gate she stood upright and gave a throaty croak, intimating, "Stranger!" Her interest in the guests soon slumped; bored, she turned her back upon the people and fell to examining her own hands and her feet.

TWO WOMEN WERE watching her. One said, "How horribly human those hands are! Look at the perfect finger nails, the thumbs, even the lines in her palms! Self-conscious little show-off creature; Darwin—oh, pshaw! The humanness of her makes me sick!"

"Aren't you judging the monkey as if she were a tenth-rate human being, not a small, intelligent beast? She has sense enough to be her own amusing self; few of us have that."

The first speaker shrugged.

Tiffed by the monkey's indifference to their presence, some of the guests tried to work Woo into a rage, poking her with sticks or trying to tweak her tail. Eyes ablaze, Woo wrenched the sticks from their hands, chewed them and spat, lashed out at those who tried to pull her tail.

"What a little fury! Jungle tricks! Savage little beast!"

I was more furious than Woo. All she asked was to be let alone, to be allowed quietly to pursue her own investigating of humans, her curiosity regarding objects. I felt Woo had had all the party she could endure, so I produced a mirror. Instantly Woo forgot the people, the party. Leaning the mirror against her tree, turning her back to humans, she fell to cooing, kissing the shadow of her own kind—her monkey self!

❧ WOO SAVES DOLF ❧

WOO'S ENEMY, ADOLPHUS the cat, had been missing for four days. I searched the neighbourhood. Dolf was the colour of dusk. A motor might easily have got him while crossing the road.

Taking Woo on her chain, "I'm not returning till I find Dolf dead or alive," I said.

"Woo hates the cat. Why take her with you?" called Lizzie.

"Woo's curiosity is enormous, her eyes quick. If one hair of Dolf shows she will investigate," I replied.

I went first to the empty house next door and peered through its windows. Could the cat have got shut in? Woo began tugging on her chain. I let her go and followed. She crossed the garden, crouched, peered under a dahlia bush by the division fence, touched something, squealed, thrust her hand in, withdrew it full of silver hair. I pulled Dolf out. He had evidently been crushed under a motor wheel, had crept as near home as he could to die. Like an empty fur he lay across my arm, limp, with glazed eyes and lolling tongue.

I took the cat upstairs; he was chill, not rigid. Having no brandy I put a little cream on his parched tongue, laid his crushed body on a pillow. The cream revived him. He was home!

Sensing that, recognition came into his eyes; he tried to rub his cheek against my hand. His flesh was crushed to jelly. I sent for the veterinary.

"Put Dolf out."

"Not Dolf! If there were broken bones, yes; if he were an ordinary cat, yes, but not Dolf. He will recover."

"I do not want him to suffer."

"You cannot make a suffering cat purr—listen!"

Dolf did recover, thanks to Woo's finding him in time. He lived another three years, dying at the age of eighteen years. He and Woo were enemies to the bitter last.

❧ A SMACK FOR HIS MAJESTY ❧

WOO AND I WENT to spend an hour in Beacon Hill Park.

The monkey climbed into a low-hung cedar tree overhanging the lake. She was dressed in a full-skirted woollen dress, covered by a scarlet apron that was buckled round her waist. The autumn days were nippy; the monkey was glad of her clothing.

The boughs of the cedar tree hid the monkey. I sat on a nearby bench to feed the magnificent pair of Royal Swans, presented to the park by the King of England, raised in the King's own swannery.

On the park's other lake were swans too, common swans with whom the royal pair were not allowed to associate. Royalty had a small choice lake; its centre was clear water, round the edges grew water-lilies.

When the majestic swans saw me seat myself and produce a paper bag, they came hurrying down the narrow waterway between massed lily pads expecting a treat.

His majesty approached grandly, high arched neck, proud breast ruffling the waterway. His queen swam gently between the troughs of ripple her lord's hurry had dug on the lake's smooth surface. Unarching his haughtiness his majesty stretched forth an aristocratic bill to take the crust I threw upon the water.

A scarlet flash! A ringing smack! The monkey springing from her bow had landed on a huge flat stone immediately in front of his majesty. The full force of her strong, black little palm hit squarely across the swan's face. The monkey seized the crust out of the kingly bill and, crouching, her eyes staring straight into his, her mouth angrily open, showed him every one of her perfect teeth. Slapping her hands on the stone in front of him, bending this way, bending that, the creature made herself a grotesque awfulness.

Obviously his majesty had never had his face smacked before! Fury and amazement blazed from his eyes. With infuriated hissings he sought to back, but the way was blocked by her majesty. He bumped into her—she turned with all the haste her gentleness and the narrow way would permit. The birds could not break through the snarl of lily pads. Splashings and furious unroyal squawks! At last they had reversed their going and were paddling madly for the open centre of the lake, hoisting their wings in two angry ridges, one either side of their bodies, bills buried down in their breast feathers in order that the arch of necks might rise higher, foamed waves scurrying before their angry breasts.

With a disdainful grunt the monkey hurled the crust after his majesty, swung herself back into the tree and tucked her cold, wetted hands into her woollen lap to warm.

"Ooo-ooo, ooo-ooo," she cooed, delighted with herself for having smacked the bundle of feathers whose arrogance she despised.

"Ooo-ooo-ooo!"

❧ WOO AND HA'PENNY AND CAMPING ❧

WOO, THE GRIFFS, AND I were tucked away in a house-boat up that lovely arm of the sea known as "The Gorge."

At high tide our house-boat floated, at low tide she tipped and one end rested on a mud bank. At low tide there was splendid crabbing along the sides of our scow-float. Woo lay flat on the boards making quick darts as the small crabs crawled out of crannies, tossing them sharply from hand to hand to prevent their nipping her fingers. Each day at five o'clock I relaxed from sketching.

The water lay flat and still. I got the oars, untied the old flat-bottomed, square-nosed boat that rented with the house-boat. The creatures crowded excitedly! Woo was the first to leap in, rushing to the square boat front and flattening her stomach to its boards. She peered into the water, called, "Woo, woo," kissing, coaxing the floating shadow monkey to come.

Koko and Ginger Pop sat themselves one on each side of me on the rower's seat, my body between their enmity. Every stroke of the right oar bumped Koko; every stroke of the left bumped Ginger—all were too happy to mind bumps or to remember hostilities. Two other griffons, John Bull and Mr. Pumble-Choke, went along steerage, being humble.

Our boat preferred to progress in circles. As neither time nor destination mattered, circles were as good as straight lines.

The silly waves rapturously kissed our craft's ugly sides and Woo tenderly kissed overboard at the shadow monkey. These were the only sounds. I forgot tenants, town, and taxes—they were as drowned as the stones and snags down in the mud, drowned in peace till suddenly across the water, "Cooey! Cooey!"—a table cloth was waving from my house-boat.

I persuaded our boat to circle towards home. The girl I had left in town in charge of tenants and kennels stood on my veran- dah holding a depressed pup with a dangling broken leg. I went into town. The vet set and splinted the leg. I brought the pup back to the house-boat. Woo was intrigued by the splint. On the third day the swelling of the foot went down. I glanced up from my work to see Woo gently slipping the splint over the pup's foot. I dared not shout for fear she might snatch the splint suddenly and unset the bone. The pup was delighted to be free. Woo slipped a hand through the bandage and fitted the splint to her own arm.

Toiling to the nearest phone, I called, "Doctor, the monkey took the dog's splint off. What shall I do?"

"Ach!" said the veterinary. "Bring 'em both in—chloroform for that monkey, new splint for the pup!"

WHEN MY CREATURES saw stir among household camping dere- licts, they went wild with delight, stuck to me with the persistence of ants and house-flies. Early in the morning bedding, food, boxes, chipped crockery, sat on the pavement before my house. Woo was fastened into her travelling-box, shrieking delightedly, rocking the box from side to side. Bearded griffon faces peeped from wire-fronted cages. We looked like an eviction out there on

the paved road. Finally the truck came rumbling down the street to pick us up. Tenants watched us from windows, presented us with camping plain wholesome cakes, wishing us well.

I expressed the hope that my understudy would be satisfactory, and climbed up beside the driver. We were off! Every twirl of the wheels left our worries more behind, raised our spirits higher. After the mild bustle and congestion of the town was past, there was nothing but sky, earth, us.

FOR FIFTEEN YEARS I camped in dilapidated cabins, too out-of-the-way, too out-of-repair for other campers to tolerate. Then I bought a cheap, ugly old caravan trailer. A truck hauled us to wherever I had wintered my van, hitched her on behind, trundled us to a new place. Each year the old van homed us for as long as the apartment house would let me be away.

There were always woods, always water, always sky. The creatures loved it—so did I. They loved sharing close quarters with their own particular human even more than they loved the freedom.

My bed was across one end of the van—only half an inch to spare for kicking. On one side of the van was a shelf-table with storage spaces beneath; along the other was a low bench on which sat four dog boxes and the monkey box, all wire-fronted so that the creatures could watch my every move. There was a small table by my bedside where I wrote at night. Above the creatures' boxes were pegs for my clothes. The van had windows facing north, south, east, and west. My bed was high; in it I could lie looking out at the stars. There seemed more stars here than in town. Underneath my bed were all my canvases and paint equipment. I had two coal-oil lamps, an oil stove for wet days. I cooked outside on a campfire; we kept our food outdoors under a canvas shelter.

The monkey camped with me for thirteen years. I don't know which of us loved it more—she or I.

IN CAMP ONCE IT rained for ten days steady. Being very tired, I went into the van, took the beasts with me and shut the door, just like Mrs. Noah. We slept and slept till the tired went out of us. If the rain stopped for a few moments we all tumbled out of the van to stretch ourselves. No shoes, no stockings—I went like the rest, barefoot. I put on a fisherman's mackinaw. We took pails and fetched water. The soft wet was underfoot, dripping trees overhead.

In the van again, hot water bottles, shakes, rub-downs, and we tumbled into our beds to sleep more. Wet days were almost as black as night—night so dark and thick you could lean against it. Rain rattled on the canvas only a few inches above our heads, rivers gurgled in the road ruts, breakers pounded on the beach. Plop! plop!—leak drops from the van's roof spattered into catch-cans. Snoring creatures, singing kettle, glow of lamps, cups of tea, hot bottles—delicious memories which remain after wet, wasps, ants, and other uncomfortables are forgotten.

Many people, forgetting I was an artist, thought it morbid, queer that I went off to the woods with the dogs and a monkey and no other companion.

The good memory of those times remains for always and Woo runs through it like laughter. I do not think the monkey had greater intelligence than my griffon dogs. She was more curious, more entertaining, more mischievous, less obedient. In spite of her adaptability to domesticity you were always curiously aware of jungle ancestry. The baffling human-acting hands, groping hands, trying, it seemed, to trick and yet to copy.

BEFORE I BOUGHT the old van, wishing to work in a thickly wooded part at the foot of Mount Douglas, but unable to locate a shack, I took rooms in an old farm house with an elderly couple. The man worked in nearby tomato greenhouses.

"I must tell you," I said when arranging for my rooms, "that I shall have several little griffon dogs with me."

"Good! We love dogs," said the woman.

"I shall also have a monkey."

"A monkey! Sakes!" She clapped her hands. "I have always loved monkeys."

We had scarcely tumbled out of our truck in front of her house when the woman's husband came home.

"Look, Father, look at the monkey!"

Father gave to each dog, to Woo, to me a separate sour scowl.

"What is to be done with this collection?" he grumbled.

Mother dived into her kitchen.

"I will see that the creatures do not bother anyone; they are never away from my heels."

Two days later Mother tiptoed to my rooms.

"Father is up cherry tree gathering top-best for Woo!"

When Father came from the tomato houses he acquired the habit of passing by Woo's tree and patting his pocket. Woo scrambled down and dived in her hand. There was always a little ripe tomato in the old man's pocket for her. The couple liked, when my work was over for the day, to have us drop into their kitchen for a few minutes' chat. Woo would jump on the arm of the man's chair, put up a finger to feel if his pipe were hot. The man stooped to gather tenderly the little deaf dog, Twinkle, in his arms. Monkey and dog sat in his lap, his hands caressing them, his heart won.

Everyone accepted the griffons, everyone accepted Woo.

We stayed a fortnight at that farm. At the end of the summer, I went out to see the couple. They had been for a trip to Tacoma.

"You should have heard Father telling folks about 'our' monkey," the wife chuckled, "him that was so surly the night you come! One never does know how husbands is going to act."

"Or monkeys either," I replied.

WOO COULD WELL have been trusted loose except for her wrecking investigations. Freedom did not attract her. The houses and things of men did. If she were loose, she watched for my mind to be occupied by something other than herself, then rummaged cottage, van, tent, wherever my things were, tearing, smashing, spoiling by her curiosity.

One morning Woo sat unchained by the campfire embers warming her toes. I was setting the camp to rights. I sat down to write a letter before fastening Woo to her stump. The van was in a grassy place under great pine trees, beyond lay a hay field loved by Woo because it was full of grasshoppers.

When I realized Woo really had gone I ran to the woods calling, calling. There was no answering "Woo." Three hours I sought, then I remembered grasshoppers in the field and how she ran after this hopper and that till she got beyond the sound of my call. I walked down the highway which skirted our big field, and came to a house set far back.

"Hi! This your monkey? I seen you yellin' an' lookin'. Lor', the critter scared me proper. Standin' at sink washin' I was, door creaks, opens—no footstep! Then I seen a little hairy hand, then I seen 'er! 'Is it a chip of the devil hisself?' I says, says I."

"Thank you."

I took hold of Woo's chain. "Please lend me a bucket and a broom."

"Lor', them's my ant traps."

Down her verandah ran trickles of syrupy water and drowned ants; empty tomato tins rolled sideways.

Woo, replete with hoppers and 'ants in syrup,' was delighted to see me, glad to be led home.

ONE SEPTEMBER WE camped on the Gold Stream Flats, a narrow spread of land lying between two high ridges. The sun came into the little valley late and went out early. Night and morning it was chilly. Our van was drawn up under a wide-spreading cedar tree, very old. Its immense bole was hollow. I put Woo's sleeping-box inside the hollow tree bole, dry, draught-proof. I wondered if the old tree could feel the throb of Woo's life inside it. She was just below the van window and could hear my voice. Nights were raw, bitter in the van.

This park was a public camping place. All the campers had gone back to town; we had it to ourselves except for a woman and her three little boys. The woman had the pop stall at the entrance to the park. Up the mountain-side was a farm. The children from the farm came down to play with the pop children. They took a great interest in Woo.

One morning the farm children rushed home with the news, "Mother, the monkey's sick."

"How sick?"

"Castor-oil sick. We saw the van lady pour and Woo spit."

There came a chattering and scattering of stones down the mountain road. Mother pushing a pram, dragging a go-cart, walk-age children hanging on to any part of woman or baby-

carriage available. They came straight to my camp. The woman sat down on the log beside me, matronly efficient.

"How does she ail?" she pushed a gentle hand under Woo's covering, stroking the listless body lying across my lap.

"A stomach full of green paint."

"Mercy! It's fatal!"

"She recovered from both blue and yellow," I said.

"Green's worse—emetics and warmth is all I know. If she lives, here's new-laid eggs and milk."

She fished a dozen of one and a quart of the other from the pram.

She said, "Dark's coming," and trundled pram and go-cart up the hill.

MRS. POP-LADY LEFT her stall in care of her biggest small boy. "Someone may turn in from the highway, Willie. I'm going along to see how Woo is."

Heavily she slumped down on the log beside me, bent, and shook a frizzy bobbed head over Woo. "Looks bad!..."

Woo's white eyelids were half closed, saliva trickled from her mouth; near the fire swathed in shawls she shivered. We were joined by another visitor.

"Willie told me."

She too sat down on the log—a spare woman, gruff voice, mannish hair-cut, thick boots, wide stride, and the softest heart in the world. This woman often spent a week-end in the park, sometimes with her husband, sometimes alone, in an old shack up the mountain. She loved wild things. She bent over Woo.

"Ah, me," she sighed. "I loved that mite from the moment I set eye on her—now she's done for!"

"Not yet! She has recovered from the yellow and from blue."

"But not from green!—deadly! Our cow died after no more'n three licks of our fresh painted boat."

"They told me yellow was the deadliest."

"Nope! Green! Woo's as good as gone!"

Excessive pessimism puts my back up—it did Woo's too.

She rolled feebly over, stretched a leg towards the fire. I offered milk, I offered egg, neither aroused interest. Violently Mrs. Pop bounced off the log, started to run over the hummocky ground in the direction of her stall.

"Willie!" she shouted, "Willie, bring a cone—vanilla!"

"Who for, Ma?"

"Woo, if you ain't too late."

"Ain't Woo goin' a-die, Ma?"

"Maybe not—hurry!"

Breathing heavily, Mrs. Pop sat again upon the log. Willie and cone came; Woo's pale tongue ran out, took a feeble lick. Woo lived.

"Beats all!" murmured a voice on the far side of Woo and me. "Monkeys is robuster'n cows."

❧ EXIT ❧

GINGER POP, KOKO, Jane, Adolphus filled out their lives, died, and became memories. Woo was fourteen years when I sold my apartment house and moved into a cottage. The uprooting did not bother her. Wherever I was, there Woo was content. She had been in and out of camp so often that to be packed into her travelling-box and trundled over the road in a truck was no new experience. There were no hot pipes in the cottage for Woo to roast her front on, no basement woodpile for winter play. She had a large cage in the big old-fashioned cottage kitchen and loved having her nose and fingers continually in my pies. There was a plum tree in the garden, lovely as Woo's cherry tree: there was a brand new admiring audience to make faces at.

Woo was heavier now, thicker through the middle. She showed a preference for sitting beside the fire rather than walking. When my heart gave out the doctor forbade me taking an active part in household tasks. Woo and I looked into the fire and thought. The doctor sent me to the hospital for a long rest. Poor old Woo! (I wonder what the nuns would have said had I arrived at hospital with a monkey!) Monkey and dogs sat forlorn in the cottage kitchen, waiting.

My sister had to go to them as well as come to me in hospital. The weather was bad—something had to be done. The dogs were easy to arrange for. A monkey? Few people want to bother with a monkey, willing to enjoy someone else's monkey, but too lazy or indifferent to earn the real enjoyment of owning. I wrote to the Vancouver monkey house in Stanley Park. Woo would here enjoy companionship and good care. The Park Board accepted Woo, friends shipped her before I came out of hospital. Giving her up hurt. Others nailed her into a box, gave her into strange hands. When I came home she was gone.

FRIENDS IN VANCOUVER went to see Woo nearly every Sunday, took all the dainties she liked best, eggs, cherries, grapes. At first they did it for my sake, these friends, but soon they went for their own pleasure. They loved to see the little hands stretch through the bars for goodies, to hear Woo's whoop of welcome. She had a roomy cage to herself, soon became a favourite with visitors. She was the "belle of the monkey house"! The keeper's daughter was especially fond of her.

WOO LIVED IN THE Vancouver monkey house for a year. My friends went one Sunday and found her cage empty.

"Old age—natural causes," said the keeper. "No ail, no mope... just died."

"Fine exit, Woo! If that is monkey way, I am glad domesticity did not spoil it."